eight painters

eight painters

The Surrealist Context

J. H. MATTHEWS

SYRACUSE UNIVERSITY PRESS · 1982

Library of Congress Cataloging in Publication Data

Matthews, J. H.
Eight painters.

Includes bibliographical references and index.
Contents: Max Ernst—Joan Miró—André
Masson—[etc.]
1. Surrealism. 2. Painting, Modern—20th century.
I. Title.
ND196.S8M37 1982 759.06'63 82-10801
ISBN 0-8156-2274-0

Manufactured in the United States of America

To CONROY MADDOX
for twenty years
of friendship

J. H. MATTHEWS is a member of the committee appointed by the French government's Centre National de la Recherche scientifique to establish a center in Paris for documenting world-wide surrealism. He is American correspondent for *Edda* and *Gradiva* (Brussels), *Phases* (Paris), and *Sud* (Marseilles), magazines devoted to vanguard poetry and art. Professor Matthews is a member of the faculty of Syracuse University and is the author of twenty-one books, most of them about surrealism. In 1977 the University of Wales conferred upon him its D.Litt., in recognition of his work on surrealism.

Contents

Preface

THE RADICALLY ANTIAESTHETIC CHARACTER of the surrealists' investigation of art forms in general has promoted, among other things, a concept of painting that consistently grants paramount importance to content. So far as surrealist painting directs attention to method, it does so coincidentally. It requires both the artist and his audience to weigh the contribution that technique makes, first to identifying and then to communicating subject matter capable of stimulating the imagination in ways surrealists regard as fruitful, when painting is examined in light of their principles and in relation to their ambitions.

The nonsurrealist may well regard this emphasis as indicative of a bias having only questionable merit. Certainly, it can appear as evidence that surrealist painters must find themselves in an indefensible position, whenever they come under attack from hostile commentators who agree in looking upon the application of painterly technique as the only acceptable justification for artistic endeavor, as imposing the only criteria by which a serious and competent artist's achievement should be judged. Such observers, we notice, evidence a preoccupation with technique, when separating the work of surrealism's pictorial artists into categories. Some of them talk, for instance, of illusionist surrealism, on the one side, and of biomorphic surrealism, on the other. However, they do so without concern, apparently, for the fundamental unity of surrealist painting. They make little or no attempt to show how, and more especially for what reasons, the so-called illusionist relates to the biomorphic as the surreal is explored.

Only limited understanding and appreciation of the nature and function of painting in surrealism can be attained by anyone who, ignoring or denying the orientation of surrealist pictorial experimentation, tries to eval-

uate it in terms that surrealists not only refuse to acknowledge but in fact reject. Stating this truism would seem pointless, were it not for one essential factor. Aspiring to assess all modes of painting strictly on their own terms and by standards in which they have every confidence, some art critics often find themselves entirely out of sympathy with surrealism. The critic may fail to recognize that surrealists have taken their stand on ground where he himself has never chosen to venture and where he would expect to encounter nothing of interest or significance. More than this, he may tend to react negatively, upon perceiving that they have removed themselves and their work from the context in which he believes painting is and ought to be situated.

Depicting art critics, or even a limited number of them, as villainous is as inappropriate as calling them insensitive, irresponsible, or stupid. All the same, it is imperative to note that evaluating surrealism is primarily a matter of perspective. The most noteworthy feature, here, is that when a critic dispenses praise to one surrealist or withholds it from another, he usually does so for reasons of which the surrealists themselves take little or no account. The value judgments at the core of twentieth-century art criticism tend to direct attention away from aspects of creative art to which surrealist theories ascribe real importance. This is why the study that follows is intended as something other than an exercise in art criticism.

When André Breton, author of the surrealist manifestoes, warned in the foreword to his book on Yves Tanguy that no reader should expect to find therein anything at all resembling art criticism, his main purpose was not to defame that respected form of interpretive commentary, or its practitioners, for that matter. He wished, rather, to stress that his published remarks had grown out of a relationship with Tanguy's painting quite different in essence from the one a professional critic would have. In consequence, he implied that, with Tanguy's pictures, the point of view adopted by the art critic could not lead to the kinds of discoveries or the sort of illumination to which, as a surrealist, he himself attached importance. In this sense there is, then, a limited parallel between Breton's undertaking and the present one.

This essay is not offered as a gesture of defiance, directed against the canons of art criticism. Nor is it meant to question the critics' aesthetic sensibility. Quite simply, it is designed to help promote fuller appreciation of eight painters associated with the surrealist movement, whose work comes under consideration here only so far as it falls within the framework of surrealism. But there the parallel with Breton's *Yves Tanguy* ends.

No person outside the surrealist group can pretend to speak with authority on pictorial experiments conducted under impetus from precepts

defended by surrealists and fostering surrealist ambitions. Hence this book attempts merely to clarify a few artists' intentions and point to the achievements they have made in relation to the aims underlying surrealist painting: those to which the artists in question have alluded openly in statements about their own work, those that surrealist painters all have in common, and those too that they share with everyone else committed to the pursuit of goals designated in surrealism.

Without seeking in any way to detract from the artistic accomplishment (as art critics speak of it) of this painter or that, we have to begin by acknowledging one essential characteristic of surrealist investigation in each and every medium of expression. To the surrealists, art appears as a means, and not as an end. In their eyes, moreover, it is the end, not the means, that grants artistic effort significance. The *why* of surrealist creative activity takes precedence over everything else, regardless of the appeal that may be intrinsic to the *how* and even, in some cases, to the *what* of surrealist creative endeavor. More particularly, it is the *why* that authenticates painting in surrealism.

Of no major movement influencing the development of modern art comparably is one thing as true as it is of surrealism. Surrealism has exerted its influence on twentieth-century painting quite incidentally, while devoting its energy to realizing ambitions extra-artistic in scope and, fundamentally, in nature too. Hence attempting to confine painting of surrealist inspiration within the framework of art, as we have come to know it in our time, violates the freedom surrealists have always demanded in the name of the painter. This disfigures surrealist painting, falsifying its nature by limiting its scope.

Confident of their objectivity, some observers may argue, and with good conscience, that it is an exaggeration to talk of disfigurement and falsification here. They may conclude that it is only justice that surrealism should be assimilated by modern art and required, therefore, to meet its standards. And yet when we are dealing with an individual who is a surrealist first and an artist second (and no surrealist painter can be anything else), there is danger in ignoring his priorities or setting them aside. Presuming to rearrange them, so as to make the surrealist artist's efforts amenable to evaluation by accepted criteria, we must end up being unfair.

Where is the surrealist painter headed, and why? What effect does pursuit of goals envisaged by the surrealists have upon the subject matter of his art, upon the way he arrives at it, and the way he treats it? These are some of the questions that can be answered only if one places his work in the context of surrealism.

Situating in relation to surrealist doctrine every painter whose work is

discussed below requires us to show how his practice as an artist has commanded respect among surrealists. Reaching this goal necessitates more than analysis of significant features of his work. It entails also consideration of the response his painting has elicited from within the surrealist group, whether or not evaluation by other surrealists happens to coincide with the judgment of critics outside the surrealist camp. Hence the twofold purpose in view here: to show what certain artists contribute to surrealism and take from it; to clarify the concept of painting in surrealist perspective. Readers seeking information on or assessment of the later work of Salvador Dalí, Max Ernst, André Masson, or Joan Miró, which does not fall within the surrealist context, must look elsewhere.

Placing one artist vis-à-vis surrealism calls for examination of aspects of his work that are based on surrealist dicta. For another, it may require consideration of features of his working method that produce results by which participants in the surrealist venture are enthused. Thus we have to take into account published remarks by recognized spokesmen (of whom André Breton is at once the most prominent and the most vocal) that furnish insights into the sources of the surrealists' admiration and so help sharpen our awareness of their aspirations through painting.

Far from attempting an exhaustive analysis of the work of a number of artists known to have been affiliated with surrealism, the chapters below have a different purpose altogether. Each examines one painter within a narrow focus. The need to answer the following two-part question has shaped each section. What has the artist under discussion brought to surrealism and what has he found in the surrealist viewpoint to further the development of his art in ways that make his work—or at all events a significant portion of it—exemplary of surrealism? Addressing this question leads us to concentrate on the nature of the individual painters' contribution, by drawing attention to the circumstances under which every one of them has enriched the surrealist creative process through painting. At the same time, it brings the added benefit of broadening our acquaintance with surrealism's demands upon its artists, of helping us see better what surrealist painting really is.

JHM

Tully, New York
Spring 1982

Acknowledgments

Enough individuals, galleries, and museums ignored requests for assistance in the completion of this book to leave me especially grateful to those responding with courtesy. Thanks are due the museums and galleries which cooperated in making available photographs and in authorizing reproduction. The generosity of Perls Galleries, the Pierre Matisse Gallery, and the Munson-Williams-Proctor Institute has proved in marked contrast with the conduct of certain museums intent on practicing highway robbery when setting reproduction fees. As for the persons choosing to remain unidentified by name but whose private collections were opened to me, their kindness has enriched my volume while offering me encouragement when it was badly needed. Special thanks go to Wilhelm Freddie for photographs of his own work and for permission to use them. Edward B. Henning earned my gratitude by reading my text in manuscript and making tactful recommendations, not all of which I have failed to follow.

eight painters

Prelude

IT IS WELL KNOWN that the surrealists are a closely knit group, jealously protective of their friends and associates. They are reputed to be capable of attacking with unbridled violence anyone whose opinions differ from their own, anybody daring to challenge surrealist doctrine and criticize creative activity inspired by or consistent with surrealist ideas. To many an observer it looks, in fact, as though the surrealists' position of defiance and their refusal to compromise have given rise to a program so unyielding that it is distinctly restrictive in effect. Apparently, surrealism confines painters and poets to a narrow function dictated by a singularly rigid theory, sure to stifle individualism.

Review of the surrealist attitude toward painting demonstrates the inaccuracy of this view. Surrealism is not a straitjacket. On the contrary, it provides an evaluative context against which one may assess the achievement of certain poets, filmmakers, sculptors, and painters. Judgment may be passed, naturally, on artists who have pledged allegiance to the surrealist cause. It may be offered, also, with respect to other individuals whose approach to their chosen medium helps the surrealists clarify, in their own minds, what this or that form of art is able to contribute to surrealism.

A few members of the French surrealist group express themselves confidently—none more confidently than their leader, André Breton—when discussing painters who enjoy their approval and trust. Isolating in their published remarks enthusiastic endorsement here or reservations there, we may infer that they have earned and now take full advantage of the privilege of speaking with authority in surrealism's name. The right is exclusively theirs, it seems, to formulate a theory of painting by which a pictorial artist must abide, if he or she desires to win acceptance, admittance to the

1

surrealist ranks. However, placing doctrinaire pronouncements on painting against the background of commentary on one painter or another from which they have been drawn, we gain a more accurate impression of the role played by surrealist commentators. Whatever one of them has to say about pictorial art records or derives from his reaction to the accomplishment of some artists who has gained his trust, fired his admiration, stimulated his imagination. So far as its defenders look upon surrealism as reserving a place for painting in its program of revolt, they reach their conclusions inductively. It is the painters themselves who actually point the way. Works, rather than precepts, define the context of surrealist painting.

However authoritative (or even dogmatic, for that matter) they may happen to sound to a reader curious to acquaint himself with reliable guidelines that could be followed by a surrealist wishing to paint, André Breton's remarks in *Le Surréalisme et la peinture* about pictorial artists closely or loosely affiliated with surrealism are presented as subjective interpretations. Statements made by Breton during the 1920s, and later too, were hardly meant to direct surrealist painting into narrow channels from which escape or release would be impossible. The first surrealist commentator to attempt to discuss surrealism and painting at any length, Breton concentrated throughout his life on helping his audience understand how certain artists had won his confidence and raised his hopes for painting. He brought no a priori definition of surrealist art to his examination of what those men and women had done. And the same is true of José Pierre, Louis Aragon, and other participants in the surrealist movement who have joined in discussing the role of painting in surrealism.

When Louis Aragon praised what he termed "an *Ernstian* atmosphere," he displayed sensitivity to a mood to which other surrealists also—people of his own generation and those coming later—were to attach value. Out of that mood, to a considerable extent, their faith in painting as a revolutionary force was to gather strength. From the surrealists' standpoint, certainly, Max Ernst's collages and the iconography he developed while executing paintings for which he took inspiration from collage technique marked an important reorientation of pictorial art. The original surrealists in France, of whom Louis Aragon was one, were quick to interpret some of Ernst's early pictures as escaping the negativity characteristic of Dada, even though those works had been completed while the artist was still faithful to Dada. They saw the collages and paintings in question as contributing significantly to a positive program which they themselves had espoused under the name of surrealism. In their estimation, Max Ernst helped advance that program when he succeeded in charging his graphic universe with a distinctive atmosphere admired by Aragon. The Ernstian atmosphere, surrealists real-

ized with excitement, bore witness to the poetic spirit of surrealism. This was an aggressive not a contemplative spirit, beginning to affirm itself through rejection of the limitations of concrete reality and reality's pictorial reflection, demanding of imagery—pictorial as well as verbal—an imaginatively stimulating alternative to the oppressively familiar world about us.

Max Ernst's early collages antedated the official launching of the surrealist movement in France, during the autumn of 1924. The example they set when placing imaginative activity above fidelity to visible reality and rational projection—not in order to distort reality but to reveal surreality as a higher sense of the real, or as the surrealist writer Benjamin Péret called it, "a rectification of the universe"—indicates that pictorial surrealism did not evolve in accordance with a pre-established theory meant to define surrealist painting in advance of its practice. No more than his investigation of frottage were Ernst's experiments with collage intended to set a confining pattern. They were not designed to lay out a method for surrealist painters to follow. The same is true of Joan Miró's implementation of a pictorial technique parallel to that of verbal automatism. First and foremost, what Ernst and Miró did for surrealism was encourage its chief spokesman in Paris, as well as the individuals whom Breton had recruited to the surrealist movement, to believe painting just as capable of lending itself to the purposes of surrealism as word poems already were proving to be.

The pictures completed by Miró during the early 1920s had the special virtue of lending support to the conviction, shared by André Breton and some of his friends (though challenged by others, under Pierre Naville's leadership), that painting really can compare with verbal language as a means of seeking and attaining poetry through automatism. During the period succeeding publication of the October 1924 *Manifeste du surréalisme*, surrealists in France readily identified in Miró's spontaneously generated pictorial imagery an unadulterated form of automatism, equivalent to the automatic writing which had enabled Breton and Soupault to write their *Les Champs magnétiques* in 1919. Many years later, José Pierre's phrase "lyrical deformation," applied to Miró's work, would emphasize reality's potential for expressing surreality. Without mentioning deformation, Breton too had been enthused by Ernst's lyricism, a similarly liberative agent by which reality, it appeared, can be forced to precipitate surreality. Ernst and Miró earned renown among first-generation surrealists by demonstrating, to their associates' delight, their ability to provide the pictorial counterpart of poetry of the kind pursued by surrealists using words—a mode of mental liberation focused on releasing unwonted, illuminating images.

A second-generation surrealist, Salvador Dalí, also made his claim on his companions' attention by placing before them some provocative picto-

rial images. Indisputably without precedent in the world of lived experience, certain of Dalí's images fascinated André Breton, who was not the only surrealist by any means to fall under their spell. Lauded by Breton, as a painter of revelatory canvases, Dalí seemed to promise much—in fact, thought Breton, more than anyone since Ernst and Miró—at the time of his acceptance into the surrealist circle. His "hand-painted dream photographs" suggested, at first, that Dalí's art might bear comparison before long with Tanguy's dream vista paintings. Hence Dalí's academic manner was tolerated for the intensity with which it fixed images obsessive in origin, both mentally and emotionally disturbing.

In some respects, the Parisian surrealists' reaction to Dalí's work is more instructive than the reception they have given any other painter. Around 1929, their eagerness to accept the Spanish artist testified to the high hopes they had for his gifts. But in the end the French surrealist group rejected Dalí. No other ex-participant in the surrealist venture was ever to provoke such bitter feelings in those by whom he had been formally expelled. The violence of the surrealists' attacks on Dalí's postsurrealist painting reveals how profound was their disappointment over his defection.

What makes his case interesting, though, is that Dalí was not guilty, really, of defecting. At best, he had been a fellow-traveler, not a dedicated surrealist. Studying the evidence, we are struck less by his final departure from the surrealist camp than by the surrealists' inability to foresee that he was bound to leave, one day. In 1941 André Breton irrevocably condemned the Dalinian academic style as "ultra-retrograde," apparently unable to acknowledge that, not having changed to any significant degree, Dalí's style had never been anything else.

Eventually, it was not his persistent use of his customary technique that dissatisfied the surrealists in Salvador Dalí but the results to which it had led. In surrealism, methodology is assessed in relation to its fruits. So when his pictorial imagery provided clear indications that Dalí was a "self-kleptomaniac" it was time, surrealists agreed, to withdraw their confidence in him and in his work. They now saw in Dalí a painter whose methods had ceased to offer new revelations. Now these methods betrayed weaknesses more than they displayed strengths. In surrealist perspective, Dalí's weaknesses were seen as confirming the suspicion with which all surrealists look upon expertise in the application of inherited painterly technique.

Surely, by the time Breton complained that Dalí was simply painting puzzle pictures, incapable of offering the revelations which earlier Dalinian canvases had brought through implementation of so-called critical paranoia, Dalí's technique was giving proof of contrivance of a kind that surrealists

judge inadmissible. No longer bringing discoveries that commanded the surrealists' admiration, Dalí's method seemed able to do nothing better than put together pictorial images found to be in radical conflict with surrealist investigative goals.

As with the seven other painters to whom we shall give attention, to surrealists the importance of Dalí lies in his success in achieving—through certain of his pictures—aims favored by surrealism. The fact that he did so while exploring art in his own way is not the crucial issue. On balance, what should matter to anyone interested in the context of surrealist painting is less the harshness of the treatment finally meted out to Salvador Dalí by the surrealists in France than the principle which inspired that treatment, in their own estimation fully justifying the surrealists' conduct.

In contrast with Dalí's self-congratulatory practice during the presentation of multiple images, Wilhelm Freddie's handling of rules of perspective and of formal structure—on occasion amounting to their misuse, by traditional standards of painting—is invariably related to the promotion of images which other surrealists readily approve, to heightening the impact made on the sensibility by imagery that disrupts the patterns of commonplace reality. In Wilhelm Freddie's work, deliberate effect never serves the cause of self-advertisement of the sort in which Dalí indulged. Freddie's painting does not invite its audience to witness a display of its creator's neurotic preoccupations, as Dalí's sometimes does. The function of a Freddie picture is to confront the spectator with his or her inner self. Hence surrealists must find it particularly noteworthy that, while Dalí—his imagery having sacrificed its forcefulness to virtuoso demonstration of technical competence—ended up an uncomplaining prisoner of his photographic method of painting, Freddie evolved as an artist. He took a direction that was to lead him away from photographic realism in the rendition of constituent elements of his pictorial images, without compromising his capacity to paint as a surrealist, to implicate the public in surrealism's revolt against the moral and ethical usages of contemporary society, for instance.

As for Tanguy and Roberto Matta, neither may be described as having bent his efforts to pleasing those affiliated with surrealism. Tanguy once explained that he painted to surprise himself. While involved in surrealism, Matta spoke of working for his own astonishment. Just as is the case with discoveries made by Miró and Masson through the application of pictorial automatic techniques, and with the revelations coming to Ernst by way of collage, a search of private significance, undertaken by the painter for purposes of his own, was given broader meaning by those he met in surrealist circles. The enthusiasm voiced by his fellow surrealists did not set

limitative restraints on the artist's creative energy, however. Having played as central a role as Miró in creating the surrealist context in art, Ernst, Masson, and Matta were free to pursue their search, each in ways of his own choosing. Meanwhile, despite their departure or estrangement from the surrealist group, these artists all had made a vital contribution to surrealist painting, even though not one of them was destined to remain, like Tanguy or René Magritte, a lifelong adherent to surrealism.

The mystery with which Magritte infused commonplace objects, by the studied use of displacement resulting in strange confrontations, complements the mystery present in Tanguy's canvases, where unidentifiable configurations are brought into proximity. Examining René Magritte's work, the spectator is puzzled by the presence of recognizable forms borrowed from the everyday world and all rendered with close attention to detail. These forms stand before him, however, disconcertingly juxtaposed or combined in ways calculated to do violence to reasonable expectation. In Tanguy's painting identification, as we may speak of it when referring to familiar elements in a Magritte, is ruled out almost every time. Figuration is not allusive to the familiar world. Yet for Tanguy's audience viewing becomes a cognitive experience all the same. In fact cognition is situated on the same plane of pictorial poetry where Magritte's pictures take hold of the observer's imagination.

Drawing inspiration from one form he had painted when going on to outline the next, Yves Tanguy would work with a spontaneity somewhat different from Miró's, which is always influenced by an instinct for formal balance. Tanguy's spontaneity led him to create a graphic universe radically opposed—or so it seems, on the surface—to Magritte's. René Magritte spent hours explaining his intentions and working methods, in letters, catalog texts, and even public lectures. By contrast, Yves Tanguy was singularly reticent. Yet Tanguy's dream vistas are as expressive of the surrealist state of mind as Magritte's "object lessons."

Surely, during the years immediately following redaction of the first manifesto, the special consideration shown by the surrealists in France to Joan Miró and André Masson was a tribute to their proven capacity to draw and paint automatically. It may appear inconsistent that two artists admired for their ability to extend application of the automatic principle from writing to painting should be subject to evaluative judgment from within the surrealist circle. Self-censorship and self-criticism are excluded in anyone who has opted for automatism. Yet Breton saw fit to blame Miró, after a while, for "infantilism," while still continuing to express admiration for Masson's "chemistry of the intelligence"—a phrase the author of the surreal-

ist manifestoes had borrowed from Edgar Allan Poe. As a surrealist, Breton felt he had every right to do this, without incurring the risk of being found guilty of attempting to systematize surrealist painting, to erect, belatedly, a theory of surrealist art. Faith in a method designed to reveal—according to the definition of surrealism provided in the 1924 *Manifeste*—"the true functioning of thought . . . the dictation of thought, in the absence of all control exercised by reason, and outside all aesthetic or moral preoccupations"[1] meant one thing for sure: that automatic writing (and, similarly, automatic drawing or painting) will reveal how the artist thinks. It does not set him, coincidentally, beyond evaluation by anyone intent on discovering what the automatic method has brought to light in his case, whether on the level of thought or feeling.

André Breton's complaint that Joan Miró is intellectually deficient makes sense when one contrasts Miró's work with René Magritte's, from the standpoint of the surrealists and in light of their ambitions. One can see why Magritte was destined to reveal more staying power as a surrealist. One notices something else, too. Miró has set no example to anyone joining the surrealist movement later than he. However, Roberto Matta's preoccupation with morphology and his concept of painting as *conscienture* evidence an intellectualized approach to surrealism via painting for which Magritte surely offered a precedent. Like Magritte, Matta questions resemblance as we speak of it, seeking instead a form of creativity aimed at discovery, at illumination.

Magritte's nonautomatic painting, in which imagery is the product of reflection, of trial and error (sometimes confirmed by the existence of preliminary sketches, accompanied by notes), complements pictorial automatism. The reputation enjoyed by Magritte among surrealists in France indicates that, although exceptional, the Magrittian way of creating images is consonant with the pursuit of surrealism's goals. On the plane of poetry, Magritte's use of calculated effect has its part to play, just like the invocation of chance, or faith in desire.

From the lyricism of Max Ernst, which caught Breton's attention several years before the first surrealist manifesto came to be written, to the "cosmic lyricism" highlighted in Roberto Matta's work by José Pierre, the focal point of interest, among surrealists, has remained poetry, of which pictorial imagery is a token. Whatever other commentators, with priorities of their own, may think of the relative merits of Masson and Miró, André Breton concludes that the former's work assumes greater relevance than the latter's to the aspirations that surrealists have in common. The distinction drawn by Breton between infantilism and intelligence is not irresponsible,

by any means. Nor is it even casual. It points to the emphasis that surreal-ists place on the role of painting as a vital expression of a disruptive force, directed against complacent or submissive acceptance of "what is," while asserting "what can be," and intimating that they look upon surrealism as "what *will be*."

Max Ernst

M AX ERNST's association with leading surrealist personalities dates back to the time of Dada, that is, to before the surrealist movement got under way or was even conceived. And it continued long after the first surrealist manifesto appeared.

In the United States during the Second World War, Ernst served beside André Breton as editorial advisor to the New York magazine *VVV*. As late as February 1954, the surrealist publication *Médium* included an interview with Ernst conducted by Jean Schuster.[1] However, only a few months later the same magazine—at that time organ of the surrealist movement in France—carried a statement signed by thirteen individuals (including both Breton and Schuster), denouncing Ernst for an unpardonable crime: acceptance of the Grand Prize for Painting at the recent Venice Biennale. The text read, in part, "former Dadaist and original surrealist—one of the most aware persons accountable for the principles upon which our activity is founded—he thus denies flagrantly the nonconformist and revolutionary spirit with which up to that point he claimed kinship."[2] In the signatories' judgment, by admitting officialdom's approval Max Ernst had set himself outside surrealism. From then onward, to the surrealists he had ceased to exist.

Ernst's case is far from unique, his exclusion from the French surrealist circle being motivated by moral considerations of the kind that, in the past, he himself had invoked frequently enough. It is worth noting, however, that, after his definitive banishment, paintings from his period of association with surrealism continued to be included in surrealist group shows, as they were for instance in the last exhibition organized by Breton: *L'Ecart absolu* (1965), held in the Galerie de l'Œil in Paris.

9

Ernst's involvement in Dada, which soon brought contact with several future surrealist leaders in France, makes it just as difficult in his case as in theirs to pinpoint the earliest signs of surrealist inspiration. With him, as with all those who after taking part in Dada rallied to the surrealist manifesto in the mid-twenties, little that is productive would result from an attempt to set up objective, universally applicable criteria for distinguishing protosurrealist works from those relating exclusively to Dada ambitions. We progress farther, with less delay, and without the distortions that partisanship would bring, when following the example of the first surrealists, among whom Max Ernst at once was assigned a position of trust and respect. In Ernst's work some evidence pertinent to surrealist investigation in the medium of painting begins to surface during the years just before the October 1924 appearance of Breton's *Manifeste du surréalisme*. It extends back to the time when, for Max Ernst as for later adherents to surrealism, Dada lighted the way. If this had not been so, then Breton would have had little excuse for citing Ernst among painters of significance listed in a footnote to his first manifesto. The surrealists' perspective becomes clearer as one notices that, in the original edition (1928) of André Breton's pioneering study *Le Surréalisme et la peinture,* the earliest Ernst picture reproduced dates from eight years earlier, 1920. In May of that year an exhibition of his collages was held in the French capital, with a catalog preface by Breton, who later recalled, "It is no exaggeration to say that Max Ernst's first collages, of an extraordinary power of suggestion, were welcomed among us as a revelation."[3] Far from diminishing the respect shared by Breton and others (like Paul Eluard) who accompanied him out of Dada and into surrealism, emergence and adoption of a program based on surrealist aspirations actually deepened their admiration for Ernst.

Speaking of "breaking with the imitation of appearances" and at the same time expressing concern for "the reach of our imagination," in his 1920 catalog preface André Breton was already looking at Max Ernst's art from an angle which would require no readjustment at all when, not long afterward, Dada yielded to surrealism as a focus for his ideas and aspirations. In fact, one sentence in a paragraph about Dada had quite a prophetic ring. It incorporated a figure of speech due to recur when, in his first manifesto, Breton came to formulate a definition of surrealism: "It is the marvelous faculty, without departing from the field of our experience, of attaining two distinct realities and from their proximity of drawing a spark; . . . depriving us of a system of reference, of disorienting us in our memory, that for the present sustains [Dada]." Four years later, he would have no hesitation in talking (less clumsily, by the way) of that very same faculty as now sustaining surrealism.

It was not technique per se that lent distinction to Ernst's practice of pictorial collage, for as he himself pointed out the method had not originated with him. What caught and held Breton's interest was proof that—this is how he was to put it in a 1927 essay—Ernst's dream was "a dream of mediation." This dream, Breton would argue, was realized through imaginative juxtapositions, comparable in their operation with "a true photography of thought"—the definition of automatic writing offered for the first time in his 1920 preface to the Ernst show in Paris.

Made at a time when he was very anxious to emphasize the pertinence of pictorial experimentation to the essential discovery of surrealism in the field of verbal poetic language, Breton's allusion to automatic writing is self-explanatory. But his phrase "a dream of mediation" sounds cryptic, especially in the absence of any fuller comment indicating how Max Ernst's art could be said to serve its mediative role. Clarification eludes us unless we examine in Ernst's graphic experiments typical signs of "a lyricism by which," wrote Breton in 1927, "any work we admire commends itself."

It is in the nature of Ernst's lyricism to reflect at one and the same time skepticism and a curiosity nourished by imaginative freedom. The former manifests itself in the boldness with which his collages undermine contingent reality. Ernst's curiosity, meanwhile, finds expression through a challenge to the presumptions inculcated by the familiar, here externalized by redistribution, through collage, of elements supplied by the world about us: an imaginative reordering of external reality, in fact. André Breton refers to this in his *Le Surréalisme et la peinture*, when saying that Max Ernst "brought with him the irreconstitutable pieces of the labyrinth" and speaking too of "something like playing solitaire with creation."[4] The agreed relationship between elements making up the world we all know from observation having been denied categorically, Breton pointed out, they are allowed to "discover new affinities for themselves."

For clarity's sake, a word of caution should have accompanied this last phrase, which might easily have led some of Breton's readers to the erroneous inference that Ernst's achievement in collage was simply to grant freedom of action to fragments taken from the real world. Unfortunately, Breton neglected to forestall the supposition that Max Ernst had permitted these to come together quite accidentally, altogether arbitrarily, and with no interference or contribution at all on his own part. It was Ernst himself who later disposed of that misleading deduction when remarking in a 1936 essay called "Au delà de la peinture" (Beyond Painting) that, if it is feathers (*les plumes*) that make plumage, it is not glue (*la colle*) that makes collage.[5] This meant that accurate evaluation of his highly prized contribution to surrealism must take the lyrical features of his art into account, must con-

cern itself with elements holding the surrealists' attention in a number of collages belonging to his Dadaist phase. Naturally, these continued to command the respect of several of his friends (Breton, Eluard, Louis Aragon) after he and they all had espoused the surrealist cause.

It was Max Ernst's stated belief that a collage is "a hypersensitive and undeviatingly accurate instrument, like a seismograph, able to record the exact quantity of possibilities for human happiness at any given time." Hence the special value of his experimentation with collage technique lies in the effort Ernst made to overthrow an obstacle that all surrealists view as standing between man and full development of his sensibility, opposing satisfactory realization of his goals. The aim was to cast down a barrier separating the inner world of dream and desire from outer reality, one that limits articulation of man's most profound aspirations and even awareness of them. That effort invested many of Ernst's collages with a disconcerting quality. Spectators risk acute difficulty when approaching his work so long as the standards they invoke and wish to apply, while judging his pictures, originate in respect for the external world of familiar reality alone. Enjoyment entails participation, not mere contemplation, and so is reserved for individuals predisposed to accept what collage technique can bring together as opening up consciousness. More exactly, it remains the privilege of people who hold themselves ready to see the boundaries of consciousness pushed back more and more while the subconscious is probed. Standing on the borderland between inner and outer perception, a number of Ernst's collages set an important precedent for surrealist pictorial exploration. They entice their audience forward, away from what we all can agree we know and onward into a universe where we have much to learn.

Max Ernst's treatment of material drawn from external reality follows essentially a regular though still quite unpredictable pattern. This consists in incorporating recognizable elements into collage and employing them in ways that displace them, so turning them into something they are not, while yet leaving them identifiably just as they are. The method is exemplified in *Hier ist noch alles in der schwebe* (1920).

Against an horizonless background, more allusive to sky than to water, passes a fish, its skeleton clearly visible. Below, not above, we see a ship with smoking stack. No bigger than the passing fish, the vessel's keel can be identified as some kind of hard-shelled insect, lying on its back, three of its legs sticking up like (and indeed functioning as) masts. Since no waterline can be discerned, in this scene the principle of flotation is compromised. As

a result, one of the permissible interpretations of its title (*Here Everything Is Floating*) has an ironic force, in that an alternative—*Here Everything Is Up In the Air*—assumes metaphorical as well as literal meaning: "Here everything is unsettled." So far as the vessel is concerned, it marks the confluence of navigation and entomology. The insect becomes a sailing ship without ceasing to be recognizably itself. Because of this, two interchangeable but rationally unconnected interpretations offer themselves concurrently, competing for our attention and acceptance in that place (*hier*) to which Max Ernst has led us with due warning that, everything being up in the air and consequently undecided, nothing is definitely one thing more than another. No meaning is immutable and beyond question: polyvalence reigns.

The ambiguous and fluctuating relationship between Dada's iconoclasm and the positive program succeeding it under the name of surrealism is typified in *Hier ist noch alles in der schwebe*. We have no grounds for presuming that, as he worked on this collage, Max Ernst sought consciously and deliberately to go beyond Dada in some way. Nothing indicates that he tried to expand graphic experimentation in a new direction for which, with time, "surrealism" would come to be admitted—would *have* to be admitted—as the only fitting designation. In fact, *Hier ist noch alles in der schwebe* belongs with a succession of works whose origins are peculiar to Dadaist activity. Inscribed on the back, after the title, are the words, "Fatagaga: Le troisième tableau." Fatagaga was a neologism coined by three Dadaists in Cologne—Ernst, Hans Arp, and Johannes Theodor Baargeld. It derived from the opening syllables of the phrase "Fabrication de tableaux garantis gasométriques," used by them to identify material created in collaboration—by "fabrication of pictures guaranteed gasometric." The careful notation that *Hier ist noch alles in der schwebe* is the third such picture to be made points to the intervention of a second hand (thought to be Arp's) in addition to Ernst's in the making of this collage.

The context was indisputably Dada, the intention unquestionably to combat the effect of egocentricity, regarded among Dadaists as a pernicious influence, reducing the creative process to the celebration of vanity. Nevertheless, this by no means unique collage differs noticeably from many of those Ernst created during his period of association with Dada. Specifically, in *Hier ist noch alles in der schwebe* iconoclasm is less marked a feature than the ordering of a suggestively strange scene, its atmosphere more in keeping with the mood of surrealism than with the negative spirit of Dada. Already, like a celebrated painting, *A l'intérieur de la vue*, to be completed by Max Ernst in 1927, *Hier ist noch alles in der schwebe* takes us inside sight.

Individuals with whom, in surrealism, Ernst came to share both com-

panionship and a common sense of purpose were deeply responsive to the invitation extended by certain of his pre-1924 collages. Louis Aragon, for one, declared in 1923, "He turns every object away from its meaning so as to awaken it to a new reality."[6] Thus, for example, instead of finding itself immobilized when laid on its carapace, the insect takes on the role of passing sailing ship. The results obtained led Aragon to praise "a very special fauna, an *Ernstian* atmosphere" in such collages (p. 31). He was to expand upon his comments in 1930 when writing the catalog preface, *La Peinture au défi* (*Painting Defied*), for an exhibition of collages by a variety of artists held at the Galerie Goemans in Paris. "Where Max Ernst's thought should be grasped," wrote Aragon, "is the place where with a little color, with pencil marks, he tries to acclimate the phantom he has just thrown down into a strange countryside, or at the point where he places in the hands of the new arrival an object the latter cannot touch" (p. 62).

As for André Breton, reviewing the time (around the beginning of 1925) when those in the surrealist group in France were debating the feasibility of a mode of painting that would conform to surrealism's requirements, he remarked in his 1941 essay, "Genèse et perspective artistiques du surréalisme," taken up in *Le Surréalisme et la peinture,* that Ernst's work shows surrealist painting already "in full flight": "Indeed, surrealism profited right away by the 1920 *collages,* in which an absolutely virgin visual organizing proposal is translated" (p. 64).

Surely no friend of surrealism after leaving its ranks,[7] Patrick Waldberg nevertheless has felt constrained to commend Breton s remarks for underlining that "independently of the antiartistic, antilogical, even antimoral bias of those works, they are charged with positive values incontestably powerful, new, and capable of overthrowing the artistic concepts up to then in force."[8] It is not at all clear from Waldberg's words what he, as an art critic, understands by the positive values of Ernst's early collages. Even so, we need have no doubt about the value those creations assumed in the eyes of Max Ernst himself. Recalling in his "Au delà de la peinture" how one day in the year 1919 he became fascinated with illustrations discovered in technical journals, he explained, "I found gathered together there figurative elements so remote that the very absurdity of this assemblage provoked in me a sudden intensification of the visionary faculties and gave birth to an hallucinating succession of contradictory images, double, triple, multiple images, superimposing themselves on one another with the persistence and rapidity peculiar to amorous memories and to the visions of half-sleep." In short, for Max Ernst the act of making collages consisted thereafter in bringing about encounters between those figurative elements on a new plane—"the plane of non-agreement." Completion of the collage picture, he said, amounted to "reproducing submissively *what could be seen inside*

me," so as to obtain "a faithful fixed image of my hallucination" and to
"transform into dramas revealing my most secret *desires* what had been,
before, only banal pages of publicity."

As time went by, Max Ernst's devotion to surrealism grew, while Dada
slipped into the quite distant past. This is why, in his 1936 essay "Au delà
de la peinture," his observations on the nature of collage accurately re-
flected his current surrealist viewpoint, by implicitly generalizing more than
his own practice during the twenties fully entitled him to do. He now gave
the impression that collage had been a more systematic investigative proce-
dure than it actually had been for him, expressive of a more consistently
purposeful aim than Dada had encouraged. Asking rhetorically about the
mechanism of collage, he remarked at that later stage, "I am tempted to see
in it exploitation of the fortuitous encounter of two distant realities on a
non-suitable plane." In the same breath, he revealed the motive behind his
definition: to "paraphrase" and "generalize" a verbal image by that time
already famous in surrealist circles—Lautréamont's "Beautiful as the fortu-
itous encounter on a dissecting table of a sewing machine and an umbrella."
Hence his very next phrase, describing collage as "cultivation of the effect
of a systematic disorientation according to André Breton's thesis."

The emphasis in this statement on systematic disorientation imposes
unwarranted unity on Ernst's collages from 1920 onward. Thus it is worthy
of notice, being fully in keeping with surrealism's treatment of pictorial
methods as means to attain goals other than those definable within the
realm of aesthetics. All in all, present concerns require us to attach less
importance to tracking down the reasons why Max Ernst made this or that
collage during the twenties (before the first surrealist manifesto was pub-
lished) than to establishing why surrealists hold so many of those early
works in very high esteem.

When painting's evolution under the influence of surrealism is being
considered, what count are the revelations engineered and communicated
thanks to a pictorial technique which, the surrealists found later, Ernst had
adopted with particularly beneficent results. Aragon, Breton, and Eluard
especially were captivated by the liberative characteristics of his first col-
lages. This is to say that they were impressed less by a demonstration of
expertise ("ce n'est pas la colle qui fait le collage") than by insights into an
admirable sensibility, discovering its own potential in the very process of
creative action.

Max Ernst's interest in and experimentation with collage is essential
to the development taken by his surrealist painting. Without the example

set by his own early collages, some of the most characteristic figurative arrangements in pictorial works completed during his surrealist period would be more difficult to explain, with respect to their form and on the level of inspiration.

Turning from some of the collages he was making at about the same time, and without discounting the influence of Giorgio de Chirico's metaphysical painting, we discern in *L'Eléphant Célèbes* (1921)—purchased from Ernst by Paul Eluard—adaptation to the painting medium of the procedure of surprising juxtaposition by collage. Figurative inventiveness displays in this picture a boldness that clearly has found impetus in collage technique no less than in de Chirico's example.

In the foreground at the right is a nude female torso with right arm raised, reminding us of de Chirico's use of statuary. At the same time we realize she is the first incarnation of Ernst's hundred-headless woman to whom, in 1929, he was to devote a collage-novel, introduced by André Breton.[9] Behind the headless torso in *L'Eléphant Célèbes* rises a structure, somewhat like a totem pole with phallic protuberances, which might well have derived from a 1920 collage titled *C'est le chapeau qui fait l'homme* (*It's the Hat Makes the Man*). In the zone appearing to be sky, to the upper left of the picture, a few fish swim by. The center of attraction is a monstrous form that Ernst's title invites us to identify as an elephant. We see it from behind, with the tips of its tusks, its legs, tail, and even—if one cares to look—its anal orifice quite visible. This is not a naturalistically depicted animal, all the same. The great body almost filling the whole canvas is a cauldron, circled by a ridge suggesting that the top may be removable, possibly when one grasps the curious howdah set on the elephant's back. The tail sticks out toward us from a circular hole in the cover of the cauldron and is a thick articulated hose or duct. Bearing near its end a wide metallic sleeve or cuff, it terminates in a strange ambiguous fist (the designation comes simply by association with sleeve and cuff) that appears to have eyes and even carries bull's horns. Although presenting itself acceptably as elephantine in shape, the composite figure standing on flagstones is no less a large, cumbersome, and somewhat menacing piece of machinery— an alembic, perhaps, or a vented cooking pot large enough (and the right shape, also) to hold a mammoth.

It is no easy matter to say exactly how real is the creature bearing a name which is itself a collage of grammatically unrelated substantives (*The Elephant Celebes*[10]). Before we can identify the figure dominating the picture as incontrovertibly an elephant, we have to agree not to look upon it as a piece of machinery of unknown provenance, designed for an indeterminate purpose.[11] And yet the care taken to render the elephant as machine prevents

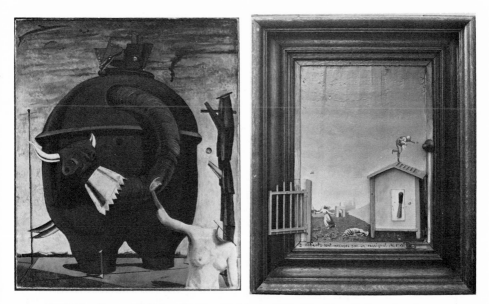

(Left) Max Ernst, *L'Eléphant Célèbes (Celebes)*, 1921. The Tate Gallery, London
(Right) Max Ernst, *2 enfants sont menacés par un rossignol (2 Children Are Threatened by a Nightingale)*, 1924. Collection, The Museum of Modern Art, New York

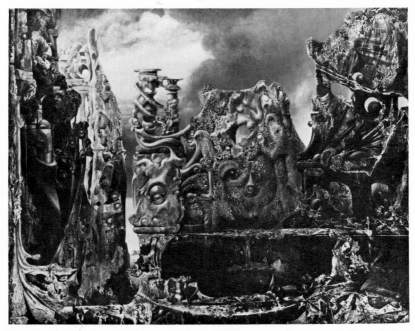

Max Ernst, *The Eye of Silence*, 1943–44. Washington University Gallery of Art, St. Louis

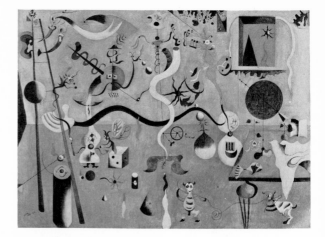

Joan Miró, *Carnaval d'Harlequins (Harlequins' Carnival)*, 1924–25. Albright-Knox Art Gallery, Buffalo, New York, Room of Contemporary Art Fund

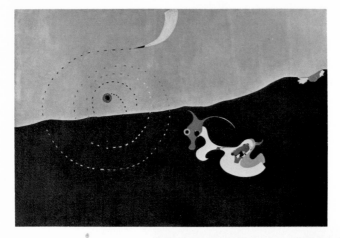

Joan Miró, *Paysage (Le Lièvre)* [*Landscape (The Hare)*], 1927. Photograph by Carmelo Guadagno and David Heald, The Solomon Guggenheim Museum, New York

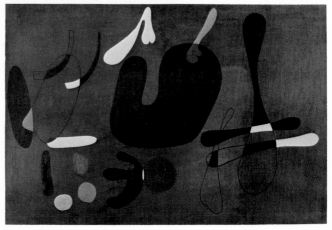

Joan Miró, *Composition*, 1933. Washington University Gallery of Art, St. Louis

us from making, without hesitation, the choice recommended by Ernst's title. Nor can we disregard that title and speak confidently of a cooking pot of some sort, unless we ignore the legs—to say nothing of the tusk points—that make its function decidedly questionable. *L'Eléphant Célèbes* is real both as animal and as machine. Its reality then cannot be measured by reference to the external world alone, but also by its power to impress itself upon our imagination.

The solid surface on which stands the Elephant Celebes extends through deep perspective to a vague Chiricoesque horizon. There it joins a sky that accommodates fish as well as smoke, just as in *Hier ist noch alles in der schwebe*. Whether animal or machine, a creation of Ernst's imaginative play (a manifestation, he would say, of dream-desire) appears before us on a plane that does not engage reason's confidence. This is the plane of "non-suitability," locus, for Max Ernst, of poetic action through painting.

The last painting executed by Ernst before he left Cologne for Paris developed out of a series of collages done for *Répétitions* (1922), a collection of poems by Eluard, who purchased the canvas in question—*Oedipus Rex*—when he and his wife went to visit the artist in Germany.

L'Eléphant Célèbes found its focal point in its central figure. In contrast, *Oedipus Rex* communicates an impression of discordance that is quite alarming as well as aesthetically disruptive. It reminds us of a comment by surrealist collagist E. L. T. Mesens, who once noted that in Ernst's collages concern for plastic construction is "very secondary."[12] Often reproduced, *Oedipus Rex* has received minimal and very cursory examination by the critics, who appear to be discomfited by the absence of formal coherence it displays.

To the right of the picture is a block that may pass for a cement wall. In front, projecting from an unaccented plane surface (painted, like the wall, a neutral shade), rises the head of some bird that eludes identification, since its beak is cut off at the edge of the canvas. Behind is another head, which might be a bird's also, were it not for bull's horns that grow out of its skull. Attached to the horns is a rope or cable, rising upward until it passes out of the picture. A possible clue to the rope's function is the presence in the background of a tethered hot-air balloon, tiny in the distance. Diagonally from the left, meanwhile, a brick wall intrudes, filling a third of the painted area. It has an oblong aperture through which protrude human fingers. These hold a walnut traversed by an arrow. The thumb and forefinger are themselves pierced by a cylindrical, thin object of metal. It is

difficult to decide whether this is a bow (that might, after all, have fired the arrow) or some kind of saw, splitting the nut along its seam. Whatever the instrument actually is, a break occurring in the space between the thumb and finger leaves us wondering how the bowstring or blade is kept under tension.

Our reluctance to articulate a response to this picture comes, in no small measure, from the absence of a reliable reference point (like the woman's torso in *L'Eléphant Célèbes*) by which to establish scale. If the hand and walnut are of normal size, then the bird-figure and brick wall are ridiculously small. Conversely, if the bird's head is to be taken for life-size, then the hand and nut must be frighteningly large. While the picture unambiguously proclaims anecdotal significance by way of its title and seems to call for explanation in Sophoclean or Freudian terms, we are at a loss to find evidence indicating what is going on, exactly, and why.

In frustration, one might be tempted to the convenient deduction that the title of *Oedipus Rex* is attributable not to the picture's subject matter so much as to the artist's wish to mystify his public, following upon his decision to thwart efforts to comprehend a picture that really has no meaning beyond the one suggested by Freudian symbols. Such an evaluation is in conflict, however, with Ernst's regular custom of naming his pictures.

Two factors have a bearing on the naming process. The first is the conviction voiced in a celebrated essay on inspiration from which Ernst's "Au delà de la peinture" derived:

> Since the beginning of no work which can be called absolutely surrealist is to be directed consciously by the mind (whether through reason, taste or the will), the active share of him hitherto described as the work's "author" is suddenly abolished almost completely. The "author" is disclosed as being a mere spectator of the birth of the work, for, either indifferently or in the greatest excitement, he merely watches it undergo the successive stages of its development. Just as the poet has to write down what is being thought— voiced—inside him, so the painter has to limn and give objective form to *what is visible* inside him.[13]

The date of *Oedipus Rex* (1921) may raise some doubt as to the applicability of these remarks to a work executed three years before the 1924 *Manifeste du surréalisme* was written. But nobody can disregard one fact, noted by Ernst on another occasion: "Never do I impose a title on a picture: I wait for the title to impose itself upon me. After painting, I often remain—sometimes for a long while—haunted by the picture, and obsession ceases only at the

moment when the title appears as though by magic."[14] So whatever we may happen to feel about the appropriateness of the adjective *surrealist* to a 1921 painting, no one can ignore this essential point. The title *Oedipus Rex* interprets the picture it names, communicating its creator's own response, an illumination no less enigmatic to some spectators than the painting itself. The humor present here is of the kind that, as the Belgian Mesens discovered, "leads us far beyond satire toward lands still unknown."

In 1924 Max Ernst painted on a wood panel the last of the series of works beginning with *L'Eléphant Célèbes* and including *Oedipus Rex, La Révolution la nuit,* and *La Belle Jardinière.* Called *2 Enfants sont menacés par un rossignol* (*2 Children Are Threatened by a Nightingale*), this picture once was described by the artist himself as "probably the last consequence of his early collages—a kind of farewell to a technique and to occidental culture."[15] It had one distinction to which Ernst also drew attention. "This painting, it may be interesting to note, was very rare in M. E.'s work: He never imposes a title on a painting. He waits until a title imposes itself. Here, however, the title existed *before* the picture was painted. A few days before he had written a prose poem which began: *à la tombée de la nuit, à la lisière de la ville, deux enfants sont menacés par un rossignol* . . . He did not attempt to illustrate this poem, but this is the way it happened."

No great effort of interpretation is needed before we can pick out a bird one may take for a nightingale flying overhead, while a young female, carrying a knife, runs through a field in which lies another girl or woman, possibly in a swoon if not already wounded. In the far background rises an archway and other vaguely delineated features of an urban landscape rendered familiar by Giorgio de Chirico's metaphysical painting (from which, incidentally, this picture seems to have borrowed its eerie lighting). We notice, though, that Ernst's words tell us emphatically what he did not intend to achieve with his picture, yet stop short of explaining what his intentions in fact were. When we have listed obvious narrative aspects, and have given credit also to de Chirico's influence, we find ourselves all the same without assistance from the artist, as we face one of the most original and arresting of his pictorial creations.

2 Enfants sont menacés par un rossignol is more than a picture releasing surprise in the spectator, the way Max Ernst's earlier collages do. It is a construction, of which the painted elements noted above make up the least innovative part. The picture was executed on wood and framed by Ernst

himself in such a way as to make the frame an integral feature of the whole. At the bottom the frame is used simply as a surface on which the title and the artist's name appear side by side. At the top and some way down each side the innermost edge of the frame has been painted to match exactly the sky filling more than half of the painted surface. Midway down the right-hand edge a blue circular piece of wood is affixed. Protruding from its center is a nipple-like button. A human figure, poised on one leg like some clumsy Eros and carrying a small child in his arm, reaches out as if to press this doorbell or alarm mechanism. He appears to be running across the roof of a kind of shed. Seen from its end, the building is made of wood, giving Ernst's picture a three-dimensional aspect by projecting toward the spectator and filling roughly the bottom right-hand quarter of the scene.

On the three-dimensional representation of a roof, made of real wood, a painted human figure, rendered on a plane surface, stretches out a hand to press an alarm bell that appears to be real. Against all probability, reality and the representation of reality are about to meet. Meanwhile, within the matching left-hand bottom corner of the frame is the open gate through which we have the opportunity to observe the knife-bearing woman. This is not the representation of a gate (as the scene we are watching is the painted representation of the drama to which the picture's title refers), but a real wooden gate, swinging outward from the picture frame on two hinges.

The contrast is marked between the tangible presence of accessories and what lies behind them in the picture's painted zone. The hinged gate, the end wall of the shed (to which some disproportionately large but un-identifiable object is affixed), the projecting section of roof, and the building's ridge boards all press themselves upon our attention. We have to look past these in order to view the scene Max Ernst has chosen to depict in paint, and with nothing like a comparable impression of realism. All the human figures appear in monochromatic shades, with rudimentary facial expressions visible on no more than two of them. Furthermore, a strange, disturbing, yet fascinating disproportion in size can be observed between the male figure on the roof and the bell button (three times as large as his head) which he seems to want to activate by reaching out of the picture onto the frame.

Reconciliation of the constituent elements of *2 Enfants sont menacés par un rossignol* eludes us on the level of concrete reality. It is denied us too on the plane of figurative painting in the academic tradition—after all, one thinks of Puvis de Chavannes as much as of Giorgio de Chirico, when contemplating the scene Max Ernst brings before us. And yet the effect, to which the word *menacé* is the key, remains unified. Ernst's creation takes us through a gateway into a world totally cohesive in its atmosphere of terror.

Time after time, looking at an Ernst collage or at one of his surrealist paintings brings us back to the same central question, that of recognizing what he makes us see. The conjunctive principle which collage first permitted him to test does more than demonstrate how the picture as a whole exceeds the sum of its parts. It catches these elements in transition, in the very process of transformation into something that exists—or will exist—only because Max Ernst's lyricism transcends the commonplace and the exotic alike in projecting his poetic vision. Though offering telltale signs of their origin, scraps of everyday reality exist, now, as component features of a new reality, which they help to bring to light and render concrete. Thus—2 Enfants sont menacés par un rossignol illustrates this forcefully—the picture exists both as object and as instrument, and hence too as the denial of the art object. It is the means by which the viewer is drawn into the world of surreality. Here incongruity is surpassed and subsumed in a new reality. The latter imposes itself upon our imagination, whether brutally or beguilingly, by awakening responses which are never stimulated so actively in our everyday lives.

Even though Max Ernst once painted a Zoomorphic Figure (1926), he was less interested in bringing together ambiguous forms simply in order to confuse his public than in achieving polyvalence of figuration and meaning. During his surrealist period this was for him a way of simultaneously exploring emotions that—in the normal course of our pedestrian lives—remain not merely unrelated but often violently contradictory. By provoking awareness of such emotions through pictorial means he sought to make painting an event his audience must confront. To the extent that he succeeded in making painting an act of provocation he attained his goal of progressing "au delà de la peinture."

In surrealism, the aim to go beyond painting is far from a contradiction in terms. It is a judgment on the narrow ambitions of the medium, and also on those working to fulfill those ambitions. Ernst therefore was not seeking to draw attention to his work, in a self-advertising gesture. He hoped to break out of the limitations conventionally set upon aesthetics by preceding artistic schools. He wanted to stimulate his audience to respond beyond those limits. He sought to penetrate to a zone of discovery and revelation where poetry acknowledges and respects no boundary between verbal and pictorial images. This is what makes understanding Max Ernst's aspirations, as a surrealist, critical to awareness of the goals surrealism always challenges its painters to attain.

Taking something that acceptably is (a hard-shelled insect, for example) and making it look to be what it is not and yet certainly has become (the hull of a sailing ship) implicates objective reality—whether mundane

or exotic, it does not matter—in an investigative procedure which ulti-
mately questions appearances, diminishing our trust in what seems to be.
Ernstian vision is the record in paint of hallucinating impressions that
conflict with the world of appearances.

Max Ernst's lyricism, to use his own words, stems from "the intensi-
fication of the visionary faculties." His poetic apperception takes him beyond
mere observation of the external world, capturing along the way that "*purely
inner model*" to which André Breton directs attention on the fourth page of
Le Surréalisme et la peinture. In the process, the unique quality of Ernst's
vision is externalized through experiments conducted on "the plane of non-
suitability," as he puts it in his *Beyond Painting* (p. 23). These experiments
are so successful that encounters between normally incongruous elements
occur, now, on a plane that is, by the artist's own testimony, only "*ap-
parently not suited to them*" (p. 22). Hence Max Ernst makes his contribution
to surrealism by transcending the apparent, so advancing to a point where
incongruity is surpassed by a higher sense of reality which deserves to be
called surreality.

Joan Miró

I T IS ANYTHING BUT WELL KNOWN that, one evening some time during the late twenties, two surrealist artists—their jealousy at a drinking companion's financial success released by the alcohol they had been imbibing—took it into their heads to hang him. The two would-be executioners bore the names of Max Ernst and E. L. T. Mesens. Their intended victim was Joan Miró who, since coming into contact with the surrealist group in France, had had two one-man shows in Paris, the second in 1928.

If this anecdote were apocryphal, it would appear worth recounting only to someone bent on persuading listeners of Miró's superiority to the surrealists among whom he might have found himself on one occasion. On the other hand, had Ernst and Mesens indeed persevered, the surrealist context could never be ignored—as it often is—in attempts to reach a definitive evaluation of Joan Miró's achievement as an artist. This true incident was reported to me in 1961 by Mesens, as we sat in his London apartment, facing a magnificent Miró canvas (no one, after all, has ever had occasion to contest E. L. T.'s flair as a businessman). The prime value of the story is that it reminds us of one important fact. There was a time when Joan Miró did occupy a place—and not a back seat, either—among the surrealists.

Some opponents of surrealism argue that the surrealist group provided temporary companionship from which they must feel more sure than ever, now, that Miró was fortunate to escape. Indeed there is no denying the significance of his forthright contribution to a discussion culminating in the surrealists' exclusion of Antonin Artaud and Philippe Soupault from their circle. Printed in 1929, beside other relevant documents, in a special surrealist number of the Belgian magazine *Variétés*, Miró's contribution takes

the form of a pointedly forthright statement: "Incontestably, to succeed in an action, we always need a collective effort. Nevertheless, I am convinced that individuals with a strong or excessive personality, morbid perhaps, fatal if you wish, this calls for no discussion, will never be able to submit to the discipline of the barracks which action in common demands at all cost."[1] Even so, with due respect for Miró's boldly implied assertion of independence, we need to redress the balance that, in critical commentary, has swung away from full recognition of surrealism's contribution to his work and of Miró's contribution to surrealism.

It has become fashionable among art critics to detach from the surrealist movement a number of major artists—like, as it happens, Max Ernst (one painter who, later in life, did not mind this at all)—painters whose work in their early years, to say the very least, was nourished in a climate such as surrealism alone was capable of providing during the first quarter of the twentieth century. Certain observers feel conscience-free about studying Miró and assessing his work without mentioning surrealism even once. Rare indeed is the objectivity shown by Sam Hunter who, while still voicing a few questionable reservations, admits, "One suspects, however, that the convulsive aspects of Miró's art in 1925 were even more related to the Surrealist uprising, that eloquent barometer of international anxiety, than to the native 'Spanish heritage of cruelty' [identified by Georges Hugnet—a surrealist, incidentally]. Indeed, the influence of Surrealism, which was officially proclaimed by André Breton in his first manifesto of 1924, may have been the decisive factor in freeing Miró's sense of the 'marvelous,' his already marked instinct for fantasy; and the 'automatic' method of such painters as Masson, who occupied a studio directly next door in the rue Blomet, gave him a viable pictorial means for expressing that fantasy."[2]

To mark the last prewar international surrealist exhibition, held in Paris in 1938, Paul Eluard and André Breton edited and published a *Dictionnaire abrégé du surréalisme*. In that abridged dictionary Joan Miró was called "the sardine tree" and classified as a "surrealist painter from 1922 down to the present."[3] This was a gesture of opportunism, the skeptical might say, pointing to the reputation enjoyed by Miró in the late thirties. In 1937, he had done a large wall painting, *The Reaper*, for the Spanish Pavilion at the Paris World's Fair. All the same, evidence of close association with those dedicated to the surrealist cause cannot be ignored. It was made public, originally, when two of Miró's paintings, *Maternité* (*Maternity* [1924]) and *Paysage catalan* (*Catalan Landscape* [1923–24]), identified under

its alternative title of *Le Chasseur* (*The Hunter*), were reproduced in the fourth number of the Parisian surrealists' magazine, *La Révolution surréaliste*, in July 1925. It became even less debatable when Miró exhibited in the very first surrealist group show at the Galerie Pierre, the same year. We cannot ignore, without danger of falsifying important evidence, the pages devoted to Joan Miró in the original edition (1928) of André Breton's *Le Surréalisme et la peinture* where—in one significant respect, to be considered in a moment—he is said to be able to "pass for the most 'surrealist' of us all" (p. 37). In the definitive edition of 1965, Breton was to add a December 1958 article on Miró's series of gouaches, *Constellations*.[4] And Miró would be represented in the last major surrealist exhibition to take place during Breton's lifetime.

Breton's proud assessment of Miró's work as "the most beautiful feather in surrealism's cap" does not prove to outsiders that the surrealists in France were entirely within their rights, claiming Miró as their own, taking credit, so to speak, for works executed by him. Cataloging is not enough, here. We need to look more closely at the kind of painting Joan Miró was doing about the time when André Breton codified surrealist ideas in the first of his manifestoes, published the year he and Miró were introduced by a mutual acquaintance, André Masson.

Limiting attention for now to the first surrealist magazine to appear in France, we discover that between 1924 and its final issue in 1929 (where Breton's second surrealist manifesto first appeared), *La Révolution surréaliste* reproduced no fewer than eight Mirós. These included *La Sauterelle* (*The Grasshopper* [1926]), used in the eleventh number (March 15, 1928) as the centerpiece of a full-page advertisement publicizing the surrealists' art gallery, the Galerie surréaliste. Among the other pictures featured were two of the best known and most admired of the paintings done by Miró during the 1920s: *Terre labourée* (*Tilled Soil*, or *The Tilled Field* [1923–24]) in No. 5 (p. 10) and *Carnaval d'Arlequins* (*Harlequins' Carnival*, or *Harlequin's Carnival*, as it is better known [1924–25]) in No. 8 (p. 19). Before examining either of these, we should glance at another of the canvases reproduced in *La Révolution surréaliste*. Called *Le Piège* (*The Trap*), it dates from 1924 and was featured in the review's fifth issue on October 15, 1925.

At this point we risk meeting the objection that, in order to be able to claim some sort of connection with surrealism, one has to be very selective when examining Miró's work from the period that interests us at this stage. The canvas in question brings together elements recognizable as characteristic of Miró's painting during the second decade of our century. Moreover, in the dominant hybrid figure, standing before us here, the head receives treatment that everyone can accept as typical of Miró. Lower

down, though, an unmistakable phallic member defies the laws of human physiology by urinating during tumescence (no wonder the hare and rooster— encountered before in earlier Miró pictures—look impressed!). What is striking, in contrast with the transposition to which Miró had accustomed his audience before 1924, is that the principal figurative presence so readily identifiable in Le Piège unashamedly defies good taste.

The question is, are we to ignore a lapse in taste unprecedented in Miró's work? Must we treat it as an unaccountable and regrettable variation on a form of realism he is commonly thought to have left behind after completing Terre labourée? There is evidence to suggest that, in surrealist context, unapologetic use of vulgarly realistic detail at the price of good taste is a significant and positive aspect of Le Piège.

When in 1959 the surrealists issued some colored picture postcards to mark an international exhibition held in Paris on the theme of Eros, among the paintings chosen for reproduction was Le Piège, from the collection of André Breton. Le Piège testifies to a noteworthy aspect of the attraction surrealism held for Joan Miró, who confided later, in 1959, "Surrealism pleased me because the surrealists did not consider painting an end in itself."[5] In a letter to James Thrall Soby he explained, "This has always been my goal, to transcend the purely plastic fact to reach other horizons. . . . I thought it necessary to go beyond the 'plastic fact' to attain poetry."[6] From such remarks it is but a short step to Breton's evaluation, made in the course of a lecture he delivered in Prague on March 29, 1935: "There exists, at the present time, no difference in underlying ambition between a poem by Paul Eluard, by Benjamin Péret and a canvas by Max Ernst, by Miro, by Tanguy."[7]

We only distort Miró's aspirations through art if we imitate one of the most reputable commentators on his work, Jacques Dupin, who remarks primly that "there is no need to dwell on the title" of one of his picture poems, Un Oiseau poursuit une abeille et la baisse (1926).[8] Dupin's words, one may suppose, explain why the translator of his book offers no excuse for failing to attempt to render the title in English. But why should the spectator not pause over that title, when Miró himself felt it appropriate not only to name his picture as he did, but also to incorporate its title into the canvas itself? The point (entirely lost, we notice, on the Italian translator, who innocently sets down abatte) is this. Although the artist's wobbly French causes him to misspell a verb form, baise, his title is quite intentionally vulgar, as is the subject matter of the picture: A Bird Pursues a Bee and Fucks It. Picture and title combine, in fact, to mount a direct attack on good taste, in the interest of poetry and in open contempt of inherited aesthetic norms.

It must be only too noticeable by now that a few strings have been left dangling. Two of them in particular surely deserve a better fate: Miró's idea of poetry and his avowed intention of "murdering painting." They may be connected quite neatly with a third: the marvelous. And all of them can be tied together very conveniently and appropriately when we pick up yet another hanging thread—technique—highlighted in the word *automatism*, to which Breton alluded in his original definition of surrealism, advanced in the 1924 manifesto and mentioned again in his 1928 *Le Surréalisme et la peinture*. Here we read:

> Instead of a thousand problems which do not preoccupy him in the least although they are those in which the human mind is immersed, there is perhaps in Joan Miro only one desire, to abandon himself so as to paint, and only to paint (which for him means confining himself to the only domain in which we are sure he is possessed of means), to that pure automatism upon which, for my part, I have never ceased calling, but of which I fear Miro unaided has very summarily verified the profound value and reason. True, it is perhaps in this respect that he can pass for being the most "surrealist" of us all. (pp. 36–37)

One cannot possibly exaggerate the importance of this statement. It openly acknowledges the uniqueness of Miró's contribution during the early years of surrealist pictorial investigation. To see things in true proportion, we have to remember that Breton's *Manifeste du surréalisme* defined surrealism as "pure psychic automatism." Moreover, by the beginning of the following year, the surrealists in Paris still had not managed to make up their minds whether there was a real possibility of arriving at a form of painting truly compatible with that of word poems born of verbal automatism. The most formidable obstacle, the stumbling block in the way of assimilation of painting by surrealism, seemed to be that cornerstone of the 1924 manifesto: automatism.

Automatism is barely mentioned in the first edition of *Le Surréalisme et la peinture,* where in fact it appears to have been omitted from consideration quite deliberately. Noticing this—and realizing at the same time that proceeding otherwise would have compelled André Breton to leave out of his essay most of the painters discussed in it—we appreciate how high a place that tentative study of surrealism's relations with painting grants Joan Miró, acknowledged to be pre-eminent among surrealist painters because of the purity of his inspiration. "On his own ground," declared Breton, "I recognize that Miro is unbeatable. No one comes as close to associating the unassociable as he does, to breaking with discrimination that which we do not hope to see broken" (p. 40).

In short, by the late twenties Joan Miró's work appeared to Breton as setting an example in its fruitful reconciliation of painting with the strict demands of the automatic principle upon which surrealist poetic creative action was assumed to rest. Hence Miró had not merely earned admittance to the surrealist circle. By that time, he had become one of its central figures, his stature as a surrealist artist unassailable.

Let us turn now to *Terre labourée*, to ask what accounts for the immense difference noticeable when this picture is placed next to *La Lampe à carbure* (*The Carbide Lamp* [1922–23])—also reproduced, without comment, in *Le Surréalisme et la peinture*. The answer, surrealists would agree, is the welcome and illuminating infusion of automatism that endows *Terre labourée* with a poetic quality to which they are sensitive. It is not a matter of disputing the poetic character of paintings like *La Lampe à carbure* but of stressing that the poetry present in *Terre labourée* is of a distinctly different nature, of a kind that surrealism helps us define.

Itemizing the contents of *Terre labourée* is not enough. What is important is to note the presence of one element in particular: a misplaced human ear. The latter bears witness to a major change in focus that, beyond a doubt, has altered Miró's concept of painting, and radically. Before we come to this, though, two remarks are worth making.

Breton's original surrealist manifesto, with its stress on automatism, served to give coherent form to ideas shared by a number of young men who, thereafter, would gladly call themselves surrealists. But his 1924 text—where, oddly enough, Joan Miró is not mentioned, as we should have expected him to be, next to his friend and neighbor Masson—created nothing ex nihilo. On the contrary, it summarized a succession of findings that had followed upon disconnected experimentation and exploration conducted by a loosely knit group of individuals over a span of the previous five years and more (*Les Champs magnétiques*, the first investigation of verbal automatism by Breton and Soupault, dates from the summer of 1919).

It would be an error to assume that Joan Miró—who did not meet André Breton until the year of the surrealist manifesto was made public—was involved personally in the long-term discussion from which the concept of surrealism finally crystallized. In the so-called pocket dictionary, *Le Surréalisme* (its cover is illustrated by a 1968 painted bronze executed by Miró) put out by one of surrealism's most gifted commentators on art, José Pierre, Joan Miró the convert to surrealism is presented as "the Miró we know." Pierre goes on to make the apposite observation that Miró brought to surrealism "the shining proof of the explosive resources that automatism was capable of introducing into the pictorial domain."[9] So as to be sure not to misinterpret this assessment, we ought to listen to another surrealist. Insist-

ing in his book on Salvador Dalí that Miró is "one of the first surrealist painters," Conroy Maddox observes that Miró's work "represents the intuitive, spontaneous approach."[10] This evaluation does more than simply contrast Miró's surrealist technique with the "realist" method ascribed to Dalí by Maddox. Coincidentally, it indicates quite precisely how, exactly, Joan Miró came to surrealism.

Miró was not a frustrated painter, casting about for a new approach to art. He had not sought admission to sturealism as to a school or a club, paid composition fees, and then begun applying rules approved by his new associates, rules regarded by them as holding out the promise of acceptable results. He was, far more importantly, an artist who, having something peculiarly and distinctively his own to offer, was welcomed with excitement by a group responsive to and keenly appreciative of what his paintings had to show. No surrealist could remain indifferent to *Terre labourée*, reproduced in color in the definitive edition of *Le Surréalisme et la peinture*.

The title of Miró's 1923–24 canvas may be said to locate its contents, but hardly after the style of another title, *La Ferme* (*The Farm*), naming a picture completed between 1921 and 1922. The label *La Ferme* situates the constituent features brought together in the earlier picture, accounting for and readily justifying their presence. But in the case of the later canvas, the effect of the title is unifying up to a point only. Farm animals, a farm, and even tilled land are all easy enough to pick out, even though curiously distorted in some instances. But who would expect to encounter an enormous ear—either attached to a tree trunk (or whatever that vertical phenomenon is) or instead protruding from behind it—without a matching partner, by the way? Given the direction taken by his painting during an earlier phase in its evolution, there is nothing really surprising in the elongation and distortion to which Miró has submitted familiar forms borrowed from the animal kingdom. The thing that catches us unprepared is the presence of an ear—intruding disconcertingly and without rational excuse upon an experience one would presume to be essentially visual. It introduces us to a universe which will be Miró's legacy to surrealism.

Although there is evidence aplenty that Joan Miró is capable of finding inspiration in the world around him, there is at the same time incontestable proof that he is attentive to the "*inner model*" which *Le Surréalisme et la peinture* presents as inspiring authentic surrealist painting. *Terre labourée* lends weight to two observations made by André Breton in the name of his fellow surrealists: "Words and images offer themselves as spring-

boards to the mind of the listener,"[11] and "Does not the mediocrity of our universe depend essentially on our power of enunciation?"[12] What is more, while authenticating these basic principles of surrealism, Miró's painting tangibly extends their applicability beyond verbal language to embrace pictorial expression as well.

Where does the ear come from in *Terre labourée*? What explains its presence? What role is it meant to play? These seem to be perfectly fair questions, in view of its unexpected and unexplained manifestation among the farm animals moving about in the scene depicted by Miró, and given its equally challenging reappearance among the fanciful forms participating in his *Carnaval d'Arlequins*, where it appears now attached to a ladder. Yet Miró ignored them when observing with ironic gravity during an interview granted James Johnson Sweeney: "Another recurrent form in my work is the ladder."[13] Miró himself having refrained from comment, the closest one comes to finding the answer that really matters, so far as a surrealist is concerned, is when reading Breton's *Le Surréalisme et la peinture*. Here Joan Miró is described as "that traveler always in all the greater hurry for not knowing where he is going" (p. 40). Being sure why the ear appears in *Terre labourée*, and again in *Carnaval d'Arlequins*, and understanding the full significance of its presence could have come to the artist only with conscious intent, by way of premeditation, which would have been in contrast with the spontaneity so admired in Miró by his fellow surrealists.

Spontaneity is reflected to a degree in the freedom with which various farm animals are rendered in *Terre labourée*. But its most impressive manifestation by far—clear evidence to surrealists of the operation of unpremeditated creativity known in their parlance as automatism—is the human ear, so singularly out of place. The ear presents itself as a sign of the marvelous, which surrealists regard as intruding, uninvited, upon everyday reality to infuse it with poetry. Acknowledged by surrealists in France as the greatest of their word poets, Benjamin Péret called the marvelous "the heart and nervous system of all poetry."[14] Even so, he took care not to define it more fully. If you were to ask him what the ear represents or stands for or means in *Terre labourée* and *Carnaval d'Arlequins*, Péret might well refer you to the first line of one of his own poems: "I call tobacco that which is ear."[15]

It would be folly to attempt to hang surrealism like a misplaced earring on Miró's tilled field. All the same, Miró's canvas alerted surrealists in Paris to the intervention and operation of creative forces to which their outlook naturally led them to grant special attention. To borrow a phrase fashioned by José Pierre, these were forces evidenced in "the orchestration of signs invented in complete liberty and at the will of a stupefying artlessness."

If taken as derogatory, Pierre's last word only misdirects us. Understood, however, as saluting Joan Miró's departure from aesthetic tradition, it points approvingly to what Pierre aptly terms "lyrical deformation"; that is, intuitive extension of surrealist poetry deep into the domain of figurative painting.

...dering what provoked such a radical modification in Miró's ...rt, we find him citing two influences of which he himself was

> ...on was a great reader and full of ideas. Among his friends were practi... ...all the young poets of the day. Through Masson I met them. Through ...I heard poetry discussed. The poets Masson introduced me to interested ...ore than the painters I had met in Paris. I was carried away by the new ...they brought me and especially the poetry they discussed. I gorged ...lf on it all night long—poetry principally in the tradition of Jarry's ...âle.

By the time one has read this far, an engaging explanation may have suggested itself for the presence of an ear both in *Terre labourée* and in *Carnaval d'Arlequins*. Does the ear not appear as an acknowledgment of the attraction Joan Miró found in word poems—poems to which one listens— during the time when, without fully realizing it, he was moving toward a surrealist mode of expression? This appealing hypothesis has its merits, but only so long as it is kept within limits. It would be foolhardy to proceed from there to the dubious conclusion that Miró introduced an ear quite deliberately into two of his first surrealist pictures, as a purposely formulated sign, as a clue planted for the benefit of alert spectators. Far more interestingly, the ear bears witness to the profoundly important change with respect to his art that Miró was undergoing. His text goes on to allude to this:

> As a result of this reading I began gradually to work away from the realism I had practiced up to "The Farm" until, in 1925, I was drawing almost entirely from hallucinations. At the time I was living on a few dried figs a day. I was too proud to ask my colleagues for help. Hunger was the great source of these hallucinations. I would sit for long periods looking at the bare walls of my studio trying to capture these shapes on paper or burlap.[16]

Would eating regularly dry up the hallucinatory wellspring of Miró's art? A glance at the paintings he completed after 1925 leaves no doubt as to the answer. Miró's devotion to a mode of painterly activity in which surreal-

ists could take a lively and admiring interest was less transitory than his
account of attendant circumstances might lead one to suppose. Writing in
the third number of *Minotaure* (a review in which surrealist influence was
paramount), he would explain in 1933, "It is difficult for me to speak of
my painting for it is always born in a state of hallucination, provoked by
some shock or other, objective or subjective, for which I am entirely
unaccountable" (p. 18).

When we hear José Pierre talk of Miró's "conversion to surrealism,"
we must remember that, painting *Terre labourée*, Joan Miró was not engaged
in a sustained effort to make his work conform to a model already approved
by surrealist edict. In fact, to an ex-surrealist poet, Alain Jouffroy, *Terre
labourée* appears as perhaps the picture that persuaded André Breton there
could indeed be a surrealist form of painting, parallel to surrealist verbal
poetry.[17] In other words, far from following an established fashion, Miró
actually set one of the trends by which surrealists were soon to be enthused.
What is more, Breton was perfectly willing to acknowledge, later, the
importance of Miró's contribution in this respect. In "Genèse et perspective
artistiques du surréalisme" Breton commented, "The tumultuous entry, in
1924, of Miro marks an important stage in the development of surrealist art.
Miro, who then leaves behind him a body of work of a less evolved spirit
but which bears testimony to plastic qualities of the first order, in one leap
clears the last barriers that could still be an obstacle to total spontaneity of
expression. From then onward his production attests to an innocence and
freedom that have never been surpassed" (p. 70).

Breton gladly acclaimed Miró—"He opens the cage to the invisible
object." Nevertheless, as principal spokesman for surrealism in France, he
voiced one major objection also: "The only other side to such natural
aptitude, on Miro's part, is a certain arresting of the personality at the
infantile stage, which protects him poorly from unevenness, from profusion
and play and intellectually places limits on the breadth of his testimony."

Such a criticism seems to be in flat contradiction with the surrealists'
faith in play as a pathway to the marvelous. We must realize, therefore,
that Breton's reference to play, here, invokes both the connotation of *jeu
d'enfant*, "child's play," and especially of *jeu nuisible*—the allusion being to a
mechanism operating, at the expense of efficiency, with too much play.
Breton's remarks combat the theory that surrealists were eager to recruit
Joan Miró at any price.

Are we to infer, from Breton's comments, an explanation for the fact
that in *Le Surréalisme au service de la Révolution* (the magazine put out by

surrealists in France between 1930 and 1933, after the termination of *La Révolution surréaliste*), Joan Miró was represented by no paintings at all and by only one sculpture, reproduced in the third issue in December 1931? Hardly. Whatever the reason for according his work less attention than before, it could scarcely be diminishing respect among the surrealist membership. Meanwhile, the artist most often represented in the second Parisian surrealist review was another Spaniard, Salvador Dalí—with eight pictures and no fewer than seven articles.

This is not the place to discuss the relative merits of Miró's art and Dalí's. Even so, the name of Dalí having been introduced by Maddox, it is helpful to take Dalinian painting as a point of reference as we begin trying to place Miró with regard to surrealism's aspirations through art.

In Dalí's painting, deep perspective is frequently a dramatizing element. It underlines an anecdotal quality, shared for instance by some of Tanguy's pictures even where, with Tanguy, the horizon is disturbingly elusive. Miró, on the other hand, discounts perspective, so understating or even eliminating altogether the narrative significance of his picture. During the period 1922–24 metamorphosis of form is accompanied by a breakdown in the familiar relationship between things and—this is just as important—between things and space. The consequence is what José Pierre has termed "the space of automatism" in Miró's painting.

One has an intimation of later developments when looking at *Terre labourée*. Here, curiously, the furrowed soil can be seen in a zone differentiated by color alone from the sky behind the farm. The result is that the picture looks exactly what it is: a painting executed ("artlessly") on a plane surface. Neglecting perspective, so that the viewer cannot count on its benefits to enhance enjoyment, Miró has begun the process that, in his work, will murder painting as three-dimensional illusion.

In *Carnaval d'Arlequins* that same process advances a step further. As with *Terre labourée*, we know we are facing the pictorial rendition of a three-dimensional scene: there is a floor in front of us and, farther back, a wall with a window. All the same, these elements that would serve as reliable indicators in familiar perspective prove to be of doubtful pertinence to our effort to situate the animated figures set against them. Not being subject to gravity, a number of the latter appear to be suspended, weightless, against a two-tone background, functioning two-dimensionally.

The procedure by which perspective is stripped of narrative value moves forward a stage in a painting by Miró reproduced in *La Révolution surréaliste* (Nos. 9–10, October 1927): *Personnage jetant une pierre à un oiseau* (*Person Throwing a Stone At a Bird* [1926]). Here the stress falls emphatically on design, not drama, in contrast—one cannot fail to notice— with the narrative character of the picture's assigned title. The difference

is instructive between this picture (as well as a variety of landscapes done by Miró the same year and in 1927) and the paintings Max Ernst and Yves Tanguy were producing during the same period. In Ernst's *Weib, Greis und Blume* (*Woman, Old Man and Flower* [1923–24]), the title solicits an exercise in itemization (one that proves ultimately less than fully rewarding) while deep perspective contributes palpably to evoking an eerie, unsettling atmosphere.

There is no mystery at all about the origins of the interest in deep perspective shared by some of the best-known surrealists of the first generation. They began to explore perspective under the influence of an older painter, the Italian Giorgio de Chirico. Reviewing the investigations conducted by Ernst and Tanguy, we appreciate that Miró stands apart, just as he does from Dalí. In pictures that first commanded the surrealists' attention, he had already started reducing the horizon (which he had learned to admire in the canvases of Modesto Urgell Y Inglada, his mentor at the Barcelona School of Fine Arts, which he entered in 1907) to the dividing line between two contrasting colors. Already he was confirming its role in promoting the impression of "flat space" to which José Pierre has referred. Against that functional background he was beginning to dispose objects as peculiar to his painting as those found in Tanguy's work are indisputably Tanguy's.

Tanguy was to show none of the independence in thought that marks the statement by Miró printed in the 1929 surrealism issue of *Variétés*. He felt no need for it. Meanwhile, though, like Hans Arp, Miró made a valuable and valued contribution to surrealism without feeling obligated to make, at the same time, the kind of commitment to surrealist doctrine that others—Tanguy among them, as it happens—found necessary to guarantee the integrity of their art as an expression of surrealism. Hence it is fair to say that Joan Miró's distance vis-à-vis surrealism (which explains his refusal to share in condemning Artaud and Soupault) did not merely suit the needs of his "strong or excessive personality." In addition, it left him free to explore painting in directions and areas holding little or no appeal for the surrealist. Considering these, we have to admit that Breton's strictures regarding the intellectual limitations imposed upon Miró's work by infantilism are harsh, and are surely inadmissible to anyone who appreciates the benefits that infantilism (the word must seem ill-chosen) brings to Miró's painting. Still, we cannot disregard what appear to surrealists as limitations, if we are to understand the position taken by the surrealist group. The latter perceive as a defect something which nonsurrealists find it very easy to discount as having no adverse effect at all on painterly qualities commanding their respect in Miró.

Even at the time when he first excited the surrealists, Joan Miró's painting was characterized by emphasis upon design. Design makes it demands felt in *Carnaval d'Arlequins*, for example. From the moment Miró felt drawn to surrealism, an instinct for design took precedence, in his work, over an impulse to shock his spectators' imagination into activity by unforeseen encounters, common to several other surrealist painters of his generation. Whenever present, the effect of mental shock was always reduced—mitigated, one might say—by the appeal of formal arrangement in a Miró. The illuminating contrast, here, is with the work of René Magritte.

The difference could not be greater, or more revealing, between the rich sensuous colors and patterns we associate, on the one side, with Miró and find so attractive in his work and, on the other side, the flat and subdued tones often used by Magritte—in *La Trahison des images* (*The Betrayal of Images*) for example.

Around the year 1929 Camille Goemans, fellow Belgian and fellow surrealist, began making notes toward a book on Magritte, apparently never finished. Among his jottings we find the comment, "No painter gives us like Magritte the feeling that if he paints, in fact, and if the means he employs are canvas and colors, that is only accidental." The obvious poverty of strictly painterly means at René Magritte's disposal (in which, as we shall see, he prided himself) may prompt nothing but fervent agreement from anyone who unhesitatingly prefers Miró. And yet, alluding to Magritte, Goemans speaks of "Living Painting," "in the sense that beyond that color of his reflections, beyond those particular objects, he leads us to that common object of our reflections which is existence. Painting is not for him the object of a science, it is rather the science of objects."—La Trahison des images: "Ceci n'est pas une pipe." It is to the extent that André Breton, who admired the results of pictorial automatism in Miró's work, still shared with Camille Goemans concern for what the latter has called "Living Painting" that he criticized Joan Miró for being blessed with only limited intellectual power, which was finally to limit his contribution to surrealism.

André Masson

I N *LE SURRÉALISME ET LA PEINTURE* we read, "What good is painting, what good is this or that meditation on painting!" (p. 35). André Breton's exclamation alludes to the central question raised by surrealism in the medium of pictorial art. We find it in a paragraph devoted to André Masson, where we are informed that there are no fixed rules for painting: "Examples only come to the help of rules at a loss to exist."

Surrealism began making its impact on twentieth-century European painting in the absence of predetermined dicta, defining itself as it took issue with current practice no less than with tradition. Evidently, in Breton's eyes this fact gave special value to the work of André Masson. *Le Surréalisme et la peinture* stresses the latter's "chemistry of the intelligence," a "science" said to produce "inevitable and dazzling 'precipitates'" (pp. 35–36). Highlighting the spirit of inquiry in which the earliest surrealists first approached painting, Breton's statement gives prominence to pictorial experimentation conducted by an artist who has not held public attention quite like some of the other surrealist painters of his generation.

When introducing his comments on Masson into *Le Surréalisme et la peinture*, André Breton did not expand upon his praise of the painter's healthy mistrust of art. However, he repeatedly identified Masson's position with his own, referring to "common considerations" as being "at the basis of everything we avoid and of everything we undertake." What his remarks lacked in precision was offset by unreserved endorsement of Masson's conduct as a surrealist whose preferred tools were pen and brush.

Not until 1941 did Breton indicate how André Masson had come to earn his approval in 1928. In "Genèse et perspective artistiques du surréalisme" he commented, "From the beginning of the surrealist movement, fully

37

committed to the same struggle as Max Ernst but searching much earlier for principles authorizing him to build on them in a stable fashion, André Masson right from the start of his route encounters *automatism*" (p. 66).

The basis for agreement with André Masson comes to light as Breton proceeds to summarize, in "Genèse et perspective artistiques," one of the tenets of surrealist faith. Here a paragraph unstintingly praising Masson affords him the chance to reiterate his own beliefs. Meanwhile it gives the French painter full credit for sharing those beliefs and, by applying them, for assisting in validating the claim—put forward publicly by André Breton himself in 1925—that painters and writers may find common ground in surrealism.

Remarking that, with Masson, "the painter's hand truly *gives itself wings*," being "taken with its own movement and with that alone," Breton goes on to define as follows the "essential discovery" of surrealism: "without preconceived intention, the pen that moves to write, or the pencil that moves to draw *spins* an infinitely precious substance not all of which perhaps is material for immediate exchange but which, at least, appears charged with everything emotional the poet or painter has within him at the time" (p. 68). Commending next the "magnificent curve" of André Masson's painting since the twenties, Breton then energetically and confidently defends the principle of automatism as being essential to surrealist expression, despite the role that may be reserved, sometimes, for premeditation in the working method of this or that individual surrealist artist. In addition, Breton draws a distinction between the kind of painting made possible by the pictorial equivalent of automatic writing, as discussed in his first surrealist manifesto, and "the other route offered surrealism": *trompe l'œil* transcription of dream images. He goes on to pronounce the latter a less reliable way for artists to reach "the total psychophysical field" of which he judges the field of consciousness to be no more than "a feeble part" (p. 70).

The possibility of extending application of the automatic principle to the medium of painting was the bone of contention among surrealists in Paris, for several months after the publication of the October 1924 *Manifeste du surréalisme*. Sure that painting was to have a prominent place among productive surrealist activities, Breton seems nevertheless to have taken care to avoid controversy, so far as he could, when embarking upon his series of articles about surrealism and painting in the July 15, 1925 number of *La Révolution surréaliste*. Tactical considerations appear to have given him reason to speak only vaguely of the sources of his liking for Masson, in the October 1, 1927 issue—just four months before his essays were reprinted as *Le Surréalisme et la peinture*. Not until the 1940s, when acknowledgment of

the role of automatism in André Masson's work no longer threatened to divide participants in the surrealist movement in France, did Breton at last explain why he admired his friend so. Still, there was evidence enough of the significance of Masson's achievement in the original Parisian surrealist magazine.

In the very first number of *La Révolution surréaliste* (December 1, 1924), three artists shared the honor of being represented by two drawings each: Giorgio de Chirico, Max Ernst, and André Masson. Inclusion of material by Masson, incidentally, was by decision of Breton and Louis Aragon.[1] Like Man Ray's, Masson's response to the inquiry into suicide, conducted in the second issue, took the form of a line drawing. In the third number, carrying four illustrations by Paul Klee, there were no less than five by Masson, two of them reproduced full page. The fourth issue, with which Breton took over direction of the review, featured Masson's *L'Armure* (*The Armor*). The fifth reserved space for two of his drawings, *Soleils furieux* (*Furious Suns*) and *La Naissance des oiseaux* (*The Birth of Birds*), next to two works by Ernst and by Miró. In No. 6, to which Arp, Braque, Ernst, Picasso, and Man Ray contributed one picture apiece, Masson gave two paintings, *Les Constellations* and *Oiseau percé de flèches* (*Bird Shot Through With Arrows*). The following number, also, included two items by him, one of them the painting titled *Mort d'un oiseau* (*Death of a Bird*). The eighth issue carried two more, including *Les Draps* (*The Sheets*). Nos. 9–10 had more by Arp, Ernst, de Chirico, and Tanguy than by Masson. The one Masson piece was, though, an example—the only one to appear in *La Révolution surréaliste*—of his sand painting.

André Masson is among the very few artists to have work reproduced in every number of *La Révolution surréaliste* up to and including the eleventh, where he is represented by a picture called *Une Métamorphose*. His outstanding record is testimony, discreet and yet firm, to the regard in which he was held during the years immediately after the first surrealist manifesto came out, just as the predominance of automatic drawings among items appearing over his name emphasizes the nature of the contribution he was making to emergent surrealism.

The absence of anything at all by Masson from its twelfth issue (December 15, 1929) is explained by the text opening the final number of surrealism's original French-language magazine—the first version of a second surrealist manifesto. Here André Breton speaks of leaving to "their sad fate" several former participants in surrealist activities. These men include André Masson who, according to Breton, took offense at being granted less attention than Pablo Picasso and Max Ernst in *Le Surréalisme et la peinture*.

It would be helpful if Breton and Masson had offered consistent obser-

vations whenever referring to their differences during the late twenties. Unfortunately, discussing his disagreement with Masson in a 1952 series of radio interviews published as *Entretiens*, Breton reported that André Masson had been struck off the list of active surrealists because of disinterest in social questions (at a time when, we know, surrealists in France were becoming more and more sensitive to sociopolitical matters) and also because of his devotion to painting as art, that is, to aestheticism. On his side, Masson also was to muster, over the years, explanations too conflicting for his motives to stand out really plainly. Among these is a comment he made during a March 20, 1961 lecture, "Propos sur le surréalisme," while asserting that, from the beginning, surrealist painting developed in two irreconcilable ways. Proceeding in one direction, Masson said, it sought to "fix" images by techniques he himself judged ironically academic. Advancing in the other direction, it displayed faith in "the vertiginous rapidity of an *execution* never behind *inspiration.*" Citing his own surrealist productions as expressive of that faith, Masson associated Ernst's collages with the other line of surrealist inquiry which—regrettably, to his mind—was to become, in his word, the "official" surrealist method.

All this suggests that Masson's dissatisfaction with Breton's 1928 volume was not the result of pique alone. Disagreement would seem to have centered on the question of profitable investigative procedures for surrealist painting. Thus "Propos sur le surréalisme" gives the quarrel between Breton and Masson special significance. From Masson's point of view, we may conclude, the appearance of "Genèse et perspective artistiques du surréalisme" would have been sufficient grounds for reconciliation, since it acknowledged that André Breton had changed his attitude and now was leaning toward Masson's position.

In retrospect, none of the departures and exclusions from the surrealist circle announced publicly in the *Second Manifeste* strikes us quite the way André Masson's does. Friendship between him and Breton was reawakened upon Masson's return from Spain in November 1936. After reading "Genèse et perspective artistiques" five years later, he could no longer complain that Breton rated Ernst too high and himself too low. All the same, it was especially unfortunate that, for almost a decade, surrealism should have been deprived of support from Masson, whose contribution, around 1924, had been important enough for his loss to be a serious blow.

In his 1973 pocket dictionary of surrealism, José Pierre singles out André Masson as differing from the other first-generation surrealist painters

in two respects. He cites Masson as having come to surrealism without passing through a Dada phase and (ignoring Miró, oddly enough) notes too that Masson is the only artist in the group who did not fall under the influence of Giorgio de Chirico.

There is no doubt that, among the original surrealist painters, André Masson developed in a manner all his own. This is because his work took inspiration not from the example set by predecessors but directly from the revelations of automatism. De Chirico may have been the originator of a form of automatism defined by José Pierre as "sensorial."[2] But he did not set a precedent in the mode of automatic inquiry that Masson was to make his own. Allowing pen, pencil, or brush to run freely, André Masson would trace shapes and patterns on paper or canvas, according to a method parallel to that of automatic writing, as described in the first surrealist manifesto.

Former surrealist Michel Leiris has defined Masson's art as essentially mythological, because, Leiris has explained, it seems to him to deal with "*affective* knowledge in which images charged with emotion come to the fore."[3] The fluidity of line characteristic of Masson's graphic work supports this judgment while illustrating the artist's maxim, "There is no finished world."

André Masson was to discover the inexhaustible nature of the world by way of pictorial automatism. Prior to his implementation of that investigative technique, he had executed landscapes and practiced still life painting. Reduced perspective and stress on blocks of color in his work had indicated a commanding interest in design, rather than in discovering unsettling images such as most of the earliest surrealists would prefer. Even the paintings he completed in 1924 (the year of his first exhibition, during February and March, at the Galerie Simon in Paris) bore witness to the influence of cubism. Therefore they seemed considerably less adventurous than pictures done by other artists, for whom the pathway to surrealism had run through Dada territory. The fluid line André Masson acquired by way of automatism resulted in graphic experimentation that was not so much the "pure representation of movement" admired by Georges Limbour,[4] perhaps, as movement itself. It led to restless exploration of something making itself known to the artist only through the act of investigation—as though the line, and not the mind behind the hand tracing it, had started with a question to which nothing but its own advance could furnish even a provisional answer.

Historically speaking, this feature of Masson's involvement in early surrealist investigation of pictorial imagery is especially important. The automatic drawings he made during the period 1924–25 were executed at a

really crucial time. They came at a moment when there was most doubt among surrealists in Paris on the subject of the relevance of pictorial inquiry to experiments being carried out by French writers in the name of surrealism, and when André Breton's longing to reconcile verbal and graphic image-making on the plane of surrealist exploration seemed least likely to be met. The example offered by André Masson's automatic drawings may not have been entirely conclusive, any more than it exhausted every possibility open to the surrealist pictorial artist. All the same, it was of unusual significance, because it extended encouragement in the face of uncertainty and the threat of disappointment.

Moreover, there could be no argument where Masson was concerned. Works of his conforming closely to surrealist edict were produced just before and just after the first *Manifeste*. At that time, his fidelity to surrealism was above question. When hailing him as one of their own, surrealists could not be suspected of the kind of opportunism that might have seemed to be their motive in hanging pictures by Arp, de Chirico, Klee, and Picasso next to material by him, Ernst, and Miró in the Galerie Pierre, on the occasion of the first surrealist group show in November 1925.

The sinuous line our eye must follow through the graphic work by Masson reproduced in *La Révolution surréaliste* lets us suppose that the figurative shapes emerging from his automatic drawings arrive before us by accident more often than by deliberate choice on the artist's part. An identifiable motif—a hand, a bird, a woman's body—does not dominate as the subject of this or that picture, but figures as a contributive element in the image as a whole. The nervous continuity of line is paramount. The forms it outlines as it moves along remain secondary, incidental to the progress of the pen, yet revelatory even so. Reduction of the importance of the human form, under impetus from automatism, results in the appearance of anatomical parts in paintings where man is no longer the sole focus of interest: the nude torso in the center of *L'Armure*, for instance, with a single breast set to one side, beneath a bird which may, in fact, have perched on it.

Superimposition of several planes within the same picture—a feature of Masson's painting long before Roberto Matta began using it—further reduces the prominence of the human. It is not that André Masson's imagery degrades mankind. Rather, it places man in his environment and in a manner often leading to moments of indecision, or more exactly of exchange, such as we witness in the picture *Une Métamorphose*. Now a balance is struck between man and nature: neither is granted precedence once

and for all, because the one grows out of the other and then, without interruption, the procedure reverses itself.

This is, in essence, the peculiar function of Masson's paintings of metamorphic landscapes. Here the human merges with nature, emerging once more without being actually separated from ambient reality. These works are evidence of the creator's fascination with an intermediary state in which man and his world do not simply coexist but are interdependent. And so we cannot perceive the one without seeing the other at the same time. These landscapes do more than place stress on ambiguity by assembling overlapping images of man and nature. They provide instructive object lessons, demonstrating how necessary to one another are man and his world: the pictorial image is born of their coincidence.

If we ask what fuses the human and the extra-human in one of Masson's metamorphic images, we find it as often as not is the erotic, an expressive force nurtured by desire and, quite frequently, externalized through humorous play.

The final chapter of Masson's *Anatomy of My Universe*, published in New York in 1943, consists of one drawing only, *The Emblematic Man*, which carries the notation, "Man is the mirror of the universe." When writing the prologue to the volume, in 1940, the author announced that the "gushing forth of different elements" making up his graphic world "has responded to the call of desire." Not long thereafter, in a lecture on the origins of cubism and surrealism given in Baltimore on October 31, 1941, he would define a painting as the "objectification" of what is imagined by the artist and would claim for art "the supreme liberty" of creating "new—unforeseen—things." Banal though they sound, these remarks are valuable as a call for evaluation of evidence, in any work of art, of its author's "most sacred, most repressed instincts." Specifically, they relate to André Masson's view of the surrealists as "tearing from the darkest abysses of our instincts forces that it was tacitly forbidden to reveal" and as giving form to the "painful, disturbing, exciting metamorphoses of our unconscious." In sum, Masson's portrait of the surrealist as having "a sense of the Unity of man and the Universe" is truly a self-portrait.

The instincts identified in Masson's Baltimore lecture as lying "at the root of being" are hunger, love, and violence, engendering affective and mythical expression in surrealism. Hence his view of surrealist artists as "leaning over the caverns and precipices of passions": "the life of the spirit will always be the fruit of Desire forever reborn and of heroic discovery." When dealing with "Le Peintre et ses fantasmes," he would mention, as part of what held the earliest surrealists together, "the consciousness of reaching the uncomfortable and marvelous plane of major eroticism," that is to say,

"eroticism proposed as genesis, center, opening out."[5] Thus André Masson felt it no betrayal of his former friends to say they thought of creating "a *Mythology of Desire*"—surely the ultimate goal he had set himself when a participant in surrealism.

As for humor, "Propos sur le surréalisme" classified its means as a hybrid of nonsense and metamorphosis, admitting that the latter category was the one which had attracted Masson, leaving its impression on those of his paintings that best conform to surrealist canons. In the same text we read of "man torn between horror and amazement—between jubilation and terror."[6]

The ideas summarized here, as well as Masson's last phrase, find illustration in examples of his drawings like the one called *Palper le sein de l'espace* (*To Palpate the Breast of Space* [1940]), inspired by a phrase from Lautréamont's *Les Chants de Maldoror*. In this sketch an emergent humanoid male figure, mouth open in a cry, looks upward across a bare landscape rent by a vulval crack to the sky, where the thumb of an enormous hand presses the nipple of a proportionately large breast. An even better example is an untitled drawing in which a reclining nude woman becomes one with a landscape, her head invisible but her breasts rising like hillocks. Sparse vegetation sprouts from her torso and a tree grows out of one of her bent knees, while the shin below forms the side of a ravine matched by a vertical cliff. The other flexed leg rests, apparently, on a second woman, whose thigh and gaping vulva can be seen. Between the thighs of the dominant figure, a nude man, tiny by comparison, leans forward in an erect position, thrusting his way into her vagina.

There is nothing disparaging about José Pierre's choice of Masson's graphic work as "an easy example" of the extension of the surrealist theory of automatism to painting. In fact, Pierre's comments usefully bring to light something that should not be ignored. André Masson's use of automatism requires the public's response to evidence more than the capacity to identify a motif on the basis of its resemblance to animal or vegetal forms. Pierre's remarks have the virtue of bringing the allusive motifs present in Masson's drawings into line with surrealist revelation, by stressing that, in its aims and achievements, the latter exceeds mere representational art:

the way so many of the automatic drawings and paintings of Masson, in 1924–1925, spontaneously associate a fruit, a bird, or a woman's breast with

an open hand would seem to bear witness at the same time to the dilatory process proper to long-term surrealist inspiration and to the irresistible precipitation with which are produced associations that, formerly unconscious (or repressed), become conscious during their transcription to canvas or the sheet of paper.

This would amount to saying that, in Masson's unconscious, diverse emotions have accumulated, followed or not by effects, relative to an apple, a pigeon, or a nude woman, which on the occasion of later insertion into a nonpremeditated graphic or pictorial composition (or one resulting from relatively little premeditation) elude the status of realistic transposition (portrait or still life) to discover for themselves symbolic signification (the apple then *equalling* the breast and the bird, who knows? the phallus or erection . . .) within surrealist metamorphosis.[7]

Looking back, in "Le Peintre et ses fantasmes," to the time when he was beginning the first series of automatic drawings reproduced in successive numbers of *La Révolution surréaliste*, André Masson specifies three conditions as required for their successful completion: attainment of a state akin to trance, "abandonment to inner tumult," and speed of execution. To these he attributes the birth of "involuntary figures," at once "disturbing" and "*unqualifiable*," releasing in the executant both shame (presumably, in his own case, at the mutilations evident side by side with what he calls "visceral obsession") and "avenging exultation"—"as though at a victory achieved over some oppressive power."

Unfortunately, the residual effects of cubism's influence—even after completion of his oil *Les Quatre Éléments* (*The Four Elements* [1924]), purchased from a dealer by André Breton just before Masson joined his group in 1924—imposed stiffness on André Masson's painting (we cannot but notice this in *Les Quatre Éléments*), in contrast with the suppleness of his line drawings. Obviously, in the mid-twenties he still had not resolved the problem of how to achieve spontaneity when laying color on canvas. The best he seemed able to do was incorporate the fruits of automatic drawing into oil paintings like *Nues et architectures* (*Nudes and Architectures* [1924]), where the legacy of cubism is still only too visible, imposing a static quality that is in strong contradiction to the mobility of the drawings he was executing at about the same time.

Late 1926 saw Masson engaging in experiments aimed at infusing his paintings with a vitality and a capacity for revelation comparable with those of his automatic drawings. Impressed, during a period of residence from May onward by the sea, with the "beauty of the sand composed of myriad nuances and infinite variations ranging from dull to sparkling," he began by

spreading glue haphazardly over a raw canvas. Then he would scatter sand, letting it adhere to the glue. Sometimes he would apply the sand in a variety of layers and shades, so bringing to an end "the first movement of an intuition in which I was soon going to find what was mine," as he puts it in "Propos sur le surréalisme." Finally the picture was completed by the addition of lines, sometimes produced by squeezing paint directly from the tube, in response to "solicitations" coming from the conformations of the canvas's sanded areas.

Obviously, Masson's technique of sand painting exemplified the productive tension of creative art in surrealism, something he termed "the marriage of the *unformed* and the *formed*—the fusion of elementary forces with the fortuitous image." The process may prove to be marvelously revealing to the surrealist, bringing to light an image of arresting power and novelty. On the other hand, it may fail to elicit anything stimulating to his imagination. Then the undirected hand is no better than the misdirected one. For nowhere do surrealist artists run greater risks than with unreserved, uncritical surrender to chance, treated as the instrument of revelation. Nevertheless, in his 1938 essay called "Prestige d'André Masson," taken up in later editions of *Le Surréalisme et la peinture*, Breton noted, "The taste for risk is undeniably the principal motor capable of carrying man forward along the path to the unknown. André Masson is to the highest point possessed by it" (p. 152). Hence Breton's assessment of Masson as "the most reliable, the most lucid guide there is in the direction of the dawn and of fabulous lands" (p. 154).

Nobody could have been more aware than André Masson of the dangers that always accompany the surrealists' taste for risk. It is an irony of his relationship with surrealism that the day would come when, having parted company for good with his old surrealist friends, he criticized surrealism for the uneven quality of its discoveries. In this connection, his *Entretiens avec Georges Charbonnier* (1958) is an open repudiation of his past. Interviewed by Charbonnier over the radio in 1957, Masson grumbled that practicing automatism is much like going fishing; you never know whether you will bring home a fish or an old boot.

In a text first published in 1948, written to accompany his *22 Dessins sur le thème du désir*, Masson had another reason for reproving automatism, now termed "an attempt at expressing the unconscious by the go-between of drawing" and condemned out of hand as "tending toward the psychiatric document, without aesthetic concern." He briefly reviews his own statement in "Le Peintre et ses fantasmes," where we read, "Let us not forget we are painters, not men of science. Fishing in the depths of the unconscious furnished us with images, not with steps having cure or deliverance as their aim."

It was not simply disappointment at the way André Breton had spoken about him in *Le Surréalisme et la peinture* that brought to an end Masson's experiments with sand painting. In "Propos sur le surréalisme," we are told that his automatic drawings, his sand paintings, and those—like his 1927 canvas *Chevaux dévorant des oiseaux* (*Horses Devouring Birds*)—in which feathers are substituted for sand, are "underground works." Here Masson presents a good reason for not having always followed "the authentically surrealist" path: "It is because it is impossible for me to be every day in a 'second state,' every day subject to vertigo, to being every day uplifted. If that had gone on continuously, I would have been dead a long time ago."

All the same, we have no reason to conclude that, after 1928, André Masson ceased to find inspiration in sources that previously had fed his graphic automatism. If there was a difference to be observed, once he joined forces with Georges Bataille (whose erotic fiction *Histoire de l'œil* [1928] he illustrated and who, in return, prefaced his album of drawings *Sacrifices* [1934] when it was published in 1936), it lay most probably in Masson's acceptance of his penchant for eroticism. With none of the narcissism that makes its presence felt intrusively in the work of Salvador Dalí, the erotic would be linked from now on with Masson's handling of the theme of violence, central to his 1931–35 series of drawings called *Massacres*. In a very real sense, during the years after his estrangement from Breton, André Masson explored the implications of discoveries made via automatism, and so never actually renounced surrealism by denying his surrealist past. In 1936 he participated both in the International Surrealist Exhibition held in London and in the show titled *Fantastic Art, Dada, Surrealism*, at New York's Museum of Modern Art. In "Prestige d'André Masson" Breton would refer proudly to the dressmaker's dummy prepared by Masson for the 1938 Paris International Surrealist Exhibition as "rightly considered its major diamond" (p. 154).

Discussing the art of our time, a little later on, in his 1939 essay on painting as wager, "Peindre est une gageure," André Masson touched on a major preoccupation common to all surrealists when he referred to "the passionate search for the ineffable" as producing "between content and container a distance that provokes despair." Surely, his own "frenetic abandonment to automatism," as he spoke of it on the same occasion, must be assessed in relation to that search and to his hope of reducing that distance. So must his concept of artistic creation as "in essence sensitive intuition." Loyal to his convictions, in the same context Masson showed himself to be aware of "a formidable plague" which he saw as having appeared among the surrealists around the year 1930: "a demagogy of the irrational" that

he criticized for having led surrealism into "stereotype and approval by society."

This veiled attacked on Dalí confirms Masson's devotion to a radically divergent approach to image-making which prompts him to comment, "The progress of images and the wonder or anguish of the encounter opens up a path rich in plastic metaphors: *a fire of snow.* Hence its attraction and fragility." These words point to the direction their author began taking after the practice of automatic drawing had revealed to him a world of images previously invisible. Denying in "Peindre est une gageure" that reflection ought to be given precedence over intuition, or intelligence over "what we agree to call inspiration," Masson pleads for the "fusion" of the hetero-geneous elements brought into play by the "painter-poet," arguing that this fusion will be accomplished "with the flashing rapidity of light." Thus the unconscious and the conscious, intuition and understanding will have to "operate their transmutations in the superconsciousness, in radiant unity."

Following a period of unquestioning dedication to the automatic prin-ciple, André Masson seems to have arrived, during the years after his first break with surrealism, at a position of practical compromise. Henceforth, it appears, he would seek to enjoy the best of both worlds, in order to benefit from the one without total sacrifice of the other. In his painting, he man-aged to resolve the conflict he had taken for granted, previously, to arrive at a productive balance between freedom and control, spontaneity and structure. At this later stage in his career, his working method is exempli-fied in *Dans la Tour du sommeil* (*In the Tower of Sleep* [1938]). Here icono-graphic elements combine to give an effect of erotic violence, supposedly attributable to the painter's intention of depicting one of his own dreams. In the crowded canvas we notice that the male figure is a victim of Masson's "visceral obsession." Meanwhile the arched bust of a woman, its bulbous breasts ending in improbably pointed nipples, is an outgrowth of a corner of landscape, hence both human and vegetal.

In *Dans la Tour du sommeil* we can see how, from the late 1930s onward, André Masson achieved liberation from the rigidity that had left him displeased with his paintings back in 1924. It is evident, however, that escape from certain restraints he had been unable to shake off in the past led him, now, to submit to concerns of a formal nature. This picture may have avoided the kind of academicism to which Masson objected in Dalí's technique. But it did not do so without betraying any weakness at all to the surrealist's eye. In fact, it betrayed an attentiveness to formal considerations that is extraneous to surrealism and at variance with the surrealists' ambi-tions. There are signs here that André Masson indeed was moving in the direction warranting the accusation of aestheticism later to be leveled at

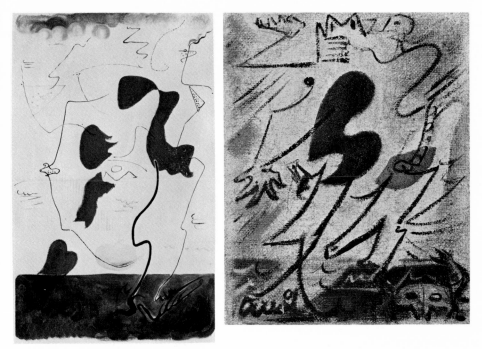

(Left) André Masson, *La Poursuite (The Chase)*, 1927. Private collection, Winnetka, Illinois
(Right) André Masson, *La Mauvaise Rencontre (The Nasty Experience)*, 1930. Private collection, Winnetka, Illinois

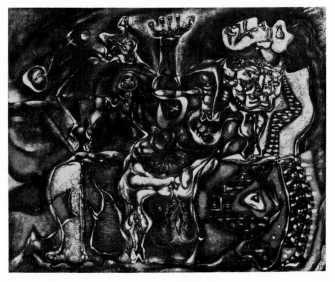

André Masson, *Parsiphaë*, 1943. Private collection, Winnetka, Illinois

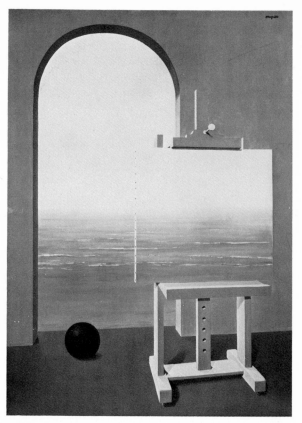

René Magritte, *La Condition humaine (The Human Condition)*, 1935. Galerie Isy Brachot, Brussels–Paris

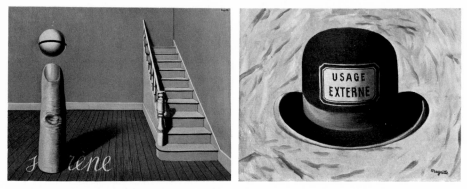

(Left) René Magritte, *L'Usage de la parole (The Use of Words)*, 1932. Galerie Isy Brachot, Brussels–Paris
(Right) René Magritte, *Le Bouchon d'épouvante (The Terror Bob)*, 1966. Galerie Isy Brachot, Brussels–Paris

him in André Breton's *Entretiens* and repeated by José Pierre on more than one occasion. Although Masson seemed to reconcile the automatic with the premeditated, it was the latter that dictated the rhythm of *Dans la Tour du sommeil*, leading to visible proof of aesthetic preoccupations which reduced the surrealist intensity of the work and announced the artist's final severance of his ties with surrealism.

When an artist, in whatever medium, begins to feel the links that bind him to surrealism acting as restraints, limiting his creative activity rather than nourishing it and promoting its growth, the time has come to admit the fact openly and to respond energetically to the situation in which he finds himself. Any attempt at this stage to reinforce those ties by artificial means—out of gratitude, a sense of obligation, or merely for self-serving tactical reasons—would be no less fruitless than dishonest. It would only strain a relationship that must inevitably suffer, once it has ceased to rest on spontaneous yet necessary commitment by the individual to the cause of exploration considered exciting by the surrealists. In André Masson's case, a conflict arose between graphic automatism and its offshoots, on one side, and, on the other, the organizing will sparked by concerns of an aesthetic order. That inner conflict, fundamental to the artist's creative activity, was resolved finally in favor of aestheticism. Thereafter, Masson had no alternative—and no desire, either—but to leave the surrealists' ranks for good. He found himself rejecting surrealism—no longer challenging to him as a means of inquiry and discovery—as being a form of unwelcome, unproductive confinement. So he turned away from those to whom his work had stood as an example. And they, for their part, recognized that he could have nothing more to contribute to surrealism's emancipative program.

René Magritte

Like his fellow surrealists in Brussels, René Magritte knew of surrealist activities in Paris before he moved to France. Subsequently, during a period of residence extending into 1930, he frequently visited André Breton's home. According to one Belgian critic, in fact, "more perhaps than any other surrealist from Belgium, Magritte makes a commitment vis-à-vis Breton's group and his final 'act of allegiance' corresponds to his installation in Paris in 1927."[1] Even so, Magritte was to be represented in the last issue of *La Révolution surréaliste* (December 15, 1929)—where Dalí's paintings are well in evidence—only by a short essay, "Les Mots et les images," illustrated with tiny line drawings. No reference to Magritte's work appeared in the 1928 edition of *Le Surréalisme et la peinture*. Not until "Genèse et perspective artistiques du surréalisme" did André Breton, almost in passing, acknowledge his contribution to surrealism, in a single paragraph where he spoke of the "unique" character of Magrittian painting. Then later, when Brentano's in New York brought out in 1945 an expanded edition of *Le Surréalisme et la peinture* (incorporating "Genèse et perspective artistiques" and a few other texts), a 1937 picture by René Magritte—who by that time had received more attention in the United States than in France—*Le Modèle rouge* (*The Red Model*), was selected for reproduction on the jacket. All the same, Breton took until 1961 to write an "Appreciation of Magritte," for a show held in October at the Obelisk Gallery in London. Only then did he state, at long last, that Magritte's work was "exemplary."

It would be an error to suppose that, while surrealism was in its infancy, Magritte somehow failed to impress Breton. Yet the latter would surely have deemed it wise, for strategic reasons, to omit Magritte from *Le Surréalisme et la peinture*, as he had done from the series of essays preceding it.

The prominence granted Joan Miró in *Le Surréalisme et la peinture* reflected Breton's pleasure at having discovered in his painting a defensible counterpart to verbal automatism. However, subsequently looking back to the 1920s from the vantage point of 1941, the author of the surrealist manifestoes no longer risked confusing an uninformed audience or simply dulling the edge of his argument when he referred for the first time to Magritte's "non-automatic but on the contrary fully deliberate" manner of going about painting: "The only one of this tendency, he has tackled painting in the spirit of 'object lessons,'" thus, added Breton, engaging in a "unique enterprise" (p. 72).

Despite this tardy praise, Magritte was to remain an isolated figure, somewhat apart from the main body of surrealist painters. His "object lessons" sometimes appear oddly lacking in positive intent. For instance, his canvases usually are not palpably nourished by the sense of the marvelous that infuses so much other surrealist painting. They breed disquiet rather than furnish reassuring revelation. And this is generally true right from the moment when, in 1925 or 1926 he made a collage and gouache picture titled *Le Jockey perdu* (*The Lost Jockey*), about which he remarked—all of forty years later—that it was "the first canvas I really painted with the feeling I had found my way, if one can use that term."[2]

Although, Breton would come to recognize and to publicize the exemplary nature of Magritte's art, he would never have occasion to call it fully representative of painting as practiced in surrealism. This does not signify, though, that René Magritte's work relegates him to a position of definitely secondary importance among surrealist artists. Magritte's painting was to be original enough to reserve him a place on the outer edge of the surrealist circle. Born of private meditation and patiently executed with a scorn for fashion in painting style that, in the end, imposes itself as a distinctive manner, the work of René Magritte is essential to surrealism. And this is the case even though it resulted from an approach implying criticism of the automatic principle.[3]

Coming to *Le Jockey perdu* unprepared by any explanation from the artist himself, we may misunderstand in which respect he felt indebted to Giorgio de Chirico. In a letter to a critic, Magritte once commented, "It was in fact in 1922 when I first came to know the works of Chirico. A friend [Marcel Lecomte] then showed me a reproduction of his painting *The Song of Love* [1914], which I always consider to be a work by the greatest artist of our time in the sense that it deals with poetry's ascendancy over painting and the various manners of painting. Chirico was the first to dream

of *what must be painted* and not *how to paint.*"[4] It was not in style or even language that de Chirico really found a disciple in Magritte. The young Belgian was impressed most by the atmosphere of the Italian's work. When, with *Le Jockey perdu,* he himself succeeded in capturing that atmosphere, in a scene in no way imitative of early de Chirico canvases, Magritte—who had been painting for a decade already—at last found his way as an artist.

Le Jockey perdu shows a jockey spurring his mount through a forest in which the tree trunks are wooden chair legs or table legs, turned on a lathe. Magritte was to speak of it in terms reminiscent of André Breton's in an essay, "Le Bouquet sans fleurs," which he published in the second number of *La Révolution surréaliste.* Here we read that surrealism calls for "isolating that mental substance common to all men, that substance up to now defiled by reason." René Magritte would describe *Le Jockey perdu* as "conceived without aesthetic preoccupation, with the sole aim of responding to a mysterious feeling, to an anguish 'without reason,' a sort of 'call to order,' which appears at non-historical moments of my consciousness and which, since my birth, gives my life direction."[5] In other words, *Le Jockey perdu* established some of the constants of his mature work. It gave warning that aesthetic preoccupations would carry no weight with him. Mystery would be the primary motivating force of his painting, where the call to order would be issued in defiance of reason and with no obligation upon the artist to effect reconciliation with rational demands.

A remarkable feature of Magritte's career was the unswerving respect it displayed, right up to the very end of his life (he died in 1967), for precepts he had laid down during the mid-twenties. Of these, one above all seemed destined to confine him to a marginal position, denying him recognition among the leading artists of his day. Interviewed by Pierre Mazars for *Le Figaro littéraire* (November 19–25, 1964), he was still defending the same attitudes: "It isn't the manner of painting that gives beauty, but the subject itself." And the consequences were still the same, for him: "I prefer people to think of what the image represents rather than of the hand's dexterity." In private correspondence the same idea recurs: "It is what one says that counts above all, the way one says it is important only if it is suited to saying exactly what must be said."[6] Here was the dictum that laid a solid foundation for the most profoundly revolutionary aspect of Magritte's work, making redefinition of the term "painting" necessary before it could apply to his creative activity as an artist. Hence this characteristic observation in one of his letters to Mirabelle Dors and Maurice Rapin, written March 15, 1956: "Still, it's a fact that despite the conventional appearance of my paintings, they look like paintings without, I believe, fulfilling the requirements defined in the treatises of aesthetics."[7]

In November 1927, René Magritte wrote from France to his close

friend Paul Nougé of "an altogether startling discovery." Up until that time he had experimented with combinations of objects, after a manner already fairly common among early surrealist painters. Alternatively, he had counted on the position in which he showed an object to make it look mysterious. But now he detected an entirely new possibility in things, "that of *gradually* becoming something else—an object *melts* into an object other than itself." He was becoming attracted to something different from surprising juxtaposition, to which other surrealists had been alerted by the technique of collage. "For instance," he noted, "at certain spots the sky allows wood to appear. This is something completely different from a compound object, since there is no break between the two materials, no boundary." Elimination of boundaries meant that no domain need be marked off clearly from an adjoining one. Hence, Magritte explained, "I get pictures in which the eye 'must think' in a way entirely different from usual."

His discovery helped Magritte cross the border separating the everyday world from one he was to spend four decades exploring. He was not to look always in the same direction, however. Nor would he make similar finds, time after time. Nevertheless, he would search invariably in ways that challenge the spectator's eye to "think" while looking at the pictures he brought back as trophies after his expeditions into a region only he had penetrated. René Magritte defined surrealism in a November 30, 1938 lecture at the Musée Royale des Beaux-Arts, Antwerp, as providing mankind with "a methodology and a mental orientation appropriate to the pursuit of investigations in areas that have been ignored or underrated but that, none the less, directly concern man."

In the years following 1927, the clarification that had come to Magritte encouraged him to paint pictures described in his own words as "the result of a systematic search for an overwhelming and poetic effort borrowed from reality, which would give the real world from which those objects had been borrowed an overwhelming poetic meaning by a natural process of exchange." Although he was not to concern himself exclusively with objects that could be shown melting into one another, he would remain devoted to reaching the goal of promoting a natural exchange in which, for him, poetic awareness resides.

The second version of a painting called *La Condition humaine* (*The Human Condition*), executed in 1935, shows an easel. On it stands a canvas in which is depicted the continuation of the scene visible outside an adjacent window. Apropos of the cannon ball that surprisingly lies in the

left foregound, James Thrall Soby remarks in his *René Magritte* that it is "perhaps intended as a reminder of warfare's simpler glories in the past" (p. 14). This kind of interpretation of Magrittian iconography, although well intentioned, leads to nothing fruitful for surrealist spectators. In fact, it actually works against their enjoyment of the picture.

Magritte was not averse to talking of some recurrent motifs in his painting—the small harness bells, for instance. Yet he never discussed in detail *why* they reappear. Soby ought to have appreciated this, after receiving a letter dated June 4, 1965, in which the artist declared that "an inspired thought combines what is offered to it *in an order evocative of mystery*" (p. 18). What matters above all is the mystery with which we are brought face to face by the ordering of familiar objects in Magrittian painting.

René Magritte's work is, in Breton's word, exemplary not because it sets an example everyone should follow, while determined to be a surrealist painter. Instead, it furnishes a succession of object lessons, brought before us in picture after picture. Magritte was fascinated by ideas, not theories, and those ideas came to him as visualizations which he subsequently undertook to transfer to canvas, so that the mental picture would become, finally, a painted image. Once completed, pictures were often left on show in his home until a title had suggested itself, either to Magritte himself or to one of the intimate friends (Nougé principally) whom he permitted to see work in progress.

In his paintings, Magritte seems to have dwelt most frequently on objects present in the everyday world. Review of a lifetime of activity indicates that those on which he chose to concentrate belong to a fairly limited range of familiar things. He never appears to have been stimulated imaginatively by the unusual or the intrinsically strange. At the same time, when declaring "I mean to evoke the 'object,'" he admitted to applying the term "object" in a way so general as to almost divest it of meaning.

The art of painting, to Magritte, had nothing to do with aspiring to capture the exotic or the exceptional. We can trace his line of thought and its consequences if we accept guidance from Nougé, who on one occasion remarked that, for an object to exist, it is not enough for it to be seen: "It is necessary to show it to us, that is to say, by some artifice, to excite in the spectator the desire, the need to see it."[8] If, according to Nougé's reasoning, "the object's power of fascination and its virtue of provocation are unforeseeable,"[9] this is because, as Magritte insisted, subject and object are inseparable. And so the identifiable nature of commonplace things counts for less, in Magrittian painting, than the ability possessed by the artist to make us respond to them with increased sensitivity: "And the mysterious wind

rises," observes Nougé, "*l'expérience* [both *experience*, here, and *experiment*] is going to begin."[10] In this manner Nougé returns to the theme which dominates his comments on Magritte: "It is appropriate to add that Magritte is not a painter in the sense understood by aesthetes, but a man who uses painting to conduct astonishing experiments in which all the forms of our lives are involved."[11]

It was typical of René Magritte that he favored elements taken directly from external reality. For the most part, they are shown in his canvases without distortion, or at least with enough accuracy to remain disturbingly recognizable for what they are. In *Le Modèle rouge*, for instance, we see a pair of men's boots ending in human toes. Both foot and footgear are easily identifiable. This is why the picture is able to "utter a warning cry," as Paul Nougé argued in the preface to an exhibition of Magritte's work held in London in April 1938. Meanwhile, Magritte himself confided, "I consider valid the linguistic attempt to say that my pictures were conceived as material signs of freedom of thought."[12]

In a letter written in 1957, Magritte explained "One day I thought of the possibility of painting the picture presently known as *Georgette*; this possibility *resembled nothing* hitherto known in the world, and was unconnected with any kind of conventional meaning. The possibility resisted and *still* resists explication."[13] *Georgette* is a picture in which, around an oval portrait of the artist's wife, six objects are arranged symmetrically against a sky with scattered clouds: a bird, a leafy branch, a key, a candle in a candlestick, a piece of paper inscribed with the French word *vague* (hence interpretable as *wave* or *vague*), and a human hand. To cries of incomprehension, provoked by this and other paintings, Magritte always had the same response: "Questions such as 'What does this picture mean, what does it represent?' are possible only if one is incapable of *seeing* a picture in all its truth, only if one automatically understands that a very precise image does not show precisely what it is. It is like believing that the implied meaning (if there is one?) is worth more than the overt meaning. There is no implied meaning in my paintings, despite the confusion that attributes symbolic meaning to my painting."[14] The year before his death, Magritte wrote to André Bosmans on March 4, 1966, "What you tell me about the unexpected descriptions of my paintings indicates a state of mind quite alien to what I believe to be correct. The errors are due to many people's inability to see *with the mind* what their eyes are looking at. Their eyes look and their minds don't see; they substitute 'ideas' they find 'interesting' for what they are looking at."

When Magritte spoke publicly, it was to reaffirm his point of view.

During an interview granted Pierre Descargues for the *Tribune de Lausanne* (January 15, 1967) he stressed:

> We won't speak of themes, if you don't mind. These are not themes. They are images that come together, that impose themselves upon me. Always images of the simplest objects, those anyone can see around him; a hat, a bell, an apple, an easel, a bird, a street lamp, a brick wall, shoes, a three-piece suit. Except that sometimes the hat is resting on the apple, the bird is made of stone, the shoes are feet with real toes, the brick wall takes the form of a desk, and the three-piece suit is really a pleasant valley. Those ideas for combining images occur to me without my looking for them.

There is nothing equivocal about Magritte's closing phrase. It relates to a statement he made when interviewed by Christian Bussy in August 1966: "I am unaware of the real reason why I paint, just as I am unaware of the reason for living and dying." He recognized only too well the necessity for making such a declaration. As he remarked to one of his correspondents, "Experimentation ended in 1926, and gave way to the art of painting to which I have remained faithful. The term 'composition' supposes a possible 'decomposition,' for example, in the form of analysis. To the extent that my pictures have any value, they do not lend themselves to analysis."[15] Asked by Pierre Mazars if his pictures can be taken for symbols, Magritte replied, "I really hope to divest the things I show of all symbol. For example, take that canvas, entitled *La Grande Guerre* (*The Great War*), in which one sees a character in a bowler hat whose face is hidden by a large apple. There's no need to tell you I didn't think of war when painting it." The tension—war—which suggested the title comes from our need to see what we cannot see: the face behind the apple, for instance.

After visiting an exhibition opening at the Musée d'Art moderne in Brussels on April 25, 1964, Magritte wrote to the show's organizer to point out "one mistake": "There is a notice, in one vitrine, describing the objects represented in my pictures as 'symbols.' I'd appreciate your correcting this. . . . My concept of painting . . . tends to restore to the objects their value as objects (which never fails to shock those who cannot look at a painting without automatically wondering what may be symbolic, allegorical, etc., about it)."[16] To the protest that symbolism may be involuntary, but no less present, Magritte has his answer ready: "Psychoanalysis permits interpretation only of what is open to interpretation," that is, he added, "fantastic and symbolic art." His own art, he insisted, rebels against psychoanalysis.

"No sensible person," he claimed, "believes that psychoanalysis could shed light on the mystery of the world."[17]

"How can anyone enjoy interpreting symbols?" Magritte asked Chavée on September 30, 1960. "They are 'substitutes' that are only useful to the mind incapable of knowing the things themselves." In any case, he stressed for the benefit of Mr. and Mrs. Barnet Hodes, "There is thus no conventional symbolic meaning that can justify the gathering of objects such as are described [sic] in Georgette."

René Magritte never tired of reaffirming that he did not utilize pictorial symbols. He addressed himself from choice to the familiar world of commonplace objects, because he believed that the mystery preoccupying him resides in the universe from which those objects came. "There is no explicable mystery in my painting," he wrote to Maurice Rapin in June 1957. "The word Vague on the picture manifests inexplicable mystery." As he saw it, painting was an instrument for putting himself and his audience in contact with mystery. This is why he protested use of words like unreal and imaginary as inapplicable to a discussion of his own work. Since he regarded mystery as indefinable, he concentrated on bringing the spectator to the point where he or she might feel its presence behind tangible reality. Hence Magritte's approval of "the invisible," which he viewed as "the removal of the habitual meaning of things that are visible in the picture, by means of which our mystery comes to dominate us completely."[18]

A statement published in the twelfth number of the magazine Rhétorique in August 1964 reaffirms that Magritte considered the visible aspects of our world "rich enough to constitute a poetic language evocative of mystery." In similar vein, his answer to an inquiry into Belgian artists' attitudes toward art and life, conducted in La Gauche on October 26, 1957, emphasized, "My conception of the art of painting consists, first and foremost, of an attempt to paint pictures like apparitions, yet in which we recognize people, objects, trees, rocks, skies." These pictures are intended to reveal "the mystery of the present." It follows that, as Magritte explained in Luc de Heusch's film Magritte ou la leçon des choses (Magritte or The Lesson of Things), "the evocation of mystery consists of images of familiar objects joined or transformed in such a way as to destroy their harmony with our naive or sophisticated notions." In other words, the art of mystery as Magritte understood and sought to practice it lies in stripping familiar objects of their innocence. Here is his reason for suggesting that "wooden

table legs turned on a lathe lose the innocent existence attributed to them when they appear dominating a forest."[19]

René Magritte built his pictorial investigation on the conviction that the innocence of everyday objects is imposed by their functional role in our lives. Therefore he argued for their autonomy as phenomena of mystery. He sought to show that, released from servitude to practical utility, common-place objects can invoke the mystery of our world: "For me, surrealism is painting, it is description of a thought that evokes mystery. . . . The way I bring objects together evokes surrealist mystery."[20]

Paul Nougé once remarked in a letter that we are all standing with our backs to the wall, adding, "But you, my dear Magritte, you've constructed an infernal machine. You've left out nothing for blowing up the wall. That's as far as your role goes." Nougé had perceived clearly that, if in the end the wall explodes thanks to Magritte's efforts, "Whatever is behind it you'll discover with us, you'll experience surprise, unknown terror."[21] Indeed, Magritte looked for intimations, not explanations. In this he agreed fully with Nougé, who appreciated that the best we can expect is that, once laid flat, the wall will reveal *"farther on"* other walls, demanding new mecha-nisms for their destruction, so that we may "push the limits of the possible back ceaselessly."

As outlined so far, René Magritte's enterprise appears to have been a dangerous one, from which there could be no guarantee of his escaping unharmed. Nougé appreciated this well enough. Referring to "the common herd," he noted, "Thus what is for us only a means of grappling with mystery is mystery for them" (p. 219). This, essentially, was the predica-ment into which, after 1925, Magritte was thrown by his ambitions as a painter, one from which he was never able to extricate himself when his work came before the public: the latter were mystified by his attempt to "grapple with mystery."

As late as 1954 Carlo Ludovico Ragghianti dismissed René Magritte's work as "brothel painting, picture postcard, vulgar illusionism that serves to give visible appearance to the cogitations and mediocre fancies of an er-ratic and Philistine mind."[22] Ragghianti directed his attack against Magritte's painterly method, obviously. Coincidentally, though, he criticized the sub-ject matter of Magrittian art, He remained impervious to Magritte's empha-sis upon the need to establish contact between consciousness and the other world. He could not comprehend on what terms that contact was to be made.

A central ambition remaining unfathomable to Ragghianti and to many another led René Magritte to situate objects where we never encounter them in the world we know, to transform familiar things, and to incorporate words into several pictures as elements of mystery. Whichever direction he chose to explore, the point of reference for a given painting remained some known object and the preconceptions everyone entertains on the basis of familiarity. The strangeness of this or that Magritte picture emerges from the marked discrepancy between what the artist's allusion to everyday situations permits us to anticipate and what he actually does with objects borrowed from reality. These are now set at liberty to pursue an independent course of action for which daily life has not prepared the spectator. The sight of a circus strongman using dumbbells presents no real novelty. But when, as it does in Le Mouvement perpétuel (1934), the strongman's face appears on the ball at one end of the weight he is lifting, coinciding with the position of his head, we have no choice but to envisage his head rising from his shoulders the moment he extends his arm. One could not ask for more convincing evidence to support Nougé's judgment in "Les Images défendues" about Magritte's images ("defended" [défendues] precisely because they are "forbidden" [défendues]): "If Magritte paints an action in process of accomplishment, he will never fail to render its mental development impossible by a few almost always identifiable procedures, of which the principal ones come from the strangeness he confers upon that action, its particular absurdity" (p. 252).

Magritte's version of perpetual motion is enough on its own to suggest the potential danger of his working method and, more especially, of the description he himself gave of it. We understand the latter only if we grasp that, when he spoke of what his images represent, he was not referring his audience to the mundane world from which his objects had been borrowed. It is not by looking back to familiarity that we truly respond to Magrittian images, but by accepting their invitation to see a new order emerging from "bizarre unions," as Magritte called them, effected under provocation from a force he called inspiration.

René Magritte once confided to Pierre Mazars, "All at once, an image rises up in me. My role consists in describing it, without fancifulness, on my canvas." The value of this comment and others of a similar nature is that they suggest how Magritte's creative imagination operated and, even more important, how he expected his audience to react to its workings. Still, this observation does not dispose of the questions raised by Magritte's statements on his own work but unanswered in what he tells us. It has the effect, indeed, of bringing us face to face with one perplexing feature of his public and private explanations, having to do with the nature of inspiration, as evidenced in his painting.

Dealing with the concept of inspiration of which Magritte frequently spoke requires attention to the preparatory stages through which he progressed toward the image finally communicated in paint.

Magritte's open contempt for symbolic art and his repeated assurances that he did not paint in order to convey meanings prepare us to see him content neither to know nor even to want to know why, in *La Durée poignardée* (*Stabbed Duration*), he had painted a locomotive emerging from the back wall of a fireplace beneath a mantelpiece. As so often it was with him, conscious intent was limited to his original decision: to paint an object common enough in our experience: a locomotive. The *problem* (and this is the very word Magritte used, over and over again) was how to render that familiar object so as to make it evocative of "the mystery to which we are forbidden to give a meaning, lest we utter naive or scientific absurdities; mystery *that has no meaning* but must not be confused with the 'non-sense' that madmen who are trying to be funny find so gratifying."[23] A picture of a locomotive is immediately recognizable. Therefore, to bring out its mystery, René Magritte added another immediately familiar picture, that of a dining-room fireplace.

When facing problems like the one raised by painting a locomotive, Magritte denied the admissibility of habitual solutions. Invariably, his starting point was the conviction that only a solution pointing to mystery rather than to pedestrian experience was worth formulating in the guise of a painted image: commonplace objects needed to be treated as questions. Finding answers meant tracking down other objects "secretly attached" to them by links complex enough to "serve to verify the answer." If the answer then imposed itself as "evident," the coming together of the two objects was "satisfactory."[24]

There is ample room for confusion, now. How is the satisfactory quality of the *réunion* mentioned by René Magritte to be measured? On what basis? By whom? To someone who would contend that we are unable to answer any of these questions without benefit of psychoanalysis Magritte would reply with a categorical negative. Yet rejecting psychoanalysis as an answer scarcely illuminates the nature of the question at the core of a Magritte painting. For assistance at this point we may turn to Nougé's "Les Images défendues," which affirms that the object is to be "thought of not as the more or less felicitous subject of painting but as concrete reality" (p. 257).

In surrealism, Magritte's pictures are distinctive, in that they follow through on ideas antedating the physical act of setting paint to canvas. Magritte was certainly not an artist who found inspiration in the creative

process itself. His attention having been held by the problem of rendering objects in a mysterious way, inspiration took, with him, the form of a discovery having the effect of releasing them from their routine role and shedding light on their potential for mystery. In his lecture, "La Ligne de vie," delivered on November 20, 1938, Magritte cited this example of his working method: "The problem of shoes demonstrates how the most frightening things can, through inattention, become completely innocuous. Thanks to Le Modèle rouge, we realize that the union of a human foot and a shoe is actually a monstrous custom."

Magritte saw inspiration as the revelation of an answer to a given problem. Inspiration arranged elements furnished by the everyday world in a novel order. Thus, in his letter about La Durée poignardée, he reported that he had come "in a moment of 'presence of mind'" upon the idea of putting a picture of a locomotive with that of a dining-room fireplace. And he went on to explain, "By that I mean the moment of lucidity that no method can bring forth. . . . When I say 'I thought of joining, etc.,...' exactitude demands that I say 'presence of mind exerted itself and showed me how the image of the locomotive should be shown so that this presence of mind would be apparent.'"

Things incorporated into a Magrittian image have been borrowed from the world about us. But the way they are rendered, the relationship established between them, confers upon them an intermediary position between familiarity and mystery. This accounts for the famous inscription on a painting of a smoker's pipe, asserting that it is not a pipe at all. It explains, also, Magritte's frequent return to the idea that inspiration is "knowing what must be painted"—thanks to "presence of mind," we must suppose. René Magritte sought to surprise and enchant under impulse from his belief that the painted image possesses the power to elicit wonder and produce enchantment and, of course, under impetus from his conviction that herein lies poetry. Writing on "La Leçon des choses" in Rhétorique in October 1962, he declared, "An unknown image of the dark is called forth by a known image of the light."

The error commonly made by many when looking at Magritte's pictorial imagery is to assume that the representation of one object or another appears on the canvas to remind spectators of the world of familiar reality. Instead, it refers forward, to a mystery that neither the painting itself nor the title assigned to it is intended to elucidate, to explain away. So titles also have a vital role to play in releasing surprise and enchantment. In "La Ligne de vie" Magritte stressed that titles must discourage reassurance and must be "an additional protection discouraging any attempt to reduce poetry to a pointless game." In other words, the choice of titles for Magritte's

pictures had to be consistent with his visual imagery, as described by Nougé when he wrote in "Les Images défendues": "Far from benignly opening up familiar perspectives to the mind, the image bars its pathway to tranquillity" (p. 231). It must instill in the audience the realization that, in René Magritte's opinion, the image is separate from what it shows.

According to Nougé, choosing a title for a Magritte has no more to do with furnishing an interpretive commentary on the completed picture than the picture has to do with illustrating a preselected title. The more we listen to Nougé, and to Magritte himself, the clearer one fact becomes. Emphasis upon analogous illumination, in which the title reinforces the enigmatic image instead of attempting to interpret it commonsensically, manifests the artist's determination to oppose reduction of the poetic charge carried by his painting.

Two factors are especially important. The first is this: René Magritte considered no picture complete until it had been given a title. The second is the nature of the titles he elected to use. "The title is not an explana-tion," he declared in the course of his remarks in the film *Magritte ou la leçon des choses.* "Image and word have the same poetic value." In short, the title is as unforeseeable as the image captured in paint: "'According to my doctrine,' it is forbidden (under pain of imbecility) to foresee anything. What I will do in *all* situations is as unpredictable as the emergence of a real poetic image."[25] The inference is clear: to Magritte the poetic remains forever related to the unpredictable. Thus, when he addressed himself to certain "questions," posed certain "problems," he could never anticipate solutions before "presence of mind" had brought about resolution, on the plane of poetry.

In the November 1967 issue of *Lectures pour tous* Pierre Cahane re-ports Magritte as having cited Victor Hugo's dictum, "We never see but one side of things," and as having commented, "It's precisely that 'other side' that I'm trying to express." Because René Magritte worked patiently at expressing the "other side," André Breton finally came to acknowledge, as the definitive edition (1965) of his *Le Surréalisme et la peinture* testifies, that surrealism "owes him its first—and last—dimensions."

Yves Tanguy

THE INITIAL REACTION of any viewer unprepared for his first glimpse of a Magritte canvas may be to wonder why the Belgian artist chose to paint, and with such meticulous attention to detail, this commonplace object or that combination of things presumably borrowed from everyday reality. Whatever variations are perceptible, however surprising the modifications introduced when Magritte copied them, the elements furnishing the subject matter of his art are of easily recognizable origin. True, broader and closer acquaintance brings to light the ironic surrealist function of identifiable features in Magritte's work. Nevertheless, at first contact one has the reassuring impression of being on ground visited before, disconcerting though it may be to find in which direction the painter seems to want to lead his public.

Looking at a picture by Yves Tanguy usually produces a very different response indeed. The nature of the uninitiated spectator's reaction, now, is such that asking why this surrealist artist has elected to paint what his canvases bring before us is not the first priority by any means. In fact, that question becomes something of a luxury, to be set aside and necessarily postponed until attention has gone to a more pressing consideration, having to do with the subject matter or rather the material of Tanguy's art. Deciding why a picture was painted is less imperative than establishing exactly *what* is communicated in one or another of Tanguy's pictures.

The production of no surrealist painter requires us to notice quite as insistently as Yves Tanguy's that the *"purely inner model"* from which surrealism encourages its artists to paint can be without traceable equivalent in the day-to-day world. None of its artists, surely, has done more to impress upon the public that surrealism requires examination on its own terms.

Thus omission of René Magritte from the original edition of *Le Surréalisme et la peinture* should surprise us no more than, immediately after Joan Miró, inclusion of Yves Tanguy.

Tanguy's universe—"that place he has discovered," Breton calls it in *Le Surréalisme et la peinture* (p. 43)—is one of unsurpassed strangeness, to be approached, Breton reckons, "only by the gleam of a siphonophore." Situating that place, Breton arrives at an oblique characterization of the world evoked by Yves Tanguy, "halfway between the ancient cities of Mexico, hidden behind impenetrable forests, and Ys" (the legendary town in Brittany, said to have been swallowed up in the sea during the fourth or fifth century and destined to emerge again, one day), to which *Le Surréalisme et la peinture* remarks admiringly that Tanguy has found the key.

It is noteworthy that André Breton's published comments on painting and painters leave, at times, the impression of being more or less fanciful, attractive no doubt as lyrical pronouncements, but scarcely enlightening to a layman whose concern is with facts. Poetic license may be construed as having released their author from feeling obligated to offer a really serious evaluation of one or another artist's accomplishment. More often than not, however, this first impression yields in the end to the realization that Breton was far from disposed to shirk his responsibilities as interpreter of works to which he attached value. For example, the phrase in which *Le Surréalisme et la peinture* refers to the gleam of a siphonophore is rationally indefensible and therefore seems critically inadmissible. All the same, it makes one vital point very clear indeed. No familiar source of light can illuminate Yves Tanguy's universe adequately. We have been led into a disconcerting world which, but for Tanguy, we should never have visited at all. Before we can embark on its exploration, we need illumination from something other—and something better, Breton hints—than the wan light by which we are accustomed to view the things around us.

The siphonophore's gleam is precious to André Breton. In contrast, it is nonexistent (or imperceptible, anyway) to those whose minds firmly repudiate his right to speak of it on the grounds that science, after all, informs us that the siphonophore neither emits nor reflects light. In other words, the manner in which *Le Surréalisme et la peinture* discusses Tanguy's work tests the reader's ability to respond—not simply to what Breton has to say but, more important, to the subject of his discussion.

It was not Breton's purpose to set up an obstacle between the public and fuller enjoyment of Tanguy's art. More significantly by far, the way he viewed Tanguy when composing the first version of *Le Surréalisme et la peinture* indicates with some emphasis the kind of difficulty that approach-

ing Tanguy's art must present anyone looking at it while encumbered with habitually commonplace assumptions and mental predispositions. The help provided by Breton in this direction makes it worthwhile to begin examining Tanguy's painting with the assistance of André Breton's earliest published comments on his work. For nothing induced Breton to adopt a more extreme position with respect to observable reality than the revelation he encountered in Tanguy's canvases. "There are no landscapes," one reads in *Le Surréalisme et la peinture.* "Not even an horizon. There is, on the physical side, nothing but our immense suspicion, surrounding everything" (p. 46). After Yves Tanguy had granted him his "first *non-legendary* glimpse over a considerable expanse of the mental world at the stage of Genesis," Breton had "closed the door on all concession," just as Tanguy himself had done.

The surrealist inspiration behind Tanguy's work is attested by a paragraph in *Le Surréalisme et la peinture.* Having cited Tanguy's name, Breton goes on at once to aver, "There is in what I like that which I like to recognize and that which I like not to recognize. It is, I think, to the conception of this most fervent of relationships that surrealism has risen, and held" (p. 44).

André Breton speaks of Tanguy's pictorial universe as equidistant from two points, the one exotically remote yet verifiable in the real world of present time, the other farther away, in the legendary past. It may seem peculiar to be so concerned with situating the place where Tanguy sets the scenes he depicts. And yet Breton has good reason to give priority to location. The protagonists of the drama enacted in Tanguy's pictorial universe are outlandishly strange. The figurative presences assembled in the picture resist identification and interpretation by reference to the familiar world. They do so stubbornly enough to make it seem very practical to look to the location of the action for a clue to whatever is going on. Rational deduction encourages the belief that the location can account, in some measure, for what is happening. Breton, though, appears to meet rationality's requirements only long enough to show—as his phrase hinging on the adjective *equidistant* proves—that he really has no desire to do so after all.

At moments, it seems that Yves Tanguy's world rises up from the floor of an immobile sea. At other moments, it stands before us in a desert of windswept sand or barren dust. Or rather, the sea floor and the desert simply furnish accessible but only very approximate analogies by which one can draw tenuous comparisons between that strange world and our own.

Tanguy's pictures are not to be described, their contents categorized, but experienced at a level of response making sustained comparison with the everyday world virtually superfluous.

The same can be said of the configurations we meet upon entry into Tanguy's graphic universe. It may be true, indeed, that, as a child, the artist was fascinated by dolmens and menhirs in the Finisterre countryside around his family's summer home at Locronan. But this does not obligate the public to view the forms inhabiting the world painted by Tanguy as borrowed from prehistory or as meant to situate his pictures quite precisely in time and space. If geographical and historical references do look relevant, they are valid and pertinent simply as rough parallels, not at all as explanations of what Tanguy has to show.

It is possible that the sight of prehistoric rock structures in Brittany impressed itself indelibly upon young Tanguy's memory. One can even accept the hypothesis that recollections from boyhood contributed to outlining some of the monolithic forms we encounter in his paintings. All the same, tracing iconographic sources is far less to the point, when we look at Tanguy's work, than noticing how features sometimes recalling a natural landscape, modified here and there by man, have been radically transformed. They have been absorbed into an "inscape"—André Masson's word is appropriate to defining Tanguy's pictorial representations. In brief, it is not by bringing to mind something we may have seen before that Yves Tanguy's painted configurations ultimately command attention. They stimulate the imagination because they are more than—and other than—recognizable evocations of the commonly known, or references to it. They bring the spectator into contact with the previously unknown. Hence, when we face a Tanguy picture, points of comparison in the world to which we are accustomed play their part just so long as they enable us to estimate how great a distance we must have traveled outside the familiar.

How do we relate to things we cannot interpret with confidence, cannot submit to the subjugation of appellation, and cannot hope to confine with the framework of utilitarianism? This question is of central importance, as we look at one of Tanguy's paintings. The wonder of Yves Tanguy's art, we discover, is that a viewer may recognize its imagery without ever having seen it before, may know it without prior introduction to anything resembling it.

Including a single line drawing, seven Tanguys were reproduced in *La Révolution surréaliste*, starting with the seventh issue of June 16, 1926. They

testify fairly accurately to an evolution toward maturity of style and content, once Tanguy had chosen to align himself with the surrealists, in 1925. Untitled on the printed page, the first painting suggests a few outside influences (from Max Ernst's early collages, in particular). However, the presence of an horizon dividing line—which brings to mind the horizon discernible in a number of Mirós from the same period—and especially intrusion of a large rocklike shape, suspended above the horizon, foreshadow features soon to become characteristic of Tanguy's work.

In the eighth issue of December 1, 1926, *Animaux perdus* (*Lost Animals*) once again shows division of the picture by what one may term, for convenience, a skyline, to which something like a wall, raised above the ground, appears to reach out. But the very large human figure, wearing a miter, and above all the introduction of identifiable animals are elements foreign to the universe where Yves Tanguy eventually will be at home. Not until *Second Message* (appearing like the line drawing in the double number of *La Révolution surréaliste* [9–10], October 1, 1927) do we encounter a painting that captures a stormy atmosphere typical of the mood of *L'Orage* [*The Storm*, 1926]). Here, animating the scene, an air of cosmic upheaval is heightened by the absence of human and animal life and by the multiplication of free-floating amorphous shapes apparently unaffected by gravity.

Similar forms appear in an untitled picture reproduced in the eleventh number on March 15, 1928. It is *Terre d'ombre* (*Shadow Country*), painted the previous year. This time the rocklike formations are rooted in a base, perhaps of sand, though whether above or below water one cannot say for sure. Both appearing in the twelfth and final issue of *La Révolution surréaliste*, *L'Inspiration* and *Tes Bougies bougent* (*Your Candles Move*) incorporate forms of the same kind. Again, some have managed to elude the pull of gravity. Meanwhile, those that remain anchored cast heavy shadows such as regularly emphasize the presence of ambiguous shapes in Yves Tanguy's mature painting.

By the time *La Révolution surréaliste* had ceased to appear at the end of 1929 Tanguy had discovered and begun to elaborate a mode of painting all his own. He never modified it throughout the years of a career that ended with his death in January 1955.

The early pictures Tanguy painted, after finding his vocation as a pictorial artist with his first sight of a de Chirico canvas in 1923, bear short titles that are no more than terse descriptive labels; for instance, *Rue de Santé* (1924), exemplary of de Chirico's influence, or *Le Bateau* (*The Boat* [1926]). With the change of direction soon to put him on the road he would follow as he matured, there came a definite shift in the nature and quality of his titles. From then on, they either sounded more fanciful, by

commonsense standards—such as *Terre d'ombre* and *L'Extinction des lumières inutiles* (*The Extinction of Useless Lights*)—or of a distinctly anecdotal character, as with *Il faisait ce qu'il voulait* (*He Used to Do What He Wanted*) and the famous *Maman, Papa est blessé!* (*Mamma, Papa is Wounded!*). All four of these paintings were executed in 1927. That was the year when Yves Tanguy's pictorial explorations took a direction entirely their own, to which 1926 canvases like *Genèse* (*Genesis*) and *L'Orage* had pointed the way. Looking over pictures finished during that period, we recognize that Tanguy's choice of titles for completed works was anything but fanciful or whimsical.

Taking into account the fact that the public relies heavily on the name of a picture to explain (and that means to justify or excuse) its contents, in 1927 Yves Tanguy called one of his paintings *Un Grand Tableau qui représente un paysage* (*A Big Picture Representing a Landscape*). This work, his title indicates, is not a landscape in the tradition of easel painting. We should be unwise to read too much into the artist's choice of words, of course, yet here emphasis falls on representation. Tanguy's big picture was not intended to evoke a scene for which nature had provided the model. Instead, it was (and still is) nothing more than the painter said it was: a picture looking like a landscape, and a very peculiar one at that.

Everything, naturally, revolves about the interpretation one places on the word *landscape*. Deep in Tanguy's picture begins a blue area nobody would object to calling sky. It fills the top third of the canvas and is separated by a line, that may be termed an horizon, from a plane surface resembling a seashore. From this surface rises a large block looking like a truncated asymmetrical pyramid. On top can be discerned three, possibly four, shapes (too indeterminate to be relegated with confidence to the animal kingdom), and just a little straggling vegetation. Other amorphous forms stand erect on the ground, one of them vaguely human, another quite like a cat (though even in these instances we wonder whether nostalgia for the familiar has not influenced our interpretation unduly). Dotted about are sketchy leafless bushes, or so it seems, all leaning at an angle suggesting that they feel a constant prevailing wind of irresistible force. A few vertical lines reach up into the sky, where a number of whitish forms, more like tiny whales than birds or flags, hang in the air.

As is usual in Tanguy's painting, the light source—less strong, on this occasion, than is often the case—lies somewhere to the left of the picture, outside frame, so to speak. It emphasizes the solidity of the unidentifiable forms assembled before us, without making them any easier to name. Even more important, we have no idea where the light originates—Breton calls it

both "the great subjective light" and "the Neptunian light of second-sight."
For this reason, we are at a loss to say where the scene before us is set
(whether perhaps this is, for example, a submerged landscape) and from
what point we are watching it. All in all, Tanguy's is a landscape where we
can find our bearings by referring to no place we have ever seen before.

Here indeed is the most remarkable effect of looking at Yves Tanguy's
work. It enables us to understand better what André Breton meant when
confessing, on the second page of *Le Surréalisme et la peinture*, that he found
it impossible to consider a picture as anything but a window, with which his
first concern was to know "what it *looks out upon.*" The exemplary character
of Tanguy's painting is highlighted in Breton's later statement likening his
pictorial investigation to "throwing oneself out of the window of one's own
eye" (p. 178). In his *Une Révolution du regard*, Alain Jouffroy has recalled
seeing Tanguy's *L'Armoire de Protée* in Breton's home:

> That picture in fact bowled me over at once; it was the sudden opening of a
> door on a world where everything is possible, and like awakening on the deck
> of a ship whose direction I shall never know: perhaps the assonance of
> Tanguy and *tanguer* ["to pitch"] had something to do with it. Learning that
> this painter had always been unaware of what his pictures "represented" I
> understood, ingenuously but fully, that painting could give *an image of the
> unknown.* Up to that moment I had believed poetry alone capable of explor-
> ing what remains inaccessible to man: Yves Tanguy convinced me on the
> contrary of the exploratory function of painting, and of the fundamental
> relationship that therefore links it with poetry. (p. 9)

Yves Tanguy was not prone to extensive commentary on his own
work. He never indulged in elaborate explanations of what his painting was
meant to communicate or even ended up communicating. Nor did he
provide information on the vision he wished to capture in paint. The most
he would do was let slip an occasional remark that illuminated his undertak-
ing in a manner revelatory of his total dedication to surrealism.

In order to minimize the risk of repetition, to resist what Breton called
"self-kleptomania" in the creative artist, but without all the same fettering
his genius, Yves Tanguy would paint a canvas set on the easel one way up,
and then would turn it the other way up. The completed scene, thus
revealed, would be as much a discovery and source of surprise to him as to
his audience. Furthermore, he admitted to being interested in letting graphic
motifs suggest one another in succession, spontaneously. His reason? "I

found that if I planned a picture beforehand, it never surprised me, and surprises are my pleasure in painting."[1]

The common links between Tanguy's canvases are soon enumerated. One does not take long to be able to identify a painting of his as resembling work by no other artist, in the surrealist circle or outside it, for that matter. As soon as he had found the key to which André Breton would refer one day, Yves Tanguy gave himself wholeheartedly over to the task that kept him occupied for the rest of his life. He was to employ a limited vocabulary and syntax, as it turned out. Even so, he would use them without monotony and with remarkable subtlety of variation.

In a sense, Yves Tanguy stands at the opposite extreme from René Magritte, in refusing to imitate recognizable shapes. Yet his work shares with Magritte's the capacity to communicate the tangible physical presence of the objects—to call them that—it brings to our notice. There is evidence that both artists experienced a sensuous pleasure when rendering the palpable. If anything, it is greater in Tanguy than it is in Magritte. We meet, also, the same aloofness, investing the object pictorially represented with a quality that leaves us feeling our touch is rejected. And in the case of Tanguy, this is just as true whether the painted object is amorphous (as so many things are, in his universe) or painted with hard-edged concreteness.

Tanguy's is not a discontinuous universe, upsetting to those who see it because it fragments the everyday world they know. On the contrary, as his originality as a pictorial artist affirmed itself, it became noticeable that the surprise generated by his pictorial imagery owes much to the cohesiveness of paintings born of unplanned investigation of the potential of form. Comparison with landscapes in nature became more difficult to establish, not less so, as the years went by. Meanwhile, Yves Tanguy's pictures gained in self-sufficiency and internal unity as they departed more and more boldly from the model provided by external reality. Without leaving the impression that compositional unity was a priority in their execution, they display an inner balance none the less. This fact accentuates their mystery rather than diminishing it. Moreover, it helps make the pictorial image impenetrable to reason, when the rational mind has been halted by titles like *Un Risque dans chaque main* (*A Risk in Each Hand* [1934]) or *Le Questionnant* (*The Questioning One* [1937]). Which of the forms visible in *L'Orpailleuse* (1945) represents the apparatus for washing gold? Their grouping in a tight cluster suggests that perhaps they all are necessary to carrying the operation through.

In 1939 Yves Tanguy painted *Le Temps meublé* (*Furnished Time*), its title no less enigmatic than the shapes disposed on a neutral surface reced-

ing to the skyline. These forms stand out as usual against a "landscape" that never assimilates them in a way satisfying to reason. Such is the artist's inventiveness that they look like—yet differ appreciably from—those identified in a 1941 picture called *Les Cinq Etrangers* (*The Five Strangers*) or in *Le Palais aux rochers de fenêtres* (*The Palace With Rocks of Windows* [1942]). In *Le Témoin* (*The Witness* [1940]) we are left asking who is witnessing what: not one of the forms we see arranged roughly in a triangle appears to fill the role of witness better than the others.

In spite of the way they are named on occasion (e.g., *Les Saltimbanques—The Tumblers* [1954]), the figures assembled in a Tanguy painting are decidedly nonhuman. Use of titles like *La Peur* (*Fear* [1949]) holds out the promise of narrative event and stresses the peculiar quality of Yves Tanguy's work. *Maman, Papa est blessé!* impresses that quality upon us by suggesting the presence of three people at least, yet showing none at all. Human figures have given way once and for all to shapes one cannot trace to the natural world familiar to us. These now serve as protagonists in dramatic incidents in which they are immobilized—not only by the fact that a painted picture brings any represented scene to a standstill, but also because the figures we see look as though they have never moved. They are apparently fixed forever in a situation of the artist's imagining. Even when titles prompt anticipation of human drama, anthropomorphism is so rigorously excluded that Tanguy's pictures are remote enough from everyday life to appear, in some spectators' eyes, thoroughly antihuman, chillingly distant from the world we take for granted. Yves Tanguy's painting betrays no indication that its creator feels an impulse to transpose human activity to a new plane. No clue can be detected, suggesting that the artist aimed at creating a world of unprecedented shapes in order to comment on the world of men.

The titles Tanguy gave his paintings do not even hint at rational elucidation for his pictorial imagery. They neither solve the puzzle of his art nor offer plausible excuses for its strangeness. They furnish no convincing evidence that he wished to meet bemused members of his audience halfway or to plead for tolerance of the painted image, should it fail to find immediate acceptance among them. One can hardly call *Ma Vie blanche et noire* (*My Black and White Life* [1944]) an essay in autobiography, any more than one could characterize *Quand on me fusillera* (*When They Shoot Me* [1927]) as premonitory or morbidly fanciful. Nothing in either of these pictures lends substance to the idea that one or the other of them proves Yves Tanguy to be a confessional artist who made his life, hopes, and fears the material of his creative work. The title of a Tanguy picture records its

author's reaction to what the painting shows. It serves neither as an expla-
nation nor again as an apology for what the spectator sees. And so the
name of a given canvas is no more than an interpretation of a pictorial
enigma—one of perhaps several keys with which we may try to unlock its
mystery. Unless we remember this, we end up chasing after shadows.

Unlike Magritte, Tanguy had no consistent viewpoint, to be illus-
trated in picture after picture. The last thing one is to expect of him is a
philosophy, accounting in a coherent way for titles like *L'Humeur des temps*
(*The Mood of the Times* [1928]), *L'Extinction des espèces* (*The Extinction of
the Species* [1938]), *Divisibilité indéfinie* (*Indefinite Divisibility* [1942]) or *Le
Malheur adoucit les pierres* (*Suffering Softens Stones* [1948]). All we can say
with some measure of confidence is that this was a painter who, to cite one
of his 1933 titles, worked with "the certainty of the never seen."

Yves Tanguy stands alone because his work explores a world no one
has seen before. So magical is the universe depicted in his painting that no
viewer is likely to be indifferent to what it shows. Some people may feel
excluded or even repelled by what they see here. They are, in fact, simply
farther along the road away from appreciation, taken by those whom Breton
ridiculed for claiming to distinguish in a Tanguy canvas some sort of animal
here, something like a shrub or a puff of smoke there: in other words, the
people castigated in *Le Surréalisme et la peinture* for "placing all their hopes
in what they call *reality*" (p. 46). In individuals who respond positively,
contemplation liberates fascination. They fall under the hypnotic attraction
released by a compelling tension, introduced into the painted image by the
inexplicable balance of unidentifiable forms that obviously relate to one
another, even though they are not of this world.

All in all, to persons who misunderstand surrealism, Yves Tanguy's
work may appear representative of the inaccurate impression they have formed
of surrealist painting in general. He confronts them with sights too distant
from their experience to be anything but unacceptably strange. Responding
to the appeal of a Tanguy picture means sharing in the surrealist experi-
ence. And this is true even though, as Breton noted in his 1939 essay on
the most recent tendencies in surrealist painting (reprinted in *Le Surréalisme
et la peinture*), the uninterpreted elements in Tanguy's work are "the words
of a language we do not yet understand, but which soon we will read, we
will speak, which we will realize is the best adapted to new exchanges" (p.
148).

With his flair for uncovering what is essential to surrealism in the
work of artists productively dedicated to furthering its ends, André Breton
headed a 1942 essay (also reproduced in *Le Surréalisme et la peinture*), "Ce
que Tanguy voile et révèle." A quite remarkable feature of Yves Tanguy's

art is, indeed, its ability to reveal by what it veils, to show by what it conceals. Blotting out the world as we know it, Tanguy substitutes another of his own invention. Here parallels with our own universe are merely accidental. In fact, most of them are made by the spectator, not by the artist at all. It would be wrong, in any event, to take them as proof of a deliberate effort by the painter to transpose the familiar in spectacular terms. The less evocative his painted forms look next to those with which we are commonly acquainted, the more minutely detailed they appear on the canvas.

The more carefully they are rendered, the more elusive those forms seem to be, to anyone trying to make up his or her mind what they are or what they are intended to be. The illumination brought by Yves Tanguy's painting releases awareness, in someone properly attuned to its poetry, that he or she can recognize the universe to which it transports us, even though memory protests that Tanguy's is a world never seen before. Enjoyment of his work marks the victory of imaginative liberation over recollection. Under the circumstances, it matters relatively little that, from Breton's standpoint, such enjoyment is no more than appreciation at its primary stage, and that Tanguy's "world of total latency" "with no equivalent in nature," has given rise, so far, to "no valid interpretation" (p. 178). One might go further and say that Tanguy's distinction as a surrealist painter can be assessed quite accurately in relation to our failure to propose an interpretation of his work anything better than tentative, and entirely subjective.

In 1946, while in exile in New York, André Breton published the only volume in which, going back over remarks previously in print, he brought together without revision comments about a single artist. His *Yves Tanguy* leaves us wondering why Tanguy should have received special attention such as Breton granted no other surrealist artist. The answer appears to be that André Breton wished to highlight the problem confronting any interpreter of Tanguy's work and to propose a way of handling it.

Breton began *Yves Tanguy* by forewarning his readers against expecting anything resembling art criticism, either in the form of art history or on the level of technical analysis. He stressed, further, the absence of didactic intent behind his own writings on Tanguy. Then he proceeded to indicate, with the greatest discretion, how he believed Tanguy's work ought to be approached. His collection of essays, he pointed out, provides no more than "a succession of echoes and flashes," elicited in the response of one individual to Tanguy's painting, at different moments in time: "Their deeper

unity comes from the fact that they mark out an uninterrupted quest for emotions through this work and, beyond those emotions themselves, tend to locate a series of *indices* likely to cast light, albeit from a flickering flame, on the route taken by man today."[2]

Nothing objectively demonstrable or verifiable comes out of Breton's encounter with Tanguy's painting or from our own, either. No incontrovertible discovery, shared by everyone, emerges from contact with what Tanguy brings to the spectator's attention. Nobody, therefore, can feel privileged to discourse authoritatively either about the content of Tanguy's painting or about what it is meant to reveal, or even—the artist's purpose, whatever it may be assumed to be, notwithstanding—about what it actually does mean. A Tanguy canvas is essentially provocative, not evocative. It fulfills its surrealist function when it stimulates our powers of imaginative response, not by persuading everybody to agree (however reluctantly, in some cases) that all of us should and therefore must share the same response. Thus a Tanguy does not capture a landscape or submarinescape to which every viewer can be required to advance by the same route or by one of several converging paths. More excitingly by far, Tanguy captures a dream vista. Looking at what the artist has placed on record demands that we bring the painted scene to life with our own private aspirations, hopes, and perhaps even fears.

Tanguy's great achievement as a surrealist lies in stirring up and bringing to the level of conscious awareness needs to which his pictorial imagery alerts his audience and makes them responsive. As needs vary from individual to individual, so spectator reaction exhibits fluctuations it would be ridiculous to seek to deny or to eradicate in the interest of uniformity or definitive evaluation. So far as Yves Tanguy assumes responsibility for what he has set down on canvas—without (as Jouffroy has noted) knowing for sure what his pictures represent—he does so by offering painted images as stimuli to the viewer's sensibility. As a consequence, they provide the latter with points of departure for imaginative speculation. The artist allows the latter to enjoy total freedom, with no pronouncement of his offered to furnish guidance toward interpretation. This means therefore that no statement by Tanguy directs or threatens to inhibit our response or make it conform in any way.

Some who look at Tanguy's work will be dismayed at an apparent discrepancy or inconsistency. On the one side, they notice the extreme care with which he applied paint, using delicately complementary colors to give tonality to his canvases and to impose internal unity on the figurative elements assembled. On the other side, they note his refusal to dictate the audience's response to the completed image, as though he were indifferent

to the effect it might produce. Beyond question, Yves Tanguy's activity as a painter was obsessive. Yet one cannot liken him to deranged artists who, creating compulsively, paint for themselves primarily, in some cases unaware of the very existence of the public. Abstaining from comment on his own work while introducing nothing into his pictorial universe to persuade us it has anything at all to do with our own world, Tanguy was simply fulfilling the role he accepted as a surrealist.

This self-taught painter investigated bizarre forms as they emerged under his brush. As he perceived it, his duty was to fix their suggestive configurations, not to attempt to domesticate them or bring them into line with the familiar, the commonly perceived and accepted. In consequence, his pictures manifest remarkable cohesiveness, completeness without fussiness or redundancy.

Of all the titles used by Yves Tanguy *L'Armoire de Protée* stands out thanks to the allusion it makes to a Greek mythological figure. As we look at *L'Armoire de Protée* what we know of Proteus certainly does not suggest an explanation for the picture, but it does assist us in characterizing Tanguy's painting as a whole.

Guardian of Poseidon's herd of seals, Proteus would emerge from the waves each day at noon, coming ashore to rest. Does the picture with which Tanguy associates Proteus' name capture the noon hour or the time when the seal herd moves about under the sea? Ambiguity of place, so common in Tanguy's paintings, leaves us undecided. As a result, we are unable to say with assurance whether one can expect to enjoy the propitious moment when, in his wisdom, Proteus reveals what fate has in store. We know this son of Oceanus and Tethys possesses the power to see into the future and speaks the truth. But we know too that he never speaks oracularly unless forced to do so. Thus one must grasp hold of him to induce him to share his revelations. The trouble is that Proteus has the ability to change shape at will. To escape from anyone trying to restrain him, he can turn himself into an animal, a phenomenon of nature, or even fire and water. Only with someone whom such metamorphosis leaves undaunted will he consent to speak.

In what form does Proteus appear, if at all, in Tanguy's painting? Where is his armoire? What does it contain? What does Proteus have to reveal to us, and how are we to lay hand on him long enough for revelation to come? While sure answers to the questions confronting us when we face *L'Armoire de Protée* prove to be elusive, we have to recognize that these

questions give value both to the picture and to our encounter with it. We know that any answers we find may seem acceptable only to ourselves, because each must discover them for himself alone. Yet this is why, if Tanguy is to be given his due, we cannot afford to ignore *L'Armoire de Protée*. The question raised by that picture and by Yves Tanguy's art in general takes us to the very core of the surrealist experience.

Salvador Dalí

O<small>F ALL THOSE EVER AFFILIATED WITH SURREALISM</small>—and not only its painters, by any means—Salvador Dalí is and seems likely to continue to be best known to the widest public. This makes him the surrealist personality least easy to ignore, the one who apparently is entitled to a central position, close to Breton, in discussions of the nature and scope of surrealism in France, especially as expressed through art. It must appear to many people that Dalí has won and deserves pride of place in surrealism. More than this, he is to be credited, they are willing to believe, with having produced the surrealist context virtually all by himself, thanks to the subject matter of some of his paintings and to the way he treats his material.

In many respects, however, Dalí is the surrealist artist about whom an informed commentator feels obligated to speak with greatest caution. Another surrealist, greatly influenced by Dalí's method, Conroy Maddox, opens his *Dalí* with a statement that more than a few of his readers must judge puzzlingly noncommittal: "Whatever the future judgment of Salvador Dalí may be, it cannot be denied that he has a place all his own in the history of modern art" (p. 7). What lies behind Maddox's supposed reluctance to link Dalí with surrealism as a matter of course? Surely it is the following. Many people, particularly in the United States, have been persuaded—to a considerable extent by Dalí's well-developed talent for self-publicity—to regard his work as epitomizing surrealism in art. Thus Dalí's inflated reputation distorts surrealism in the eyes of perhaps the majority of its audience.

Salvador Dalí's contribution to enriching surrealist painting and extending its range is incontestable. All the same, the surrealists have come to deplore—this is the very least one can say—that long after ceasing to draw inspiration from some of the same sources as they, Dalí continued, for

79

personal gain and in the cause of self-advertisement, to exploit the very techniques that had once held their admiration. In consequence, they have seen fit to give him the anagrammatic nickname invented by André Breton: Avida Dollars. They condemn Dalí as guilty of confusing even that sector of the general public genuinely eager to learn what surrealism aims to be and actually is.

In fairness, we have to bear in mind that, during the time when he consorted with the surrealists, Dalí never made any effort to deceive his companions about his personality or about the ambitions it bred in art. It is, then, a measure of the timeliness of a contribution he was supremely well equipped to make that, for a while, he himself, the ideas he propounded, and his painterly methods were accepted and approved by Breton no less than by his followers in Paris. In the history of surrealism, Salvador Dalí earned himself a place that is noteworthy, although by no means as prominent as many outside the surrealist movement have concluded. Examining his provocative ideas against the background of surrealist thinking, we learn not merely from their application in the medium of painting, but also from the enthusiasm they fired in the imagination of his fellow surrealists. The latter saw Dalí's program as remarkably stimulating. It came to their attention opportunely, at a moment when members of the surrealist circle in France were fully prepared to react with the kind of admiring encouragement that Dalí craved and in which his creative drive gathered energy.

Full discussion of the nature of the appeal exercised by Dalí when he was accepted into the French surrealist fold would necessitate detailed analysis of the persona he made his own and was so careful to bring to his associates' attention. The attraction of this individual whose conduct in France played original and fascinating variations on the figure of the nineteenth-century *dandy* was immediate and magnetic among the men and women who, to quote Breton's *Second Manifeste du surréalisme* (written on the eve of the centenary of 1830), might be fairly regarded as "the tail of romanticism," its "*so very prehensile* tail" (p. 184). Yet, being the projection of an innate, irresistible need for total personal freedom, that same persona eventually intruded between Dalí and the enclave to which, for a while, he was very happy to belong. An interesting feature of his case is that, although single-mindedly devoted to attaining uniformly private goals, Salvador Dalí commanded the surrealists' respect for as long as he did. When he arrived among the surrealists his eccentricities provoked no imitation but met with tolerance. One must assume that the benefits Dalí brought in the realm of creativity impressed surrealists in Paris as concrete and highly valuable. He managed somehow to be immune to an atmosphere in which several others were unable to survive, finally suffering exclusion.

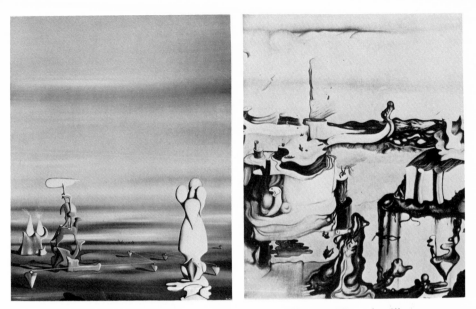

(Left) Yves Tanguy, title unknown, 1937. Private collection, Winnetka, Illinois
(Right) Yves Tanguy, *L'Armoire de Protée (The Armoire of Proteus)*, 1931. Private collection, Paris

Yves Tanguy, *L'Extinction des espèces (The Extinction of the Species)*, 1937. Private collection, Winnetka, Illinois

(Left) Salvador Dalí, *L'Angélus architectonique de Millet* (*The Architectonic Angelus of Millet*), 1933. Perls Galleries, New York

(Above) Salvador Dalí, *Les Lèvres de Mae West* (*The Lips of Mae West*), 1936. Collection J. H. and Jeanne Matthews

(Below) Salvador Dalí, *Cardinal, Cardinal!*, 1934. Munson-Williams-Proctor Institute, Utica, New York

Examination of Dalí's relations with surrealism brings to light an anomaly worth noting. The individual who has succeeded in reaching the broadest audience, among outsiders, is the one who has done most to hedge the public's understanding of surrealism within harmful preconceptions and confining suppositions. These, of course, do highlight some forms of surrealist investigation—specifically those that Dalí himself practiced, or spoke of practicing, anyway—but only at the expense of others in which he did not participate and, more to the point, for which he lacked mental and emotional prerequisites as a painter. It is hardly too much to claim that, for most people casually acquainted with the word, *surrealism* is Dalí, painter of, shall we say, limp watches—initiator, in other words, of one or two visual images above all, shocking enough on the surface but (so numerous observers are easily persuaded to conclude) readily and adequately explained in symbolic terms. The irony of the situation is that Salvador Dalí has fallen into a trap of his own making. He has paid a price for technical facility and for seeming to be a relatively accessible pictorial artist. These commonly prized virtues have promoted his popularity with the public while appearing to limit his aspirations, to the disadvantage of his art as well as to the disservice of surrealism.

Whereas an allusion to Dalí's astonishing facility may sound unexceptionable, speaking of accessibility with respect to his painting must strike the prudent as unduly optimistic. Even so, the word does call attention to one salient feature of Dalí's work. No twentieth-century painter of comparable stature has developed to a higher degree than he a style immediately recognizable as his alone. This fact invests Dalinian painting with its air of accessibility; we know with whom we are dealing and think we know also what to expect of him. Handling what is captured by Dalí's style is another matter, of course, and it is here that accessibility proves to be an illusion, bought at the cost of over-simplification.

As for the French surrealists' enthusiasm for Dalí's painting, between the years 1929 and 1938 at latest, it merits comment. Those years are bounded by the appearance of the second surrealist manifesto and publication of *Pour un art révolutionnaire indépendant*, written by Breton in collaboration with Leon Trotsky. The thirties were the period during which surrealists in Paris were determined to broaden their program of revolt to embrace sociopolitical protest more actively. Thus one of the important themes of the *Second Manifeste* was echoed in a change of title, when *La Révolution surréaliste* gave way to *Le Surréalisme au service de la Révolution* (1930–33). A remarkable thing about Dalí's reputation within the surrealist camp was its flowering at a time when his complete indifference to social and political issues (if anything, he had fascist leanings, which he liked to

flaunt in order to provoke his surrealist friends and, no doubt, so as to assert his individuality, in their company) ran counter to the dominant trend in surrealist thought.

Dalí's first surrealist picture, named Le Jeu lugubre (The Lugubrious Game) at Paul Eluard's suggestion, was an oil and collage on canvas, painted in 1929. It incorporated a number of startling features of striking originality. Even so, we are informed in the painter's autobiography The Secret Life of Salvador Dalí (1946), it made Breton hesitate a long time, thanks to one flagrant scatological motif: a male figure in the right foreground with excrement on his shorts and on the back of one thigh.

In Dalí's opinion, the surrealist leader need not have been alarmed: "The involuntary aspect of this element, so characteristic in psychopathological iconography, should have sufficed to enlighten him." And, in any case, Dalí remarked imperturbably, there was no cause for deep concern, given the fact that "I, then, and only I was the true Surrealist painter, at least according to the definition which its chief, André Breton, gave of Surrealism." Thus, "Between the excrement and a piece of rock crystal, by the very fact that they both sprang from the common basis of the unconscious, there would and should be no difference in category." These comments tell us something of the uneasiness Dalí's work as a painter was capable of stirring up in the surrealists. Like the rest of The Secret Life, they bear witness also to the complete self-assurance Dalí felt and to his conviction—rare indeed among the surrealists—that his special gifts (about which he never had an instant's doubt) should and must guarantee him an unrivaled and unchallenged position at the head of surrealism's pictorial artists.

Although committed to scandal as a necessary and vital means of defeating stultifying traditions in art and of stimulating the public to a new, fruitful awareness, the surrealists could never be quite convinced they were not harboring, in Salvador Dalí, someone dedicated to scandal for scandal's sake, or even a fraud. Perhaps indeed scatology really was, as he affirmed, a terrorizing element. But it was still scatology, was it not? And there remained a few prejudices, social and even moral ones, that some surrealists were unable to surmount—Breton's against homosexuality, for example. Perhaps, too, Dalí's decided aversion to grasshoppers—he firmly called it a phobia—was another element of the same order. But surrealists were not at all sure that this entitled him to affix the title Le Grand Masturbateur to a 1929 painting of a large livid head (the mouth replaced by an enormous

grasshopper, its decomposed belly full of ants) from which, at the nape of the neck, grew a woman's head, in suggestive proximity to genitalia of indeterminate sex.

Dalí both fascinated the surrealists in Paris and perplexed them. In some way, his conduct and art looked to be true projections of their ideas, appearing to exemplify the precepts surrealism was dedicated to defending. Yet the man and his work inspired some misgivings. This was an artist who boasted that the only difference between himself and a madman was that he, Dalí, was not mad. Disturbingly, he seemed not only unable to avoid the taint of exhibitionism but actually to revel in being an exhibitionist. More than this, it seemed as though, had he felt the need for excuses, he might have found justification for his eccentric behavior in surrealist doctrine. As a consequence André Breton would have no option but to acknowledge in his *Entretiens* that, "for two or three years," Salvador Dalí "embodied" the surrealist spirit (p. 159). So far as painting goes,

> Whatever reservations we shall be led to make later regarding his academic technique which he justifies by saying he assigned himself the task of "trompe-l'œil photography of dream images," it is undeniable that the poetic, visionary content of these canvases [three early pictures, *Le Jeu lugubre*, *Les Accommodements du désir*, and *Les Plaisirs illuminés*] is of exceptional density and explosive force. Nothing, in any case, has taken on such a character of *revelation* since the 22–24 works of Max Ernst, of the type "Revolution at Night," "Two Children are threatened by a Nightingale," and Joan Miro's 24 works like "The Tilled Field" and "The Harlequins' Carnival." (p. 155)

Breton could not have paid Dalí a higher compliment than comparison of his place among surrealist painters of the thirties to that occupied in the previous decade by Ernst and Miró. In some ways, ignoring Dalí would make the situation less complex for us. But doing so would be as unfair as perpetuating the myth of Salvador Dalí as surrealism personified. Dalí *was* excluded from the Paris group as early as 1934. However, he still was allowed to exhibit in surrealist shows for several years thereafter and was even listed in the 1938 *Dictionnaire abrégé du surréalisme*. The year of his expulsion, during a lecture given in Brussels on June 1, published under the title *Qu'est-ce que le surréalisme?* (*What is Surrealism?*), André Breton was still praising him for having brought surrealist experimentation renewed momentum.

The complexities of Dalí's case, in the context of surrealism, all have essentially the same source. To a considerable degree, Dalí's association

with the surrealists was a demonstration of shameless opportunism for which he never was to feel under the obligation to apologize. At a time in his career (and no artist of our day has done so much to render the word *career* anathema to surrealists everywhere) when he responded gladly to encouragement to be aggressively himself, the surrealists provided Dalí with a sympathetic audience. In return, his sustained exploration of his own fantasies, erotic daydreams, and neuroses rewarded their attention. It furnished something quite irreplaceable in surrealism: pictorial testimony to the intricacies of a creative sensibility in allegiance to nothing so much as to the urge to provide a mirror image of itself through art.

The closest Salvador Dalí may be said to have come during his surrealist phase to making a political allusion in his painting was in 1931 or 1933 (the date is not certain), when he completed a canvas entitled *Hallucination partielle: six images de Lénine sur un piano.* In more ways than one, this picture is typical of his work during the thirties.

A human figure, its facial features indistinguishable, is seated on a piano bench with one hand resting on the back of the chair spread with a cloth on which lie some cherries. The man faces a grand piano. Along the keyboard appear six pictures of Lenin's head, each visible in a patch of yellow surrounding it like a halo. The walls of the room are a nondescript brown. In the background, through an open door, can be descried a distant landscape where a high cliff terminates in a woman s head. The keyboard is visible, but the sheet music standing in place shows no notes. Instead, we see crawling over it some ants, like those running over a human hand in a sequence contributed by Dalí to a film, *Un Chien andalou,* with which he and Luis Buñuel had impressed the surrealists in 1928.

There was no place for political statements, overt or covert, in the kind of world evoked by Dalinian surrealist painting. And this was not merely because Salvador Dalí refrained from making public his views on society and politics, or was reticent about doing so. Following private obsessions left no place in his work for matters not directly related to their communication. Thus characteristic features in *Hallucination partielle*—the square of cloth inexplicably attached with safety pins to the back of the man's jacket, the fruit on the chair, the ants that swarm about as they frequently do in Dalí's pictures—all these belong to a universe where the painter appears to feel quite at home. Here they stand as enigmatic landmarks by which we, as spectators, have difficulty taking our bearings or else fail to do so when we try.

Even supposedly quite innocuous objects are endowed with startling qualities in Dalinian painting. Limp as the famous timepieces in a 1931 tribute to the persistence of memory (*La Persistance de la mémoire*), in *Pain catalan (Catalan bread* [1932]), the piano reappears in a canvas, *Femmes aux têtes de fleurs retrouvant sur la plage la dépouille d'un piano à queue (Flower-Headed Women Finding on the Beach the Skin of a Grand Piano* [1936]). It is present again in Dalí's *Crâne avec son appendice lyrique reposant sur une table de nuit qui devrait avoir la même température que le nid d'un cardinal* (1934). Here the "skull resting on a night table that ought to have the temperature of a cardinal's nest" has a piano as its *appendice lyrique*—at once lyrical appendix and lyrical appendage—a grand piano whose white keys metamorphose into the teeth of the skull. That same skull, it would appear, aggressively follows its sexual preference in *Crâne atmosphérique sodomisant un piano à queue* (1934). And let us not forget that, although the behavior of the "atmospheric skull sodomizing a piano" catches our attention first, Dalí's title expressly invites us to note also that this is a *piano à queue*—a "grand piano," of course, but at the same time a "piano with a prick," its gender confirmed, then, by something more than French grammar.

Other motifs are better known, no doubt. We think of Dalí's phallic loaves (one, a French loaf, shown in 1932 trying to sodomize a crumb of Portuguese bread), fried eggs, and crutches (we see one of these sustaining the skull's *appendice lyrique* in the most improbable manner). Nevertheless, beginning with the grand piano suits our purpose well enough. True, there is no great subtlety about the way teeth in the skull become piano keys, and vice versa. But for one fact, indeed, there would be no reason to pay particular attention to the process: it reduces to the lowest terms a technique developed by Dalí out of a theory that stands as his most original gift to surrealism—critical paranoia.

One 1936 Dalí canvas purports to depict the outskirts of a critical paranoiac town. Among other features, this picture shows a girl skipping rope in a square, visible under an archway (beyond question, Giorgio de Chirico made as strong an impression on Salvador Dalí as on any other surrealist painter). The girl's outline is reproduced perfectly, a kind of visual echo, so to speak, at the top of a tower in the background, where it serves as a church bell.[1] *La Charrette fantôme (The Phantom Trap* [1933]) shows another city, seen in Chiricoesque deep perspective across a stretch of sand over which a horse and trap are moving. From where the spectator observes

the scene, the head and crupper of the horse and also the head and torso of the driver are, at the same time, all parts of the urban landscape. We face two simultaneous images, each dependent on the other for its effect, the two inseparable. In this way, we find ourselves introduced to the principle of critical paranoia, presented here in basic terms. We are confronted with what Dalí called "the paranoiac mechanism by which is born the image with multiple representations."

In his experiments with multiple imagery, Dalí's unabashed use of contrivance, of studied effect, went obviously to the opposite extreme from pictorial automatism. The moment would come, years later, when distance from the magic presence of Dalí would permit a reliable spokesman for surrealism to dismiss critical paranoia as a negative force: "His 'critical paranoia,' greeted favorably at the time as a new theoretical contribution, aimed in the end at liquidating the concept of automatism so as to substitute for it megalomaniac delirium. Dali was demanding nothing else, when exploiting his own psychological complexity in light of psychoanalysis, than the right to cling to pure and simple *fabrication,* thus placing himself among the corporation of men of letters and painting whose incompetence surrealism had brought out from the beginning."[2] However, whereas José Pierre was to conclude that Dalí brought his influence to bear "in the most reactionary sense [direction]," the surrealists' first impression was excitedly positive. No voice was raised in protest or warning when Dalí declared, "I believe the moment near when, by a process of thought of a paranoiac and active character it will be possible (simultaneously with automatism and other passive states) to systematize confusion and contribute to the total discredit of the world of reality."[3]

The attraction of Dalí's proposition was so great, it seemed to fit in so well with surrealism's program, that critical paranoia seemed destined to place itself very fruitfully at the service of surrealism. Hence Dalí soon found support for his argument, to which nobody in the French surrealist circle could remain totally indifferent. It appeared, in fact, that approaching reality as "simple amnesia of meditation" committed Salvador Dalí to pursuing, in his own peculiar way, a "dream of mediation" shared by Max Ernst.

Now and again in Dalí's work multiple images result from a distortive process, as they do in his *Bureaucrate moyen atmosphéricocéphale en train de traire une harpe crânienne* (1933). An amorphous shape, quite like one of Dalí's long loaves, afflicted this time with limpness, is propped up by a crutch. Hanging down from it is a protuberance that looks like the lower half of a human skull, stretched so that the teeth are elongated and the chin looks to be an udder. In front of it sits a male human figure whose left

hand touches this projection in a gesture ambiguous enough to suggest, concurrently, playing the harp and milking a cow: here, then, is the *Average Atmosphericocephalic Bureaucrat Engaged in Milking a Cranial Harp.*

A great admirer of François Millet, "whose erotic cannibal" he saw as spreading through "the tragic myth of 'The Angelus,'" Dalí was virtually hypnotized by "the drama that cannot be suspected [but which he, nevertheless, was fully able not merely to detect but to analyze at considerable length] hidden under the most hypocritical appearances of the world, in a simulacrum, obsessive, enigmatic and menacing of the so-called twilight prayer in the desert still officially called by that imprecise concealing title, Millet's 'The Angelus.'" There is no need to pause over Dalí's interpretation, growing out of the conviction that, at the hour of the Angelus, an old peasant has doffed his hat simply to conceal his erection.[4] What matters is that Salvador Dalí painted a number of pictures inspired by Millet's best-known canvas. Among them *Réminiscence archéologique de 'l'Angélus' de Millet* (1933–35) shows a small adult figure on a seashore, holding a child by the hand and pointing to two towering ruined stone buildings that, in outline, look like the central figures of *L'Angélus*, the peasant and his wife.

Typically, however, the presentation of two images at once is a more elaborate affair in Dalinian painting. This is because the presence of multiple imagery can be traced to the painter's concern for "the Subject–Object relationship" which originally led him to adopt the word *paranoia.* In his vocabulary, paranoia does not retain its clinical sense, but denotes "delirium of interpretation implying a systematic structure." Imposed upon objective reality by the subject's consciousness, that systematic structure, according to Dalí's definition of critical paranoia, constitutes "a spontaneous method of irrational knowledge based on interpretive-critical associations of delirious phenomena."

All this follows upon the belief that external reality can be dominated by what Dalí called, in his book *La Femme visible,* "the reality of our minds." In the mind, he contended, "the violently paranoiac will to systematize confusion" is paramount. For the paranoiac procedure to which he turned his attention yields the double image. As Dalí put it for the first time in "L'Ane pourri," the double image is "the representation of an object which, without the slightest figurative or anatomical modification, is at the same time the representation of another absolutely different object, this too devoid of any kind of deformation or abnormality that could reveal some arrangement" (p. 10).

The classic example of multiple imagery as Dalí refers to it is not a painting at all, but a document reproduced in the third issue of *Le Surréalisme au service de la Révolution* (May 1933). An accompanying note by Dalí

explains its significance. After a period of reflection on the subject of Pablo Picasso's treatment of the human head, especially under the influence of African artifacts, while searching a pile of papers for an address Dalí found something he took for the reproduction of a face sketched by his compatriot. It proved to be—glimpsed by chance, on its side—a photograph of some African natives seated in front of a hut. Commenting that "analysis of the paranoiac image in question allowed me to find once again, by symbolic interpretation, all the ideas that had preceded the vision of the face," Dalí goes on to report that, being preoccupied with the work of D. A. F. Sade, André Breton interpreted the face as that of "the Divine Marquis," surmounted by a powdered peruke.

There is a marked difference between the manifestation of paranoiac double images in this instance and the multiple images present in Dalinian painting. Salvador Dalí introduced double images into his canvases with at least some degree of deliberation. In two of his pictures, *Paranonia* (1935–36) and *Espagne* (1938), a woman's face seems to be absent, in the first case from a bust labeled "Paranonia," in the second from a full-length figure (Spain?) leaning against a chest of drawers. However, in each instance the missing facial features are supplied by a graphic arrangement that captures, simultaneously, an equestrian battle scene occupying the top section of the canvas. One cannot see the face without observing the battle, and one cannot survey the battle scene without being aware of the face. Similarly, rock formations make up the facial details in *Plage enchantée avec trois grâces fluides* (1938), explaining the title's reference to three fluid graces on an enchanted beach.

Successful completion of Dalí's "hand-painted dream photographs" was dependent on the painter's command of a technique that, in its precision and care for fine detail, could rival photography. In one respect, therefore, Dalí's manner of painting appeared to be not only at odds with trends common to surrealist painters (with the exception of Magritte) who had preceded him, but also in conflict with the general tendency of European pictorial art from no later than the last quarter of the nineteenth century. Openly—and quite brilliantly—imitating the style of Ernest Meissonier and Vermeer of Delft (in 1934 he painted *The Ghost of Vermeer, Able to Serve as a Table: Le Spectre de Vermeer de Delft pouvant servir de table*), in the end Dalí inevitably drew fire from André Breton, who in 1941 dismissed his technique as "ultra-retrograde."

How could Breton form this damning judgment while yet, on the same occasion, acknowledging the value of Dalí's painting up to 1936? The technique Dalí applied during the years when he held the surrealists' admiration was no less academic than later, after he had left France for the

United States. Basically, the difference lay not in method so much as in the use to which it was put.

In numerous Dalí canvases, academicism proved itself an effective instrument of surrealist subversion, undermining objective reality. This is how it played its part in pictures that appeared to record the painter's dreams and fantasies, suffused with an even, bright light and accentuated by heavy dramatic shadows, after the example of de Chirico's metaphysical painting. The same was true when Dalí contrived to foster ambiguity by way of precisely rendered overlapping, contradictory images. It was in the creation of multiple images, naturally, that his talent for painting like Meissonier contributed most positively to the surrealist cause. Concrete reality, scrupulously recorded, provided a glimpse of another reality, perceptible only because Salvador Dalí had taken such care to render what exists objectively. Once again, Dalí's accomplishment rivaled that of Max Ernst. As before, the methods by which he pursued his goal were radically different from those preferred by Ernst, even though that goal remained essentially the same: mediation between objective reality and subjective desire. Where there were differences—and their presence shows how fallacious would be the assumption that all surrealist painters aim to capture the same kinds of images, by just the same means—these had to do with the nature of the hallucination communicated in paint. Ernst's hallucinatory vision challenged commonplace reality. Dalí's offered conflicting yet interchangeable and interdependent views of the world as simultaneously present, as contained the one in the other, each needing its competitor for its own projection.[5]

To Dalí paranoia did not appear as an aberrant mental condition. He saw it as a liberative quality of perception. This is why he used paranoia to reach out through the world everyone sees in order to capture something that his skill in rendering the commonplace enabled him to set down in a manner that would communicate to his audience his own kind of *"inner dream."* Objective reality could hold his interest just so long as it lent itself to his purposes. To Dalí the surrealist, paranoia was anything but a helpless, motiveless state of dependence on compulsive illusion. Had it been that way, he would have had no reason to link with it the adjective *critical.* The paranoiac activity recorded in Dalinian painting denotes criticism of the external world, projected from within the artist and imposed through his pictorial rendition of that world by the intensity of his desire. Hence André Breton's commendation in a 1936 catalog essay called "Le 'cas' Dalí," where Salvador Dalí is praised as being "half-judge, half-party to the action brought by pleasure against reality."

The liberative lesson Dalí helped teach other surrealists demonstrated

that contemplation of the world as we customarily see it is not necessarily a limiting experience. Vision is far from being passive submission to whatever nature places before us. It means grasping something the objective world both conceals and yet marvelously reveals. An essential prerequisite for paranoiac activity, as Dalí spoke of it in "L'Ane pourri," is utilization of "recognizable materials," drawn from the tangible world around us. But no less fundamental a requirement is that these materials be "controllable," as he put it, that is to say, lend themselves to "bringing out the obsessive idea" (p. 10). In short, Dalí's theories prefigure a statement of faith drawn up by André Breton in his Point du jour of 1934: "Secure from all deliriums, one can systematically work at making the distinction between subjective and objective lose its necessity and its value."

The dominant characteristic of multiple images, as Dalí brings them before us, is not simply that they are a clever play upon pictures the way a pun is a play upon words. Their value, from the surrealist perspective, is that they always prove to be mutually dependent. Each time, they instruct us in the same manner.

If objective reality is the medium—the usual channel—through which subjective desire projects itself upon awareness, then desire cannot assert itself except by way of concrete objective forms. To take away from these forms would restrict desire's full expression. Anything short of meticulous care, in the act of recording the external, would damage the second image and possibly invalidate it. Now, there is no incontrovertible law prescribing that reality and desire must be mutually dependent. We have only to observe their interdependence in Dalinian surrealist painting to appreciate the special contribution Salvador Dalí made to surrealism through his use of multiple images. When he created a double image he posited such a law. While at work, he respected it so completely that he gave credibility to a theory of complementarity that maintains reality and dream, the real and the desired in harmonious balance. Without mistreating reality, Dalí proved its amenability to desire.

Salvador Dalí's relations with surrealism offered a strange spectacle and may seem to be noteworthy above all for bringing to light a fundamental paradox in surrealist painting. Dalí was a man of extreme views, given to uttering opinions shared by no other surrealist, like his declaration in La Conquête de l'irrationnel (1935): "I can therefore paint only according to a certain system of digestive delirium." To any surrealist inclined to demur, he could reply that nothing in surrealist theory precluded a concept of art

such as his own. Still, among the surrealists, his behavior provoked hesita-
tion on more than one occasion.

Joan Miró drew no adverse comments when he announced that he
was entirely unaccountable for what he painted. In fact, his spontaneity
provided a guarantee of approval in surrealist circles. Dalí, however, did not
escape criticism when asserting that he should not be held accountable or
blameworthy for the paintings he executed. The fact that as he shrugged off
responsibility Dalí expected to be praised and admired, all the same, is not
the point. The outstanding aspect of his case emerges when one wonders
about his "lyrical state founded on pure intuition," applauded by André
Breton in a catalog preface written in 1936. Did this lyricism confer upon
Dalí all the credentials he needed to pass through surrealism without let or
hindrance? Apparently not. The surrealists placed Miró's spontaneity beyond
criticism but soon began to judge Dalí's with increasing harshness.

We cannot help wondering whether the violence with which Breton
and his supporters finally turned on Salvador Dalí was not partly attribut-
able to self-reproach for earlier indulgence toward peculiarities they ought
to have detected from the beginning and should have acknowledged as
potentially more injurious than helpful to surrealism. But if it is true that
his later evolution as an artist proved to be nothing less than heretical by
surrealist standards, the seeds of dissension may well have been sown at the
time when Dalí's work appeared most faithful to the spirit of surrealism.

In his essay "Des Tendances les plus récentes de la peinture surréa-
liste" (1939), reprinted in *Le Surréalisme et la peinture*, Breton wrote, "Al-
ready profound, real monotony lies in wait for Dalí's painting" (p. 147).
The stricture sounds unwarranted, as if inspired more by antipathy than
by measured judgment. After all, one does not hear the same complaint
leveled at Konrad Klapheck or Wifredo Lam, even though each of these
surrealist painters explores with persistence the limited territory he has
marked off for himself. There is something more, here, than personal en-
mity. André Breton continued: "By wanting to be punctilious in his para-
noiac method, it can be observed that he is beginning to fall prey to a
diversion of the order of a *crossword puzzle.*" We can see just what happens
in, for instance, a 1940 canvas, *Marché d'Esclaves avec le buste invisible de
Voltaire.* It shows a slave market in which two seated figures, dressed in
black and white, form the features of Voltaire, while an archway outlines
his head. Hence the bust of Voltaire is not invisible at all, but present for us
to find in a picture puzzle. We are far more likely to notice contrivance
than to be impressed by revelation. The mystery of multiple imagery has
given way to a mere trick—all one sees, after all, is a bust familiar to us all
before we look at Dalí's picture. The technique has outlived its usefulness

and now can only be enjoyed for itself, instead of being appreciated for what it brings to light.

Dexterity does not hold the surrealists' respect when it leads to no discovery. In *Marché d'Esclaves* and pictures like it the methodology of paranoiac imagery survives, but its value in surrealism has been lost. Hence when it seems closest to what he was producing while a surrealist, the postsurrealist work of Salvador Dalí exemplifies the self-kleptomania which Breton held in contempt.

Breton's term "self-kleptomania" is grandly and provocatively crushing. This is not to say, though, that it obviates discussion of Dalí's work. The fact goes unchallenged among surrealists that self-exploration—a more accurate word for describing Dalí's work as an artist—seems to be a crime, in his case, while not being viewed as reprehensible in others. Why should Dalí's brand of spontaneity draw criticism whereas Miró's provokes no opposition from within the surrealist ranks? Joan Miró's indisputably richer and more subtle craftsmanship cannot be mentioned without embarrassment to the surrealists, who have always professed scorn for painterly technique. With easier conscience, a surrealist can point to thematic repetitiveness in Dalí. He can direct attention to the fact that exploring the world of Dalí eventually becomes an experience that brings no more surprises. He can argue that only a person as enamored of himself as Dalí unquestionably is feels so little need for renewal, for creative rejuvenation. In prospect, the Dalinian method had promised surrealism much. In retrospect, it could be seen as having fallen short of its promise. Finally, Salvador Dalí was revealed, sadly, not as surrealism personified but as only Dalí.

Wilhelm Freddie

SURREALISM IS NOT A STYLE IN ART OR PHILOSOPHY. It is a permanent state of mind," Wilhelm Freddie once declared. That state of mind, he found, was to bring him under attack from art critics, officials in government (his own, as well as Nazi Germany's), professors, newspaper columnists, the church (which clamored for his expulsion from Norway in 1936), a gang of pro-Nazi youths, who once stopped him in the street, slapped his face, and called him "Perverted Yid," and even from British Customs. No surrealist has paid a higher price for fidelity to his convictions. None has testified more forthrightly and at greater personal risk to surrealism's role as necessary subversion, forever at odds with bourgeois society, its usages and demands, its limitations and distortions. Moreover, enjoyment of Freddie's work leads to guilt by association. As Karl Otto Götz noted in 1959, whoever gazes attentively at a Freddie canvas "feels behind him the eye of the law."[1]

Wilhelm Freddie's painting is characterized by an austerity that sets him at a distance from the more popular surrealists—or at least the more easily tolerated ones. It is free of the mannerisms that have earned Dalí notoriety and even an audience among people who want nothing to do with other surrealists. It lacks the surface charm that guarantees Miró acceptance, even among those who have never heard of surrealism. And it is without the easily recognizable traits that allow the gallery-goer to pick out a canvas by Magritte or Tanguy, whether or not he or she approves of or reacts favorably to these artists.

Of the painters qualifying for first rank within the surrealist group, by achievement and not mere reputation, none has been shunned virtually everywhere, by critics and public alike, quite as Wilhelm Freddie has been.

True, in his native Denmark he earned an unenviable reputation, shared by no artist in the surrealist movement. During the late thirties, two of his pictures and one of his surrealist objects were confiscated by the authorities (to be held for no less than a quarter of a century in the Copenhagen Criminological Museum), while he was jailed for pornography. Outside Scandinavia, though, he has remained comparatively unknown. On the occasion of a 1972 exhibition held at Acoris, the Surrealist Art Centre in London, appeared an abominable translation of a study by Jens Jørgen Thorsen, published in England under the title *Where has Freddie been?* It might have been more appropriate to ask, simply, who Freddie was and why it mattered. People visiting the 1978 London show *Dada and Surrealism Reviewed* had no hope of finding answers to these questions. The Arts Council of Great Britain exhibited seventeen Dalís, Massons, and Tanguys, twenty-eight Magrittes, thirty Mirós, fifty-six Ernsts, and just one Freddie.

Born in 1909, Wilhelm Freddie discovered *La Révolution surréaliste* some twenty years later and can be credited with having introduced surrealism into Scandinavia: a picture of his on the theme of liberty, equality, and fraternity led the Oslo newspaper *Dagbladet* to invite its readers to suggest what the painting might mean. During an interview granted Christian Houmark when his first one-man show was held in May 1930, Freddie spoke of his art as "founded on the theory that the subconscious, dreams, desire and instinct alone represent the absolute in human existence." By then Wilhelm Freddie was thinking like a surrealist and acting like one, too.

In 1934 Freddie met Wilhelm Bjerke-Peterson, local organizer (his collaborators included André Breton, whom Freddie was not to meet until 1947) for a cubism-surrealism show, due to open in Copenhagen during January of the following year. Emphasizing surrealism, the exhibition included works by Hans Arp, Victor Brauner, Dalí, Oscar Dominguez, Alberto Giacometti, Paul Klee, Meret Oppenheim, Man Ray, and Tanguy. But it was Wilhelm Freddie who was singled out for special treatment in the Copenhagen daily *Berlingske Aftenavis.* Saluting his incontestable talent for conforming to the spirit of the show (which it described as having gone to the limit of the disgusting and the nauseating), the Danish paper set the tone for most subsequent critical commentary on Freddie's work. There was promise of things to come, also, when in November 1935 the police had one of his paintings removed from a gallery window, charging that it was pornographic.

While on a trip to France and Belgium during the following summer, Wilhelm Freddie was given an opportunity to participate in the 1936 London International Surrealist Exhibition. The paintings he sent across the

Channel were deemed pornographic by British Customs, held at the port of entry, came close to being burnt, and finally were returned to him—in a sealed crate. Similarly, pictures he submitted upon invitation to the Frederica Fair were removed from the walls by the Fair's director himself. On police orders, some Freddie canvases to be exhibited in a show in Odense devoted to a quarter-century of Danish art were taken down even before the private showing. Those that remained prompted King Christian X to ask whether Freddie had been committed. "Not yet," was the museum director's laconic reply.

Before leaving in 1937 to live for a while in France, Freddie exhibited in Copenhagen some forty objects and paintings which so incensed one visitor to the show that he tried to strangle the artist. On March 19 (the day a local newspaper, *Nationaltidente*, contemptuously dismissed Freddie as a sex maniac) the police impounded every one of his works on display. Two days later, three of his pictures were rejected by the director of the Skånska Konst Museum in Lund, which was putting together an exhibition of surrealism in Scandinavia. Brought to court in April, the artist was condemned in July to a fine or twenty days' imprisonment. Upholding the confiscation of three of his works (originally six of them had been held), a court of appeal reduced the sentence in September. As a result of its leniency, when Freddie was incarcerated it was for ten days only.

Those unfamiliar with Freddie's work may be excused for concluding on the basis of this information that its contribution to surrealism, although patently scandalous in the well-known tradition of surrealist art, must be severely limited in range as much as in appeal. The impression made by his canvases in his homeland would suggest that they lack variety and must have brought little enrichment to surrealist painting. In short, where reputation precedes direct acquaintance, it does Freddie's art a grave injustice.

The vigor with which, throughout his life, Wilhelm Freddie has displayed a very personal vision entitles him to a place in the first rank of surrealist creative artists. Not the least of his virtues is the energy with which he has demonstrated the folly of confusing the erotic with pornography, when we face surrealism.

In 1937 Freddie gave the title *Sexsurreal* to one of his shows, displaying a courage that was to keep him devoted to surrealism despite the misunderstanding it bred and the penalties it earned him. He indicated that, regardless of his reputation for disgusting the public, his motive in exploring eroticism was neither vulgar exploitation nor sensationalism. One

of the collages from the exhibition, which gave the show its subtitle—*Træk gaflen ud af øjet på summerfuglen* (*Withdraw the Fork from the Butterfly's Eye* [1937])—incorporates a reclining nude female torso and a pair of woman's legs, complete with the paraphernalia of fetishism (shoes, stockings, garters, underwear). But it features also an element annoyingly distracting to anyone seeking nothing but titillation: a dead soldier in uniform, whose presence adds another dimension altogether to the picture as a whole. What is more, the collage introduces a portrait photograph of the artist, whose picture appears again on the cover of the catalog. Far from indicating a weakness for self-advertisement, the photo testifies to Wilhelm Freddie's commitment to his art, to the honesty and boldness with which he gives of himself through his work.

We can be sure the famous object impounded in 1937—*Sex-Paralysappeal* (1936)—was considered offensive because, on a bust of a woman, Wilhelm Freddie had drawn a human penis extending from the woman's hairline at her temple down over her cheek. When in June 1961 the Council of the Danish Academy finally acknowledged the two paintings held at the same time to be (permissible) expressions of surrealist art, it still denied *Sex-Paralysappeal* that status. Evidently, the Council continued to be incapable of perceiving that the surrealism of Freddie's object lies as much in the mannequin's placid indifference to or unawareness of or submissiveness to the phallic member worming its way purposefully toward her mouth as it does in the presence of a thin rope, tightly wound about her neck, from which two glasses hang incongruously, one of them containing liquid that the public is free to take for wine or blood. Whenever in the work of Wilhelm Freddie the sexually stimulating imposes itself provocatively upon our attention, it never intrudes merely to release or satisfy voyeuristic impulse. Its effect is to precipitate the spectator into a realm where the erotic helps bring about an encounter with what surrealists term the *marvelous*.

The erotic element in *Sex-Paralysappeal* is mentally and emotionally challenging. But the role of familiar and usually innocuous motifs is also disruptive of the commonplace, a brutal shock to the conditioned responses approved by social custom in the name of good taste. We notice the proximity of a red rose stuck in the woman's hair, behind her ear, in front of which a phallus stretches down makeup expertly applied to her cheek. Ironically, the rose brings a disconcerting admixture of conventional sex appeal—within the limits of flirtation that society readily condones as more appealing when it is less overtly sexual—to an object distressing to people some of whom could not possibly think of themselves as prudes. No less disturbing is the presence of a man's suede glove, for it neither "makes

sense" nor again seems to fit naturally with the aggressive sexuality em-
blemized in the displaced virile member (an active, demanding, though
evidently severed organ). Inexplicably, the glove rests atop the woman's
head, like some kind of distorted crab, at once ludicrous and strangely
threatening.

Glove and penis invade the domain of the socially acceptable, the
politely tolerable. Both attack social man's predispositions, even though
they do not do so in altogether the same manner. They strike at different
preoccupations and presuppositions regarding acceptable conduct. Even more
important, they share the common surrealist purpose of furthering liberation
from the inhibitions imposed in Western society as much by rational thought
as by approved sexual customs.

So far as Freddie's painting is concerned, infusion of eroticism is the
most obvious sign, following his introduction to surrealism, of his willing
abandonment of abstractionism. Taking place around 1930, injection of
erotic motifs marks a reorientation in Freddie's ambitions as an artist no
longer satisfied with his earlier formal experiments. The influence of Salva-
dor Dalí's technique, which we sometimes hear mentioned, is really not
profound at all. In fact, it is limited; so much so that even when it
appears to be most pronounced (in a picture like *Meditation over den anti-
nazistiske Kærlighed—Meditation on Anti-Nazi Love* [1936]) one might speak
more fittingly of motifs adapted than of voluntary or even involuntary sub-
mission to influence. Given Freddie's penchant for incorporating collage into
his painting, in fact, one's impression is almost that certain elements have
been borrowed from Dalí's work (for instance, the elongated thigh in *Medita-
tion*) and deliberately introduced by the Dane for purposes quite dissimilar
to those we know to have been important to the Spaniard. What some ob-
servers would term Dalinian elements, therefore—the exaggeratedly deep
perspective of *Grammofonlandscap* (*Gramophone Landscape* [1936]), for ex-
ample—merely open our eyes to a universe that only a casual examination
might lead us to confuse with Dalí's.

In *Mine to søstre* (*My Two Sisters* [1938]) appear two female figures
small enough to suggest the vast distances that appear, too, in Dalí's paint-
ing. It seems likely that the two sisters mentioned in the picture's title are
the other women in the foreground. One of these is walking in our direc-
tion, her face mysteriously swathed in bandages, on her head resting some-
thing resembling the skull of a prehistoric bird with a large menacing beak.
The other hangs almost upside down, right in front of us, her ankles
attached by metal rings to a section of wooden fence. She wears shoes,
stockings, and waist cincher, yet her buttocks are left invitingly bare. The

outstanding feature of the picture is that, structurally, it diverts attention from conventional elements to concentrate on the unconventional. A distant promontory visible to the left across the water is balanced, on the right, by a landscape of trees, seashore, grass, and even a little church. However, the eye is drawn inexorably to the victim (how else to describe her?) in the foreground. She is evidently untouched so far, yet unaccountably readied from the waist down for whatever treatment the spectator's imagination may propose.

The major difference between Freddie's use of erotic motifs and Dalí's lies here. Dalinian eroticism is obsessive in origin and primarily symbolic in expression. Freddie's aggressively implicates the spectator. It does not do so by following the artist's private fantasies through, but by bringing to the surface of awareness libidinous responses common to us all. Thus viewers who, priding themselves on recoiling in horror, cry pornography condemn themselves through their condemnation of Freddie.

Wilhelm Freddie's use of erotic motifs is always calculated. It frequently violates rules of pictorial composition of the most elementary sort in order to defy sexual taboos more openly. For example, in *Mine to søstre* vertical lines are stressed: the two distant female forms to the left of the woman walking with a skull on her head, the trees and church tower to her right, even the planks forming the fence in the foreground, ahead of her. But it is evident that the verticals emphasize brutal disruption of the rhythm of this picture: diagonal lines resulting from the way the lower half of a nude woman appears, chained to the fence up close to us. Used by a lesser painter, such formal means would appear as evidence of ineptitude. In Freddie, they reveal, instead, productive devotion to surrealism's antiaesthetic program.

Edouard Jaguer points to essentials when speaking of Freddie as "substituting apparent disorder for the false established order" and as having effected "a higher order" that is the "alchemy of reason and desire."[2] Jaguer's high-flown phrases have a redeeming virtue. They bring out the nature of Freddie's undertaking as a painter and indicate, at the same time, where his achievement lies. From the moment Wilhelm Freddie gave up imitative abstractionism in the later 1920s, compositional concerns no longer interested him, except so far as their denial could be made an instrument of revolt, to be used in the service of surrealism.

Analysis of its structure soon reveals how *Mine to søstre* works. Yet it does not show quite so quickly what this picture works to do. It merely leaves us sensitive to the manner in which, literally and metaphorically, Wilhelm Freddie has brought eroticism to the fore. Now, confronted with the erotic, which the artist has highlighted in a way not to be ignored,

we face the most impressive aspect of *Mine to søstre*. This is the uneasy balance struck between the known and the unknown, and perhaps even the unknowable.

Why does the woman advancing toward us out of the picture have her head and face bandaged? Why is there a large skull resting on her head? Where did the skull come from? Would it help to know who applied the bandages and who set the skull in position? Was this the same person (assuming, of course, one individual to be responsible for both actions) who chained the semi-nude woman right in the foreground, attaching her to the fence? And what about the latter? Presumably unable to see where she is going, although she is walking a very narrow path, the other woman appears likely to collide with the fence if she continues on her present course. One can ignore these questions only at the risk of failing to appreciate the motivation behind Freddie's picture, the reason why he has created this image of the inexplicable. In *Mine to søstre* Wilhelm Freddie brings together recognizable elements of two kinds, some admittedly drawn from the familiar world of common experience, others belonging to the domain of erotic fantasy. Then he combines them so that, coming together, they raise questions common sense cannot answer. Imagination is left to resolve these questions all by itself on the plane of the surrealist marvelous, attained through the projection of desire.

In Freddie's pictorial universe the erotic plays exactly the same subversive role as in his surrealist objects. Eroticism polarizes response, thus separating those to whom surrealist art can have nothing profitable or even palatable to show from those who are intended to be its beneficiaries. At the same time, to the latter's advantage, eroticism helps energize Freddie's imagery. It takes its effect through something more than vulgar stimulation of responses such as pornography (of which surrealists disapprove) exists to provoke and keep alive. It contributes to the release of feelings of wonder before the spectacle of the marvelous. Closely related to desire, these in turn generate nonrational imaginative speculation, which is invested with the greatest importance in surrealism.

At considerable risk, Wilhelm Freddie's painting defies taboos. Committed to unmasking hypocrisy, the artist faces and accepts the consequences. In addition, he opposes unquestioning acceptance of a status quo that all surrealists resist in the interest of emotional, mental, and social liberation. Examining a Freddie canvas brings proof that vital surrealist art, of a sort nourished by self-renewal, not self-kleptomania, is a means to an end and never an end in itself. Freddie's work is likely to discomfort, even infuriate, anyone who views its erotic features outside the context of surrealist aspirations. Yet it never ceases to appeal to all surrealists, who share

André Breton's opinion that a painting is to be considered a window, interesting above all for "what it *looks out upon.*"

Introduction, as if by collage, of the figure of Adolph Hitler into *Meditation over den antinazistiske Kærlighed* attracted the attention of the Third Reich's ambassador to Denmark, who formally lodged a protest. Before long, the German invasion of his homeland resulted in censorship of Freddie's work. In 1943 (this time, it is only fair to say, aided by the Danish police, not harrassed by them) the artist was compelled to seek refuge in Sweden, where he remained until 1952. His period of exile corresponded, roughly, to the second major phase in his painting. No longer offering blatantly eroticized images of familiar reality, captured with photographic realism, Freddie set about commenting upon life from another direction and in a somewhat different manner.

Frontpromenade, a painting executed in 1943, is typical of one form of experimentation that held Freddie's attention during the 1940s. It demonstrates what can result from the painter's increased disrespect for the unity of the human body. In one sense, it brings to mind a 1942 picture called *Venus*, showing a nude woman standing before us, her pubis discreetly shaded, as classical convention demands. Where her nipples should be, however, the pupils of two eyes can be seen, as though visible through incisions in her breasts.

There is a world of difference between *Frontpromenade* and *Venus*, on the one side, with their frightening atmosphere and hint of sadism, and, on the other side, René Magritte's picture *Le Viol* (*Rape*), representing a nude woman's torso that doubles amusingly as a human face for which her pubic hair neatly supplies a Van Dyke beard. Neither in *Venus* nor in *Frontpromenade* do we feel anything has been introduced merely to appeal to jaded sexual appetite. No doubt thanks to the influence of current events in a Europe under German domination, *Frontpromenade*, especially, proceeds via dismemberment to rearrangement in an image of horror.

A collage effect assembles a number of disparate free-floating forms, most of which are too ambiguous to name with assurance. At least two, though, are instantly identifiable: a small white terrier and the inverted head of a woman, obscured, except for the mouth, by a cloche hat. All these elements are dwarfed by an enormous figure or, possibly, by one that is just very much closer to where the spectator stands. This demonic promenading creature incorporates some features which either evade definition or make us very reluctant to set a name to them. Is that, for instance, a

large tongue to be seen at the right end of the monster, or is it in fact a scrotum?

Other parts of the composite creature are only too easy to recognize. We see a large human or animal bone that may well be a femur. More disconcerting, we pick out a human calf and thigh (on the latter, incidentally, an inverted human face can be seen) joined at a bent knee. In some way concealed from us, this single leg is attached to a man's head. The latter appears upside down, gagged by some indescribable substance which, on second thought, may be vomit issuing from its own mouth.

Indefinable or not, the elements making up Wilhelm Freddie's monster come together, against common sense, to form an intolerable image of the insanity of a wartime world. It makes a timely comment that compares very well indeed with Max Ernst's far better-known transposition of evil— his depiction of "the domestic angel" in 1935 and, two years later, of "the angel of hearth and home." These elements occupy the upper two-thirds of a painting completed in a manner for which Freddie's earlier work has not prepared us.

Seen in black and white reproduction, the bottom third of *Frontpromenade* would suggest that the central figure, promenading miraculously and terrifyingly on only one foot, is jumping or floating over an agitated sea. This impression is misleading. Paint has been laid all over the area in question, in multicolored blobs. These call for elucidation while yet leaving us without confidence in our interpretation of them. There is nothing reassuring here, or again in a canvas called *Lulaby* (*Lullaby* [1945]), so disturbing that its title has an ironic ring even though—more disturbing—it is frighteningly applicable to the picture, like the name of a 1946 painting called *Barneværelset* (*The Children's Room*).

Looking once more at *Venus*, we discover something worthy of note, especially when that painting is placed next to others completed during the same period. A heavily dark background appears to have absorbed the woman from the neck up. Thus she looks as if she is headless. To a very significant degree, the mood of *Venus* owes its really alarming quality to the presence of invading shadows. The same is true of *Glasvinden og mor besøger min hvide hund, den paralyserede og dronningen* (*The Glass Woman and My Mother Visit the White Hound, the Paralyzed Man, and the Queen* [1942]).

In one respect, it is tempting to speak of a parallel with Giorgio de Chirico's use of shadows, cast across the canvas by objects (statuary, mainly) not visible in the picture. Yet this painting by Freddie cannot be called simply derivative, although it shows the shadow of the woman hidden outside the door crossing the threshold. Even more than with *Venus*, it appears that a certain amount of perceptible detail has been supplied for one

reason only: to leave us responsive—in the room where shadows abound—to mysteries shrouded in darkness such as one never encounters in de Chirico's work.

If Salvador Dalí seemed to offer a precedent, earlier on, now Wilhelm Freddie's experiments appear to take their starting point more readily in the art of Arnold Böcklin, with its heavy, brooding, often oppressive atmosphere. Still, as before, establishing a point of departure really serves only to facilitate measurement of the distance Freddie is capable of traveling all on his own.

The more rigidly we divide Freddie's work into separate, succeeding phases, the less justice we do his restless search for renewal, his distrust of self-repetition. There exist a few suggestive affinities between the kind of painting he did during the forties and a 1935 collage called *Salmonske inspirationer* (*The Inspiration of Solomon* [based on a scene from the Old Testament]). As for a 1934–35 canvas depicting Satanic love, it looks to be quite literally a work of transition. On the left is a nude female, equipped with a *vagina dentata* (red lips, parted in a cheerful smile to reveal white teeth, cover her crotch). On the right, however, is a strange figure. Almost disembodied because it merges so well with the picture's dark background, it offers only two clearly identifiable features: eyes of unequal size.

Eyes appear also in *Salmonske inspirationer*. A single eye replaces all the facial characteristics of the executioner about to sever a baby in two. A second eye, similarly, covers the face of his assistant. Other quite unsettling elements intrude here, too. All the same, Wilhelm Freddie has retained the dress, posture, and gestures of the biblical characters, as imagined by some classical draftsman. By the time we come upon a 1943 picture called *Duellen* (*The Duel*), our impression may be that Freddie has begun to favor historical subject matter.

In the foreground of *Duellen* lies a sprawling figure dressed in clothes of another time (like Dalí's William Tell). A second man advances toward us without a sign of shame, his codpiece uncovered. Between the two, supposedly, the duel is in progress. But a third man lunges forward, his actions concealed by the buckler attached to his left arm. Meanwhile his protagonist has the mysterious quality of the presumed Satanic figure from 1934–35. This person in doublet and plumed helmet appears engulfed in shadows that make him—if indeed this is a male human being—virtually unidentifiable.

In the decade after 1940, invasion of the canvas by menacing shadow,

inexplicably eating away at familiar shapes, becomes a recurrent motif in Freddie's painting. Time and again we notice the inexorable erosion of the human figure by the environment in which it is shown. In *En helts død* (*The Death of the Hero* [1943]) part of the head and face, a hand, and most of the legs of a reclining man emerge from a dark surface which has swallowed up the rest of his body. Against a beautiful sunset sky, in *Bella Vista* (1946) all that can be made out are the feet and legs of a human form that seems to have been absorbed in shadows rendering the upper body and head indistinguishable.

Previously, much to the confusion of the Danish authorities (who discovered on one occasion that a group of school children had been taken to see one of his exhibitions), Wilhelm Freddie seemed bent on confronting anyone approaching his work with the undisguised presence of flagrant erotic activity. But now he appears to have changed his purpose noticeably, just as he has modified his methods quite definitely. At this stage it looks as though he is intent on covering up and even withholding details, prudently or tantalizingly concealing them from spectators well disposed toward his work as much as from people likely to be antagonized by it. Meanwhile, the anecdotal aspects of Freddie's painting have become more pronounced, often reflected in narrative titles. Hence our need to satisfy ourselves about features of this picture or that, where the artist's meaning remains in doubt.

It is no longer enough for the viewer to show good will toward Freddie's art, to demonstrate how well he or she responds to it by neither evincing nor even feeling distaste or embarrassment. Now revealing less, Wilhelm Freddie demands more of his public. He requires proof of active commitment, in the form of increased audience participation in the act of animating the pictorial image. Heavy shadows are not simply a dramatizing feature of the image-making process, meant to emphasize the endeavor in which the artist is engaged. To the benefit of the spectator's self-knowledge, the accentuated presence of shadow invites him to supply for himself elements that the painter, literally as well as metaphorically, has left in the dark. Image-making thus turns into an implicative venture, incomplete and unsatisfactory so long as we the painter's audience have not contributed the share that is ours by obligation, even more than by right.

Denied access to essential clues by the painter's handling of his material, we must fall back on our own resources. Imagination is left to furnish what Freddie has chosen to supply with enticingly insufficient clarity, if not actually to suppress altogether. Painting continues to be a provocative act, with Wilhelm Freddie. A shift of emphasis suggests, at first, that the 1940s will mark an entirely new departure in his art. Yet, just as in the past, his work continues to solicit from its audience a form of participation that

spectators will be unable to offer until they look into themselves, acknowledging and releasing feelings and thoughts found within.

When Wilhelm Freddie's work enters its third evolutionary phase, the significant modification claiming our attention is of a technical nature. After 1950 or thereabouts, he seems willing to entrust himself more and more to the method by which he was able to complete the bottom third of his painting *Frontpromenade* in 1943.

A self-portrait finished in 1938 realistically depicted the artist front face, with a key incongruously inserted into a keyhole cut in his left cheek. There could scarcely be a stronger contrast between that strange likeness and two other self-portraits, completed in 1957 and 1959, respectively. The 1959 painting locates Freddie's face off center in a large canvas where his features are visible behind a wooden door, swinging outward on hinges. Broad streaks of color partially obliterate the facial traits still to be seen in the 1938 portrait. It is as though this picture from the late fifties were meant as a warning to anyone presuming to look for pictorial imagery mainly in the careful rendition of recognizable detail. Freddie extends an invitation to meditation markedly different from the one that in 1936 displeased Hitler's ambassador to Denmark.

As for the 1957 self-portrait, it gives up likeness entirely, in favor of colors that—as in so many of Freddie's later paintings—offer their inducement to meditation by way of tone. Very dissimilar in the manner of execution, all three self-portraits nevertheless are linked in one respect. Each of them communicates an image in which mystery, rather than resemblance, has the painter's attention and calls for the spectator's.

When we look at a Freddie picture or object, the central issue raised by his art soon emerges. It has to do with the nature of the image made concrete by the artist, and especially with the reaction released in us by that same image. Many of Freddie's pictorial images draw upon observable reality, just the way some of his objects incongruously embrace mundane elements like the man's glove in *Sex-Paralysappeal.* Hence when one comes to ask what his images actually mean, it is very easy to find oneself looking to common presuppositions for guidance. The danger is that, finding in Wilhelm Freddie's work pictorial elements borrowed from familiar reality, we grant the latter priority, erecting upon it our own interpretation of his imagery. Nonsurrealist viewers—especially those well content with the world the way it looks—incline to assume the image must refer to something already known to them from past experience or observation. Hence they

regard Freddie's images as dependent on the already known for both mean-ing and value. Their assumption works against the artist, placing him at a disadvantage. It leaves some of them aggrieved when they encounter in his image-making activity an affirmation (in defiance of the real, as they know it) of a freedom that holds no attraction for them.

Disrespect for everyday experience and for the spectacle of habitual reality is linked very closely, in Freddie's work, with revolt against the dictates of reason. The latter are no less restrictive of fruitful imaginative play, surrealists believe, than is submission to a code of conduct grounded in accepted morality, which Freddie is not alone among them in regarding as the very essence of hypocrisy.

Wilhelm Freddie persistently repeats the same lesson, demonstrating how surrealism is capable of slipping through the grasp of anyone counting on the surrealists' work to display a distinctive style, whether in painting or in another medium. There is—and to Freddie this would sound like a compliment, if it were not simply a statement of fact—nothing stylish about his pictures. We never have the impression (which might reassure some of those who, in its absence, feel hostility toward his art) that Wilhelm Fred-die has faced and tried to solve problems of a technical nature thought to be important by prominent artists of our time. Nor does any of his work encourage the belief that it has been undertaken with the purpose of set-tling questions posed within the narrow framework of aesthetics.

Freddie must share the blame heaped upon the surrealists for engaging in figurative painting during a century when dominant trends in art have brought it under so much suspicion that its practitioners are found guilty of naiveté and quite reactionary methodology. He must do so, for the very reasons that give surrealist painting its raison d'être. His paintings belong rightfully to surrealism because they externalize his devotion to the aim shared by all surrealists: they exist to capture images.

Wilhelm Freddie does not merely refuse to strive for decorative effects such as predispose the public at large to respond indulgently or even posi-tively to many a canvas by Joan Miró before they understand it or—one has to admit—even when there is little or nothing to comprehend. Freddie works vigorously against that sort of allurement. He cannot do otherwise, so long as he continues to refuse to let his audience forget what they are looking at in his painting, and why they have been asked to look. Negative reaction, which may take the form of bewilderment or (at the other ex-treme) rage, is inevitable in individuals whose hypocrisy, prejudice, and inhibitions are to be unmasked while the pictorial image fulfills its pre-scribed role as a surrealist statement, intractable to bourgeois thinking.

José Pierre once declared that "poetic and artistic denunciation of

conformism must go hand in hand with denunciation of moral and social conformism."³ Whether or not universal respect for such a principle must be considered idealistic, there can be no doubt that Pierre has isolated an underlying rule applied with extreme rigor in work meriting designation as surrealist. In the case of Freddie's paintings and objects, anticonformism is not a pose calculated to attract attention or draw publicity. It is the sine qua non of viable artistic expression.

When resisting conformism and opposing or even abusing the values that surrealists identify with bourgeois thinking, Wilhelm Freddie is not laboriously applying rigid regulations to which he has made a formal and dutiful commitment. On the contrary, his work applies the surrealist ethic of revolt in an unforced way, naturally. It is therefore neither contrived nor mannered in its resistance to the values and outlook that surrealists condemn, and also in its pursuit of the liberative goals surrealism recommends to its adherents.

Roberto Sebastian Antonio Matta Echaurren

On the last page of André Breton's 1941 essay "Genèse et perspective artistiques du surréalisme," figure the names of a number of recruits to surrealism, new and not so new. Their participation draws comment, evidently, because it confirms automatism's continued vitality in keeping "the great physico-mental traffic" going in surrealism.

Seventeen years after he first emphasized in his *Manifeste du surréalisme* that automatism is central to surrealist activity, Breton points to it again, this time as the common element linking the work of a varied group of artists: Oscar Dominguez, Max Ernst (specifically, in recent work done in 1940 and 1941), Kay Sage, S. W. Hayter, Jacques Hérold, and three young artists. The last he identifies as embarked on the conquest of "a new morphology exhausting in the most concrete language the whole process of repercussion of the psychic on the physical." Of the three—Matta, Esteban Frances, and Gordon Onslow Ford—the first, apparently, is the one whom Breton regards at this stage as having the greatest promise. The final sentence of "Genèse et perspective artistiques" runs, "As for Matta, it is already clear to many people that he has *all* the spells at his disposal" (p. 82).

Born in Chile (1911) of Spanish and French parents, Roberto Sebastian Antonio Matta Echaurren traveled to Paris in 1933 to study architecture under Le Corbusier. Before the end of 1937, however, he had started to paint and had been admitted to membership in the surrealist circle in France. At the outbreak of war in 1939 he and Onslow Ford were among the first in the group to seek refuge in the United States. A decade later, Matta returned to Europe, temporarily estranged from the surrealists.

Matta attracted attention immediately on the surrealist scene, finding

virtually all the elements from which he was able to project a pictorial universe without parallel. Initially, he may have come under the influence of Yves Tanguy's painting. Very soon, though, he had discovered that suppression of the horizon line (which never quite disappears from the majority of Tanguy's canvases) could give him access to a world where no one had preceded him and which he was able to devote some of his most productive years to exploring.

Here, Sir Fire, Eat (1942) is among the first paintings in which a major consequence of the horizon's absence may be discerned. The spectator has the impression of looking through receding shifting planes that yield to one another as the eye penetrates the picture. The painting releases in us a feeling of giddiness that prepares us for the title and content of another work, *The Vertigo of Eros*, completed two years later. The subject matter of the 1944 canvas is not readily described. A process of elimination leaves us with the rationally defensible impression of looking, perhaps, at a dark pool. Here float a variety of forms, including two eggs. However, the thought that we are gazing at a pool arrives only by analogy. There is no convincing proof that Matta actually intended to paint one. Moreover, we face an insurmountable difficulty when trying to locate the pool. Inconsistent perspective intrudes upon the scene, with the introduction of roughly geometrical shapes which look as though they have been superimposed on the painted surface.

It may not dispose of our difficulty in approaching a painting like this one to know that Matta was engaged in what he termed *"conscienture,"* the painting of consciousness. Even so, his neologism illustrates the purpose behind his canvases. Noting Matta's opposition to "retinal painting," derided earlier by Marcel Duchamp, Sarane Alexandrian reports, "At this time, Matta said to me, in a private conversation, 'I want to make pictures which leap to the eye.' And with his hands raised like a tiger's claws, he made as if to seize an invisible spectator."[1]

Before we can plumb the vertiginous depths of the erotic in *The Vertigo of Eros*, we have to let the picture lead us down into the painter's consciousness, where erotic motifs have liberated themselves from attachment to external reality. Matta's universe remains closed to us, until we have allowed his practice as a painter to rearrange our priorities, to show that the inner world can be more real than the outer, more exciting by far to explore through an iconography largely independent of elements borrowed from the everyday world.

In the spring of 1938 Matta contributed to *Minotaure* an article entitled "Mathématique sensible, architecture du temps." It was his aim in

this text to do more than reveal something about his professional training in architecture. "We need," he wrote, "walls like damp sheets which warp and correspond to our psychological fears." With the idea of creating buckling walls and bending furniture he started to project the "psychological morphology" he would investigate, soon, in his painting. The following year, Breton was already full of praise in "Des Tendances les plus récentes de la peinture surréaliste": "Each of the pictures painted by Matta during the past year is a festivity in which every chance is taken, a pearl that becomes a snowball drawing to itself every gleam, the physical and mental ones at the same time" (p. 146). And he was signaling with enthusiasm one outstanding feature of Matta's work: "The need for a representation suggestive of the four-dimensional universe is affirmed very particularly in Matta (landscapes with several horizons) . . ." (p. 149). The four-dimensional universe of Matta images states of mind more faithfully than it resembles the external world. The latter is "warped" beyond immediate recognition, used in fact to bring us face to face with the reality of psychological tension and alarm.

Time after time the same effect recurs, although with variations that rule out any danger of monotony. Our eye drawn down into the picture, we have the distressing feeling (akin to a physical impression, it is so strong) of losing footing, of being precipitated into a new environment. The latter is either vertiginously turning like a maelstrom or mysteriously still, but of infinite depth. Here perspective is frequently self-contradictory, as it is, for example, in *The Onyx of Electra* (1944). Perspective ceases to be a reassuring phenomenon by which, according to the canons of traditional painting, we find our bearings and learn to know where we stand in relation to what is represented. There are no longer any unquestionable signs testifying to stability and permanence. Typifying more than the dislocation of familiar reality, their suppression intimates that Matta may well have announced his main purpose when naming one of his 1944 pictures *To Escape the Absolute*. Like abandonment of the horizon line, the confusion of perspective is, for him, a means of casting us adrift on an ocean where we miss the lodestar by which we are accustomed to take bearings.

In a July 1947 essay, reproduced in *Le Surréalisme et la peinture*, Matta is singled out as having undertaken to "revolutionize perspective" (p. 192), which Breton condemns as having the grave defect of satisfying the eye only. Matta's revolutionary gesture surely has consequences on the technical plane, but it has an even more significant effect also. Matta, Breton argues justifiably, brings other senses into play—"from the coenesthesic sense to the (more or less lost) sense of divination" (p. 193). He is concerned

with "representing inner man and the odds he faces." Breton implies here that conventional perspective has no useful role in the work of an artist who immerses man in an element other than "physically breathable air." That element is chance, "a sort of geometrical plane of resolution of his conflicts."

Roberto Matta may not resolve, every time, the conflicts his pictures represent. Even so, one does not have to be willing to follow André Breton blindly each step of the way before agreeing on one basic point. Disruption of familiar perspective in Matta's work is not a device used for aesthetic reasons. It is a method employed to communicate a response to life, experienced at a level other than that of commonplace exchange between individual consciousness and external reality.

Having stressed that surrealism is "essentially a revolutionary step," Matta once affirmed in an interview granted F.-C. Toussaint for Les Lettres françaises (June 16, 1966) that, for the surrealists and himself, all activity is revolutionary and therefore precludes "contemplative aesthetics." He could not own to an aesthetic position, he said, for "when one makes a revolutionary gesture, it is possible that it is very ugly in its immediate appearance." Even when eventually it can be perceived as beauty, he suggested, the creative gesture and whatever follows upon it really have nothing to do with "the aesthetics that interest many painters." Seen this way, the artist's actions must be weighed against the aims set for him by surrealism: "the complete emancipation of man." For Matta, the significance of emancipation is poetic in the sense that "the function of poetry is to enlarge consciousness of the world."

So far as Matta can be said to show us our own world, it is a world blown apart, caught either in the process of disintegration or engaged in reintegration. "The power to create hallucinations," he once wrote, "is the power to exalt existence."[2] In other words, Matta's own hallucinatory painting is a comment on living. "The artist is the man who has survived the labyrinth"—even though he may still paint for us a labyrinthine world. Hallucination, now, is affirmation, setting its stamp on life, not recoiling from it. The purpose in view? "To use hallucinations creatively, not to be enslaved by other men's hallucinations, as usually happens."

There is some danger that we may read too much into these remarks. After all, they express Matta's response to the painting of Max Ernst and were not offered as a statement outlining their author's own position. Nevertheless we can recognize in Matta's words a sensitivity that helps open our eyes to the nature of his own experiments, situated, like Ernst's, "beyond painting" in that zone where the pictorial artist may make a vital contribution to surrealism. At the same time, the evidence furnished by Matta's

pictorial investigations indicates that, even though he felt something in common with Ernst, he was not disposed to explore imagery in exactly the same manner as Ernst did when first approaching surrealism.

Matta's painting displays a characteristic that deserves attention at once. His "means of forcing inspiration"—to borrow Ernst's well-known phrase—do not owe much to implementation of mechanical techniques such as Dominguez developed in his "decalcomania without preconceived object" and Paalen discovered in his "fumage." Dominguez and Paalen followed where Ernst had led, seeking imaginative stimulation from methods expressly designed to bring chance into play. Matta's way of arriving at pictorial imagery appears closer to Joan Miró's use of the accidents of the chosen medium[3] and the revelations produced through accumulation of successive layers of color, overlapping and sometimes bleeding into one another. Matta would apply successive washed layers of paint, utilizing rags as well as brushes to lay them on. He also would wipe away through the accumulated layers, discovering shades of coloration and unforeseen forms as he went.

The method was nonmechanical, but the results obtained were still discoveries facilitated by the intervention of chance, eventually to be embraced in the final multidimensional image. Oddly, though, when giving Yves Tanguy credit for setting Matta an example he was eager to follow, Breton did not mention André Masson. Yet the Chilean painter's technique seems to have more than a little in common with Masson's use of superimposed pictorial planes.

Examined without reference to his work as a painter, Matta's allusions to experiencing hallucinations can sound very ominous and therefore quite misleading. One has to look at his canvases, reflecting on the titles he gave them, in order to appreciate that Matta's was an endeavor sometimes touched by a humor not thoroughly sardonic. Why give a title to what you have painted, Matta seems to ask, unless it be with the purpose of increasing the alarm your picture is more than likely to generate in many a viewer? When he selects an elementary verb form (first person singular, indicative mood), *je marche,* and modifies it to read perplexingly, *Je m'arche,* he manufactures a title that is now a reflexive verb for which the dictionary can offer no definition. As a verb form, *marche* derives from *marcher* ("to walk"). But the French *archer*—the hypothetical infinitive of the verb from which *arche* presumably has come—is exclusively a substantive, having the sense of "bowman" or "archer." This is to say that when calling his picture *Je m'arche* Roberto Matta proposes an entirely original verbal construct,

where the first person pronoun is attached to a previously nonexistent reflexive verb that will defy confident translation. All one can say for sure is that the French noun *arche* means both "ark" and "arch." Thus, as he looks at the title *Je m'arche*, the rational-minded spectator is going to conclude he must have a defective copy of the gallery catalog in his hands. But those to whose imaginative powers Matta appeals will find this title suggestive of meanings where the French language has established none with certainty. These are the people who will be ready and able to look with profit at *Je m'honte* (a corruption, supposedly of *Je monte*) being capable of following Matta when he announces, "I am going to make a tour of the I, from the South to the Rmis [sic]."

The title of Matta's 1946 picture *Splitting the Ergo* is representative of a creative procedure in which semantic play goes appropriately with rearrangement of the physical world by way of a unique pictorial language to which, as Matta took care to indicate, the essential key is morphology.

A necessary step in progress toward appreciation of Matta's work is the realization that titling has nothing more to do with facile cleverness than with triteness. We take this step as we notice that the image is more than the pictorial counterpart of a merely witty play on words. *Splitting the Ergo* offers a puzzling confrontation with shapes tangibly present yet disturbingly free of allusiveness to familiar objects, bewilderingly assembled in disregard of unifying perspective. Thus it is impossible to say that, finding one motif, *therefore* we find the next, and the next, and so on. Instead, the effect is such that the spectator has the impression of seeing space all jumbled. Strangely dismembered, it is still at the same time uncannily consistent with itself. Here, indeed, lies one of the most remarkable characteristics of Matta's art: its ability to achieve inner cohesion in pictures appearing on first contact to exist as affirmations of cohesion's collapse.

In 1938 Matta executed *The Morphology of Desire*, a painting with a title that brings to mind the term "psychological morphology" by which he was to define his early production. The following year he finished both *Prescience* and *Inscape*, so, as it were, completing a program at which he arrived early and within which he was to conduct his pictorial inquiry henceforth. Landscape painting—in which the artist turns toward the outside—was to attract Matta far less than the kind of picture-making for which he coined the useful term "inscape": the painter looks within for the panorama that becomes the subject of his art. Meanwhile, review of knowledge already gained was to count far less, to Matta, than intimations of the as yet unknown, mirrored in prescient pictorial imagery welling up from the depths captured in the canvas. One can see how the point of departure might have been the strange inviolable universe depicted by Tanguy, but

Wilhelm Freddie, *Sex-Paralysappeal*, 1936. Moderna Museet, Stockholm

(Left) Wilhelm Freddie, *Mine to søstre (My Two Sisters)*, 1938. Photograph by Jørn Freddie, Collection Charles and Pat Sonabend, London
(Right) Wilhelm Freddie, *Frontpromenade*, 1943. Photograph by Jørn Freddie, Fine Art Exhibitions, Zurich

Roberto Sebastian Antonio Matta Echaurren, *Morphologie psychologique (Psychological Morphology)*. Private collection, Winnetka, Illinois

(Above) Roberto Sebastian Antonio Matta Echaurren, *Prince of Blood*, triptych, 1943. Pierre Matisse Gallery, New York

(Right) Roberto Sebastian Antonio Matta Echaurren, *Lambeaux irononiriques (Iron-Oneiric Scraps)*, 1942. Washington University Gallery of Art, St. Louis

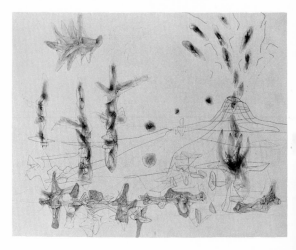

one can appreciate just as readily that attempting to imitate the Frenchman would not have served Matta's purpose by any manner of means.

In 1966 F.-C. Toussaint asked Matta what surrealism represented for him, at that time in his life. In his reply the artist insisted it meant "looking for more reality," in other words, realization of the "social and economic emancipation of the world, and also that of the mind." It was in relation to this last ambition that painting took on relevance for Matta. Gladly paraphrasing Breton's definition in the first *Manifeste*, he continued, "The goal is to find the true functioning of thought, without prejudice or moral or aesthetic regulation, to grasp and understand at the same time human beings and the world." Now the world, he argued, is grasped in its "gestures": "Everything is a gesture," even if it be an inanimate product of nature such as an apple or a flower. "And so all these gestures provoke in me emotions, desires that are themselves also gestures. The confrontation of these two gestures was for me my first language, in what I called 'morphologies.'"

In Matta's work, morphology, the science of form, is present not as a motif but as a structural constant, assuming both its biological meaning and its philological one too. The subject matter of his painting may be explained more easily if considered in relation to Matta's interest in structures, homologies, and metamorphoses that govern or influence animal and plant form. At the same time, he is curious about the branch of grammar concerned with inflection and word formation. He displays curiosity about biological morphology only so far as it provides a metaphor for psychological investigation.

Facing his painting we find ourselves dealing with iconographic discoveries of a kind for which morphological change is a permissible analogy and an enlightening one. Attention to the outside world yields, now, to preoccupation with self-exploration for which, by way of philological morphology, the term "inscape" seems to be perfectly acceptable.

Pleasure at seeing how the meanings of words can be bent, fractured, reconstituted, and subjected to modification so as to bring out new insights beyond our anticipation goes with fascination at the spectacle of strange pictorial forms. Before they can hold our attention, the latter do not have to rely on surface resemblance to objects familiar to everyone in their customary context. They exist autonomously, as products of an imagination stimulated by revelatory chance. So, with his painting, Matta leads us to the heart of the surrealist creative process as a cognitive act. The latter is unpredictable because unprecedented. It is inexplicable because creative gestures are accomplished in accordance with no recognized criteria by which artist and public can agree that its viability may be established

objectively. Hence knowledge is not verified by the pictorial evidence presented, but is enlarged and deepened by it. As we look, awareness that we are deprived of customary points of reference becomes sharp enough to release a feeling of vertigo, indicative of the disorientation we experience in contact with what we are seeing.

Alluding to the excitement of the hunt and to the unpredictability of its outcome, early in his 1944 preface to a Matta exhibition, Breton referred to searching for rough agates on the Gaspé Peninsula (which he had just visited on his honeymoon). He wished to draw the following parallel: "To the increasing grayness of thought-out and 'constructed' works it was surrealism's first gesture to oppose images, verbal structures altogether similar to those agates" (p. 183). Taken not in its literal meaning but as the stone of which the occultists spoke, the agate contains the "exalted water," the "soul of water." Hence the connection between the verbal image mentioned by Breton and the graphic ones for which Matta is responsible. Fascinated by the esoteric tradition, Breton could not have shown greater regard for Roberto Matta's achievement than to place him among the alchemists.

In the paintings of a number of prominent artists who joined surrealism before Matta (it is ironic that one of these, Salvador Dalí, was instrumental in introducing him to André Breton), the mind is challenged to find enlightenment through adventurous rearrangement of pictorial motifs directly allusive to the everyday world. The work of these painters invites the spectator to make an imaginative leap by which, in an illuminating image, he can embrace a variety of elements that experience and education have taught him to view as incompatible. Thus the means by which we are encouraged to advance into the unknown patently belong to the known. The mystery of the revelatory act of painting can be traced to no other source than the artist's ability to displace, relocate, and rearrange in an order that, while incorporating familiar motifs, mocks the familiar, requiring us to take a step outside the reality recognizable to one and all. Hence in the mind of the museum-goer the classic surrealist approach to painting has bred a cliché (that of the dream-painting) in which it is impossible to accommodate the canvases of Roberto Matta with their "cosmic lyricism," admired by José Pierre. With Matta, progression from reality to surreality, considered to be a fundamental necessity, does not come through use of a method that takes from the known so as to encompass the unknown. As a result, for many viewers the subject matter of his work is difficult to inter-

pret, the way it should be, as sharing common ground with that of artists whose figurative preferences Matta does not enjoy. "Surprise," he once forecast, "will explode as does a fluorite ruby in ultraviolet light."

In strictly formal terms, Matta's painting is radically innovative and unrestrained by tradition—evidence, then, of self-absorption. One has no trouble appreciating how fascinating André Breton found his pictures during the late 1930s. At that time Breton was becoming more than disenchanted with critical paranoia as Salvador Dalí spoke of it. Later, in his preface to the 1944 Matta show reprinted in Le Surréalisme et la peinture, Breton would announce—with undisguised pleasure, and with more than a trace of relief, no doubt—that Matta's painting made paranoiac critical activity seem a retrograde step after all. By comparison, Dalinian painting—so impressive when it made its first impact in surrealist circles—could be seen as promoting only "anecdotal aspects," caught "in silhouette," that is to say, "not transcending the immediate world in any way at all" (p. 186). By now thoroughly disappointed with Dalí's indisputable degeneration into "obsession with riddles," Breton was ready and eager to salute Matta for taking "the disintegration of exterior aspects" in a very different direction, so permitting the spectator, in Matta's own words, to "touch the opaque shoulders of the steaming trees" (p. 187).

The confidence Matta inspired helped measurably in laying to rest misgivings about nonfigurative painting, previously viewed by the surrealists as an inauspicious invitation to abstractionism, some aesthetes' field of action. On the plane of surrealist inquiry, it hastened a reconciliation between abstractionism and the figurative mode that had predominated for a decade and more. Therefore it facilitated acceptance of a number of painters—the Montreal automatiste Jean-Paul Riopelle, for instance, Rufino Tamayo, Endre Rozsda, and Yves Laloy, to say nothing of Arshile Gorky—who all had a welcome contribution to make. As a result, by 1945 André Breton was stressing, apropos of the work of Jean Degottex, how "things" disappear so that "the spirit of things" can be unveiled.

The ambience evoked in Matta's work is not populated by "things." For all that, their spirit is mysteriously pervasive, usually threatening man and severely constricting his activity, when not ousting him altogether from the scene. As practiced by Matta, nonfigurative painting had nothing to do with disposing abstract forms on a canvas in deference to aesthetic principles by which certain artists outside surrealism are pleased to have their achievement judged. Where we may find ourselves speaking, for convenience, of abstractionism, we have to admit, in the end, that its manifestation is quite incidental to Matta's presentation of his special viewpoint on

modern life. Hence balances attained in some pictures—sometimes very precarious ones indeed, we notice—have much more to do with the tense anxieties of modern living than with considerations of formal symmetry.

In the mid-forties, a major change of focus led to the appearance of humanoid forms in Matta's canvases. He now directed attention to these in titles like *The Heart Players* (1945), *Starving Woman* (1945), *Octrui* (1947), *The Pilgrim of Doubt* (1947), and *Who's Who* (1955). Tortured figures sometimes, figures of extreme cruelty at other moments, they lend themselves to interpretation as personifications of the terrors and threats besetting mid-century Western man. Although their presence does not bring with it a return to concrete reality such as furnishes the background in Dalí's surrealist painting, for some spectators it reduces the charge of mystery from which earlier Matta pictures derived their capacity to rivet attention and induce shock. Looking at these canvases, the surrealist viewer is sure to sympathize with José Pierre's judgment that, here, the human element brings about "a relative diversion of lyrical energy."[4] It is surely true that the referential character of paintings in which that element may be detected compromises free expression of automatism from which Matta's previous work drew its ability to disorient the mind and alarm the sensibility.

This is not to say that, henceforth, the figurative will predominate in Matta's painting. When he begins to introduce human figures into his pictures, where they have been poignantly absent before, it is to show them agonizingly taut, subject to the brutal push and pull of a hostile environment. Rendering the latter entails communication of feelings released by the pressures under which human beings are obliged to function, not painstaking reproduction of identifiable significant phenomena isolated in the world we know. Meanwhile, distortion of the human form—hands and facial features, notably, that often present an animal aspect—goes far beyond stylized commentary on human suffering. Matta's écorchés display the grim, irresistible effect of forces rending man as they bend him into conformity with a world committed to severe strain that Matta devotes himself to evoking.

From the outset, Matta brought to his task special gifts which no surrealist has ever had cause to deny. The first time Breton prefaced a show of his paintings, he spoke of Matta's scale of colors as constituting the richness of his work. To Breton's mind, Matta's distinction was a palette unrivaled in its innovation since that of Matisse. Although with the passage of time the overlay of black, through which these colors emerge in the early pictures, disappears, they continue to be just as distinctive in the later canvases, often more brightly lit than their predecessors. If José Pierre has some reservations at this stage, they are provoked by signs that Roberto

Matta has chosen with some degree of deliberation the colors to be intro-duced into pictures where representatives of mankind have a place. Pierre's objections center on the reduction of the role of automatism in the creative gesture, once Matta begins to be preoccupied with man's predicament in a world from which he is alienated and yet by which he is held prisoner.

One can understand that a certain idea of surrealist purity underlies and gives seriousness to Pierre's criticism. But meeting the standards such a concept must lay down could scarcely be demanded in a situation permit-ting automatism to survive only where spontaneity remains. The sponta-neity of automatism is granted a catalytic role. Matta would have been able to ignore the latter's effect only at the price of infidelity to himself. Proceed-ing no further than automatic experimentation would have been inconsis-tent with acknowledgment of automatism as a mode of surrealist inquiry. It would have meant failing to follow where discovery led. In Matta's case, meeting that obligation required closer scrutiny of the fate reserved for man by life in the world of today. Furthermore, the clash between destructive and disruptive forces on the one hand and erotic vitality on the other is so fundamental a feature of Matta's art that it must inevitably bring man on the scene. It explains, for example, the arrival of the figure of the glazier, present in both a 1944 painting, *The Glazier*, and in a 1947 drawing, *Success to the Glazier*. The allusion is patently to Marcel Duchamp, creator of the large glass, *La Mariée mise à nu par ses célibataires, même* (*The Bride Stripped Bare by her Bachelors, Even* [1915–23]), which is, incidentally, the subject of an essay written by Matta in 1941.

Man's presence does not indicate that Matta—judged by Duchamp to be "the most profound painter of his generation"—hopes or expects to solve through his painting any of the problems of living. It brings to our atten-tion confrontations as with the Pilgrim of Doubt, entrapped in the coils of an indifferent universe. And now the strength to push forward often comes from the erotic drive, as is the case in *Elle Hegramme to the Sur-prise of Everyone* (1969). The semantic shift from the familiar (*telegramme*) to the inexplicable (*elle hegramme*) is rationally indefensible. Its effect, though, is to bring the human element—*elle* ("she")—into the communica-tive process.

Matta the surrealist does not paint with the aim of projecting har-mony by way of pictorial imagery designed to show the world's imperfec-tions fortunately corrected. Nor does he take up the brush in the hope that its use will bring to light harmony of a kind that, in the world to which we

belong, seems always so elusive. It would be impossible for him to work in either fashion, because he looks upon the harmonious in painting as evidence that the truth of existence has been falsified by aesthetic predispositions in the artist. We understand Matta's antiaesthetic position better when we bear in mind that he once spoke of "the *space* created by contradictions" as best imaging man's estate. He dismisses all art from which contradiction has been pruned, on the grounds that art betrays reality once contradictions in the real have disappeared under pressure from aesthetic values, unacceptable as much to him as to other surrealists. What is more, his use of perspective exhibits flagrant contradictions that assume a dramatizing role in his work and could never find resolution without betraying the reality of the mind which his painting is meant to communicate.

With Matta, refusal to heed aestheticism's demands could never be taken for ostentatious posturing. Nor, for that matter, could it be confused with a chronic incapacity to meet aesthetic norms. A radical departure from aesthetically oriented art is imposed by his firm conviction that the clash of contradictions is at the core of human experience with which art must attempt to deal. Why paint, if not to testify to contradiction and to the anguish that reflects appreciation of its central role in our lives?

Matta's working principle is a simple one: "Create in order to see."[5] As the creative act is essentially investigative and not demonstrative in surrealism, Matta does not create in order to show. This is why the results of his "gesture" are to be examined—first by the artist himself, and afterward by his public—as visible proof of creativity. If the bridge between creating and seeing were to sink its foundations in the supposedly solid rock of the predictable, then it would lead to no place worth exploring, allowing us to see nothing substantiating the artist's bold claim to have functioned creatively. Creativity, in fact, turns away from what is commonly termed resemblance, Matta believes.

How then is visible proof to be attained? Matta's answer establishes yet another distinction between surrealism and fantasy, that other surrealists too have found it necessary to emphasize: "Not flight into the fantastic but constitution of the inner *maquis*, the *guerillero* and the inner provo in place of self-criticism." Reference to a variety of revolutionary types indicates that there can be nothing merely narcissistic about the creative gesture, which for Matta is exploratory in character and descriptive in essence. Preparing notes on Infra-Realism for presentation during the Havana Cultural Conference opening at the end of 1967, Matta advised forthrightly, "Respond to cultural revolution with a revelation, the awakening force in the conduct of our infrared life" (p. 18). Commenting on these words, Jean Schuster was to observe, "Supposing an organization of the eye that would permit dis-

cernment of infrared and ultraviolet, apprehension of objects simultaneously from different angles, penetration of the glance through the opacity of bodies, the part of imagination would be reduced" (p. 19). But as this in fact is not the case, it falls to the imagination to complete physical perception, the way it does in Matta's work. Schuster's advice is that imagined reality be approached from the working hypothesis that "it does not depend on perceived reality."

Schuster's recommendation brings us to Matta's pointed reference to "a poetic thought that can make the man in us the blind swimmer [the allusion to two canvases by Ernst (1934 and 1948), both bearing the same title, *Blind Swimmer*, is too clear to be missed] or the man shipwrecked within" (p. 26). The idea of an inner shipwreck must not be equated with failure, any more than that of swimming blind is to be regarded as a pointless and potentially dangerous expenditure of effort. Physical blindness need not preclude illumination, by any means. A wreck can mark a release from confinement, actually holding out the prospect of new discoveries: "The inner image, for the real under inspection, corresponds to the woman one loves before meeting her. The whole stress of poetic action is grounded on this divination" (p. 34). Years after André Breton mentioned divination in connection with Matta's work, the artist himself speaks of it also. For Matta, image-making is divination, the discovery of something hidden and now brought to the light of day by the magical means the painter has acquired for himself. The important thing, here, is that discoveries emanate from within, as the artist practices magic upon himself. "I am only interested in the unknown and I work for my own astonishment," Matta once explained. "This astonishment, in front of my pictures, comes from the fact that structures in appearance far removed from anthropomorphy [sic] are capable of communicating the nature of man and his condition with more 'resemblance' than anthropomorphy does."[6]

Like René Magritte, Roberto Matta teaches us to beware of resemblance. More precisely, both these painters demand that we face up to the preconceptions bolstering our habitual idea of resemblance. Both show how these may be prejudicial in the extreme, sapping the vitality of the pictorial image. Matta, though, undertakes to discredit resemblance, as commonly understood, in a manner very different from Magritte's. The Belgian artist sets about encouraging wariness concerning the identity of painted objects which happen to look like things we know, meanwhile urging us to be responsive to a form of resemblance quite independent of surface similarity. Matta, too, gives resemblance a new meaning, but by liberating painting from the role of pursuing resemblance through accurate reproduction of the familiar or the recognizable.

Some spectators find it difficult to penetrate the distracting surface realism which Magritte's canvases require us to transcend, if we are to become sensitive to the poetic virtues of the surreal. Others—and this is a matter of individual conditioning, surely—find it harder to see how Matta attains resemblance while for the most part bypassing similarity, so lending weight to the axiom recorded in Paul Eluard's *Donner à voir*: "There is no model for someone looking for what he has never seen."[7] Working without a model, in search of surprise, Roberto Matta achieves the only kind of resemblance to which he ascribes value. It is for this reason that, during the years when he was estranged from the surrealists—reconciliation with Breton came in 1959, under dramatic circumstances[8]—Matta never ceased to paint in a way that fully qualified him for their approval.

Coda

CONFIDENT IN SURREALISM'S DESTINY, André Breton asserted in a characteristic lapidary phrase that surrealism "is what *will be*." At no time, though, did he ever contend that surrealism would be art, have artistic merit, aspirations, significance. Dealing with surrealist painting brings us face to face with a fundamental paradox which, among those outside the surrealist circle, has led to confusion, misapprehension, and the diffusion of misinformation. To a very considerable extent, attainment of the high standards imposed by surrealism is at variance with the art of painting, as this has come to be commonly understood and practiced in the twentieth century.

A rebel movement from the first, and by design not accident, surrealism is out of step with and singularly out of key with the art of its time, thanks to the aims it sets its adherents. Individuals affiliated with the movement who have chosen to comment publicly on art—Breton and José Pierre at their head—have never ceased to be alert to the basic fact that consenting to fall into step would betray the underlying principles which dictate the conduct of a surrealist engaged in creative activity of any kind. This is why, when praising one painter or another, they often highlight in his work features different from those that preoccupy art critics. The latter feel justly aggrieved when they notice that a surrealist commentator does not bother to address the same aspects of painting as they themselves do and, by the look of things, may even be incapable of doing so. Given their training and the assumptions about the nature of painting it has inculcated, a number of critics have no hesitation, sometimes, in reaching the conclusion that surrealists are far too easily distracted by features of an artist's production that are really nonessential. As for the surrealists, they have no trouble at all coming to the same conclusion about those critics.

This means that surrealists do not even condescend to pay attention to the majority of artists on whom critics confer importance. It follows that several painters whom surrealists place high are judged uniformly by critics to be unworthy of serious consideration. When the surrealist and the critic do manifest interest in one and the same artist, his work can elicit in the first a response differing radically from the impression registered by the second. At times, they might well be reacting to two artists, not one.

Now when the painter under consideration happens to be a nonsurrealist, no significant conflict occurs in the minds of the public, usually content to read the surrealists' appraisal as no more than a curiosity, next to the art critics' presumably authoritative evaluation. However, when the work of a surrealist painter comes under examination, the situation is very different indeed. We cannot, without grave injustice, fail to acknowledge the pertinence, the reliability, of the surrealists' assessment.

Why is it that, when approaching surrealist painting, critics so frequently find it unacceptable and resist it obstinately? The answer can be traced to one crucial fact. The critic and the surrealist usually are separated by profoundly conflicting ideas about the nature and function of the work of art. Their difference is one of perspective. It will never be resolved so long as, looking at surrealist painting, the first views surrealism as the occasion for creating an art form, without appreciating why the second treats art as the occasion for surrealism to find expression.

By and large, from the 1920s onward artists whose work the public most quickly associated with the surrealist mode of painting embraced figuration resolutely, so much so that a few critics, including some influential ones, did not take long to begin speaking of pictorial surrealism as, very often, "illusionist." Over the years, a number of commentators seem to have felt no qualms about giving that adjective a condescending quality, not to say a touch of hostility. Even with those who do not oppose figurative surrealism consciously, referring to illusionism imposes limitations on surrealist imagery. It restricts the purpose and effect of surrealist graphic images to communicating illusion and promotes a distorted and distortive viewpoint.

Beneath open condemnation or even simple skepticism regarding surrealism as illusionist lies misinterpretation of the nature of the goals common to all surrealists. Quite erroneously, surrealism is treated as devoting itself to the assiduous cultivation of mere illusions, rather than being seen for what it really is: an effort to surpass realism out of regard for a higher

realism, captured in a French word which surrealist convert Herbert Read was unsuccessful in introducing into the English language in its semantically correct translation—*superrealism.*

In an essay, "A Further Note on Superrealism," Read once quoted the definition supplied in the first *Manifeste* as "pure psychic automatism, by which it is intended to express, verbally, in writing, or by other means, the real process of thought. Thought's dictation in the absence of all control exercised by the reason and outside all æsthetic or moral pre-occupations." He went on to say, "It follows that superrealism must be dissociated from all those forms of art which under the guise of fantasy or imagination are merely attempts to avoid reality, to take refuge in an illusion."[1] From the beginning, the surrealists rejected fantasy, reproving it as a false substitute, an ineffectual palliative, an unacceptable effort to come to terms with burdensome reality or to nurture the impression that its unwelcome effects can be evaded. All the same, one can acknowledge that surrealism is different from an attempt to avoid reality while still viewing it as illusionist nevertheless. This inaccurate deduction sounds logical and hence plausible. Whether one refers to the "rearrangement" of realistic details in a surrealist picture or to their "displacement," one risks forming a prejudicial assessment of the pictorial image. The norms granting such terms credibility belong to the realm of observable reality. The latter is implicitly given precedence over the pictorial image. Thus the image seems an illusion because it does not respect the limitations everybody is accustomed to see applying in the everyday world.

The important point is this, then. The spectator's interpretation will remain stunted so long as it sends down its roots into a basically incorrect presumption about the nature of painting in surrealism. This common presumption develops out of an erroneous notion: that the surrealist must find the material of his art in the outer world, even when submitting it to more or less surprising modification during the process by which he creates a collage or lays paint on canvas, paper, burlap, or board. For worse, not for better, the "strangeness" of the painted image is measured, now, in accordance with its obvious infidelity to mundane reality, instead of by its fidelity to surreality, perceived subjectively.

In painting as much as in other modes of surrealist expression, departure from accepted norms sustaining our habitual idea of what is real strikes many an observer as producing more or less amusing or shocking oddities. It appears entirely fair to judge these next to the reality from which they seem to deviate, when observers look back to the reality rejected by the artist, instead of forward to the surreality prefigured in his painted image. As a result, a surrealist painter's disagreement with the model supplied by famil-

iar reality may seem no more than a curiosity. There is small likelihood in these circumstances of his image being assessed in relation to the task he has before him: sharing his awareness of surreality as an enriched perception of life, caught in images that are to be evaluated according to their capacity to afford glimpses of the higher reality all surrealists are determined to bring to light.

A complicating factor must be noted. Our education has taught us to strive to understand the world around us by way of reasonable postulation and explanation. Reason has been erected as a buttress to shore up the reality of everyday experience in places where, in its absence, certain weaknesses would be visible. Surrealists look upon reason as a barrier across the path to the surreal. They believe this barrier must be removed if progress is to be made. In addition, they are convinced that reason will topple under pressure from imagination. Imagination is liberative in essence, they contend, and activated by desire. Desire, meanwhile, demands that the world— our view of it, anyway, and our response to it—change in harmony with subjective needs. Often, in the realm of surrealist painting, those needs are objectified through pictorial imagery. The value of surrrealist images—*value* is less misleading a word by far, in the present context, than *meaning* would be—has nothing to do with things we commonly accept as existing concretely. The value of surrealist imagery has everything to do, though, with what desires impels the artist to seek out through imaginative play. Whatever form it takes, the image judged authentic by surrealists is the imaginative precipitate of subjective desire, beyond the limitations of mundane reality.

When in his radio interviews, *Entretiens*, André Breton looked back in 1952 over the history of surrealism, he took pride in recalling something of particular interest. As early as 1924, in his first manifesto, he had taken care to emphasize that he was not concerned with future surrealist methodology. His purpose remained, as it had always been, to resist erroneous and demonstrably pernicious suppositions according to which surrealism must be treated as a technique only. "Do canvases by Max Ernst, Magritte and Brauner have less bearing on poetry than on painting?" he now asked (p. 221).

Confusing as it may sound at first, by linking poetry with painting this question directs attention to the very essence of the surrealist undertaking in the pictorial domain. In brings into sharp focus a statement Breton sets forth in his 1942 "Prolégomènes à un troisième manifeste du surréalisme ou

non," where he opposes conformism—surrealist conformism as much as any other. Here an attack is directed at imitators, the "innumerable followers of Chirico, Picasso, Ernst, Masson, Miro, Tanguy" (and, as Breton pointed out, "tomorrow it will be Matta"). These imitators are accused of being unable to realize that "there is no great expedition, in art, not undertaken *at the risk of one's life,* that the road to follow is not, obviously, the one bordered by a guardrail and that each artist must resume, alone, pursuit of the *Golden Fleece*" (p. 345). Here Breton points to one of the compelling myths vitalizing surrealism and guaranteeing it the capacity for self-regeneration. The Golden Fleece can and must be pursued by the individual artist, since no guidance from others releases him from the obligation to search for himself, in ways of his own.

The tone of Breton's injunction may sound exaggerated to someone unaware of the quite high incidence of suicide among surrealists, a significant number of whom have discovered that pursuit of their ambitions through art literally places their sanity in jeopardy. All the same, nobody can misunderstand that Breton sought to impose the heaviest of demands on everyone aspiring to the rank of surrealist, and that he did so out of a strict sense of necessity.

Breton's grandiloquence detracts in no way from one central aspect of a situation peculiar to surrealism. From the outset, individuals admitted to the surrealist camp retained right of entry only while they continued to be surrealists first and foremost. As soon as anyone began devoting himself less to probing the surreal than to developing his artistic talent (Masson as painter, for instance, or René Char as a poet), he either drifted away from the surrealist group or was ostracized by its members. Once surrealist aims lost their attraction for a painter, or once he found himself turning to pictorial investigation and its techniques for a purpose other than attainment of those goals, then his ties with surrealism were severed.

At one extreme, the blatant selfishness of Salvador Dalí (who from the first intended simply to make use of surrealism) cannot go unremarked. At the other, the total commitment to surrealism voluntarily made by Yves Tanguy authenticates an impressively unified body of work. The latter reflects devotion to surrealist precepts and acceptance of an austere discipline that Joan Miró, for one, would never have been capable of respecting without compromising something essential to his creative genius. Surrealism helped some painters like Yves Tanguy, and Toyen find themselves. After making contact with surrealism, these people needed to look nowhere else to find inspiration. Others, like André Masson, brought with them notable potential, which participation in surrealism encouraged them to develop. Later on, however, they were to step back, after finding surrealism made

unacceptably restrictive demands, or again could not guarantee them the chance to advance in directions to which they felt drawn.

The more evidence we survey, the more difficult it becomes to credit the presence, here, of hard-and-fast rules. Certain artists passed through a phase in their development during which association with surrealism was beneficial to the evolution of their art. Others—Hans Arp is the most shining example—were content to maintain their distance, while yet hailing the surrealists as their friends and gladly exhibiting in surrealist shows. Safe from the stress to which active involvement in the group subjected participants, they remained independent. Hence, they were free to make a valuable contribution, more sustained in some cases than that of persons caught up in the day-to-day life of the surrealist movement

For a number of artists (Pablo Picasso, Masson, eventually even Max Ernst), surrealism came to nothing more, in the long run, than a way of raising a variety of artistic questions but of solving only a few of them. When some questions persistently eluded resolution in the context of surrealism, those artists faced up to their need to seek answers nonetheless, even though meeting such a need must take them outside the bounds of surrealism. To other painters, however, surrealism offered total fulfillment, as it did to René Magritte, Tanguy, and Toyen. In their minds, art and surrealism were completely and satisfyingly one. No other form of painterly expression being capable of holding meaning for them, when they spoke of art and practiced it, they spoke of and practiced surrealism.

Solving the "problems" he deliberately set himself as a challenge while painting, Magritte invariably approached art as a means of facing questions, not as an exercise of aesthetic scope and significance. In the least ambiguous fashion imaginable, he reduced art to a strictly functional role, one imposed upon him by his aspirations as a surrealist. Hence appreciation of Magritte's work begins with recognition of the close limitations placed on art by surrealism and, conversely, with understanding of the breadth of the demands surrealism makes on every artist recruited to the movement. The surrealists' habitual disregard for technical expertise may lead some people to imagine that surrealism relaxes altogether the requirements to be met by any individual seeking qualification as a surrealist painter. But this cannot seem true unless one ignores the broad extra-technical requirements that, in the end, may be met no more competently by charlatans than by opportunists. For a moment perhaps it may appear that, among surrealists, those with proven inability to paint have some sort of advantage. But not for an instant is it possible to argue that any surrealist painter is truly successful until he has met demands that technique, of itself, is inadequate

to satisfy, but that everyone has to meet before winning a place among the surrealists.

Tanguy never had any explanation to offer for his painting. In fact he claimed he did not understand the meaning of his own work. His pictures derived their freshness from the relationship they expressed between the pictorial images presented and the uncomprehending sensibility creating them. It is this peculiar relationship—in which reason and understanding are extraneous to and even at odds with the creative act—that makes Tanguy such a pure surrealist, someone for whom surrealism never could be just a method, because it was always a state of being externalized through the tentative gesture of painting.

Handling the question of purity when surrealist painting is at issue entails, to begin with, knowing how surrealists look upon elements and skills normally thought to have a place in the painter's art but nevertheless ruled inapplicable in surrealism. These range from technical matters dismissed as irrelevant all the way to moral, ethical, and aesthetic considerations viewed as positively dangerous, because they are judged serious obstacles to the artist's advancement in surrealism. Surrealists regard as immaterial any concern that does not play an active part in bringing the painter closer to fulfillment of surrealist ambitions. At the very least, such concerns are viewed with distaste, whether present in the artist or in his audience. So far as they tend to take attention away from what surrealism recognizes as essential, they can only detract from the value of the created work. There is a serious risk that they will deprive a painting of the very characteristic it must retain if it is to meet surrealist criteria: functionality. Distracting preoccupations become distinctly harmful wherever they undermine the functionality of surrealist art by confusing it with something it is not and cannot be.

It is easy to see why, being obliged to defend themselves against incomprehension, antagonism, and out-and-out misrepresentation, the surrealists have often ended up describing their position in negative terms, as though the only way to define their concept of art were to declare what art is not and never must be allowed to become. More puzzling, no doubt, is the fact that surrealist doctrine does not redress the balance by indicating precisely what art ought to be if it is to merit and earn approval. Not so much indecisiveness as disinclination to close off promising avenues of inquiry accounts for the surrealists' unwillingness to formulate a clear rigid

definition. All that matters, they believe, is that surrealism directs attention at all times to areas of investigation appearing to hold out the chance of new discoveries in art, without specifying in every instance what the nature of such discoveries has to be.

It does not follow that surrealists take refuge in vagueness or merely lapse into it. When they speak of the artist's role as they do, they are not indulging in the elaboration of an obscurantist jargon, designed to impress or befuddle outsiders who might be listening. Nor, for that matter, is their purpose to hide weaknesses in surrealist theory or practice, as best they can, behind phrases strung together in justification of a position that their opponents would consider untenable. Basic to their point of view, to their concept of valid artistic exploration, is the vital need to outline a significant relationship between man and the work he creates, whether he be a painter, a sculptor, or a writer. Yves Tanguy's refusal to give an accounting of his own work, or to endorse explanations put forward by others, parallels André Breton's castigation of "ridiculous means of knowing" rejected by all surrealists.

Defining the artist's relation to his work, surrealists are convinced, is of the highest relevance to the central task of situating the individual in the world about him and more particularly to that of clarifying his sense of the real. Via art, surrealists aim at nothing less than posing and facing questions of fundamental importance to self-awareness. It is in connection with the latter that reality finally takes on definition and consistency for them. Modified self-awareness brings with it a modified sense of reality, surrealism affirms. Hence expansion of the former is accompanied by a broadening and deepening of the latter. With Tanguy, for example, what counts is locating "the key to the mental prison" of which Breton spoke, and then turning it. This act can be accomplished only with the proviso that the artist bear in mind Breton's warning: "the bars are on the inside of the cage." He or she must be attentive at the same time to the concern expressed in Breton's *Yves Tanguy* for "the other side of the horizon, then, not of art but of life."

Against the background of self-discovery and self- definition as understood in surrealism the functional nature of artistic activity stands out with such clarity that no compromise or adjustment is conceivable, let alone required or even permissible. No excuses stand for a moment before the surrealists' determination to look at painting in a light projected by ideas in which they place their trust. Compromise, here, is never wisdom or practicality; it is nothing short of capitulation.

In the context of surrealist thinking, noteworthy discoveries are located beyond the range of the familiar, the habitual, the known, extending as far as the supposedly unknowable. Thus the state of mind that is surreal-

ism expresses a yearning for the total emancipation of thought, freed at last from confinement by inherited ideas, feelings, and sentiments. Art then is a mode of cognition, vital to the surrealist enterprise. It casts the painter, like any other artist, in the role of explorer, searching for something he does not know and cannot conceive until he finds it, in pursuit all the time of something he recognizes when he meets it without having seen it before, always heading out after something he re-cognizes without ever having known. And art leaves no surrealist artist contented, unless whatever it has taught him incites him to learn still more.

Notes

The place of publication for all books in French is Paris, unless otherwise indicated. For books in English, it is New York.

PRELUDE

1. André Breton, *Manifestes du surréalisme* (Jean-Jacques Pauvert, n.d. [1962], p. 40. This edition of the surrealist manifestoes, to which all subsequent page references are made, brings together the first (1924) and second (1929) manifestoes, "Prolégomènes à un troisième manifeste du surréalisme ou non," "Position politique du surréalisme," "Poisson soluble," "Lettre aux voyantes," and "Du surréalisme en ses œuvres vives."

MAX ERNST

1. "Interview de Max Ernst sur l'Allemagne," *Médium: communication surréaliste* n.s. 2 (February 1954): 27–29.

2. "A son gré," *Médium: communication surréaliste* n.s. 4 (January 1955): 36.

3. André Breton, *Entretiens 1913–1952* (Gallimard, 1952), pp. 68–69.

4. André Breton, *Le Surréalisme et la peinture*, pp. 24–25. All page references are to the definitive edition (Gallimard, 1965), which assembles essays on surrealism and painting written by Breton between 1925 and 1965.

5. First published in *Cahiers d'Art* 6–7 (1936).

6. From a 1923 essay "Max Ernst, peintre des illusions," published for the first time in Louis Aragon's *Les Collages* (Hermann, 1965), p. 30.

7. An ex-associate of theirs, Waldberg enraged the surrealists in Paris with his exhibition *Le Surréalisme: sources, histoire, affinités,* which opened at the Galerie Charpentier on

April 15, 1964. See their broadside, "Face aux liquidateurs" (April 13, 1964), in *Combat-Arts* no. 108. The catalog cover, incidentally, was decorated by Max Ernst.

8. Patrick Waldberg, *Max Ernst* (Jean-Jacques Pauvert, 1958), p. 141.

9. *La Femme 100 têtes* is discussed in J. H. Matthews, *The Imagery of Surrealism* (Syracuse, N.Y.: Syracuse University Press, 1977), pp. 94–99.

10. The canvas is inscribed, back and front, *Celebes*. Its title derived from some vulgar verses, popular among schoolboys in Germany, beginning, "Der Elefant von Celebes / Hat hinten etwas gebeles" (The elephant from Celebes / Has sticky, yellow bottom grease). The conjunction (*von*) has disappeared from the French version of Ernst's title.

11. The image of the cauldron on legs was inspired by an illustration Ernst had seen in a British anthropological journal, showing a communal corn-bin peculiar to the Konkombwa tribe of the Southern Sudan.

12. Preface to *Exposition Max Ernst*, Knokke-Le-Zoute, July 4–August 30, 1953, published in Brussels by Editions de la Connaissance in 1953.

13. Max Ernst, "Comment on force l'inspiration (Extraits du 'Traité de la peinture surréaliste')," *Le Surréalisme au service de la Révolution* 6 (May 15, 1933): 43, as cited in Max Ernst, "Inspiration to Order," *Beyond Painting* (Wittenborn, Schultz, 1948), p. 20.

14. Max Ernst, *Propos et présence* (Gonthiers-Seghers, 1959), p. 16.

15. "An Informal Life of M. E. (as told by himself to a young friend)" expanded from, notes that began appearing in *La Révolution surréaliste*. See the catalog *Max Ernst* (New York Museum of Modern Art, 1961), p. 13.

JOAN MIRÓ

1. *Variétés* (Brussels), numéro hors série, "Le Surréalisme en 1929" (June 1929): xi.

2. Sam Hunter, introduction to *Joan Miró: His Graphic Work* (Harry N. Abrams, 1958), p. xx.

3. André Breton and Paul Eluard, *Dictionnaire abrégé du surréalisme* (Galerie des Beaux-Arts, 1938), p. 17.

4. Breton's contribution to the published volume *Constellations* is discussed in J. H. Matthews, "André Breton and Joan Miró: *Constellations*," *Symposium* 34, no. 4 (Winter 1980/81): 353–76.

5. Joan Miró, "Je travaille comme un jardinier," interview granted Yvon Taillandier for *XXᵉ Siècle* 5, no. 1 (February 15, 1959).

6. See James Thrall Soby, *Joan Miró* (The Museum of Modern Art, New York, 1959), p. 10.

7. André Breton, "Situation surréaliste de l'objet," printed in his *Manifestes du surréalisme*, see p. 311.

8. Jacques Dupin, *Joan Miró: Life and Work* (London: Thames and Hudson, 1962), p. 164.

9. José Pierre, *Le Surréalisme* (Fernand Hazan, 1973), p. 118.

10. Conroy Maddox, *Dali* (London: Hamlyn, 1979), p. 47.

11. Breton's statement is taken from his first surrealist manifesto. See *Manifestes du surréalisme*, p. 51.

12. André Breton, *Introduction au Discours sur le peu de réalité* (Gallimard, 1927), p. 31.

13. James Johnson Sweeney, "Joan Miró: Comment and Interview," *Partisan Review* (February 1948): 209.

14. Benjamin Péret, "La Poésie est UNE et indivisible," *VVV* (New York) 4 (February 1944): 10.

15. Benjamin Péret, "Qui est-ce," in his *De Derrière les fagots* (Editions surréalistes, 1934).

16. Quoted in James Johnson Sweeney, "Joan Miró: Comment and Interview," p. 209.

17. Alain Jouffroy, *Une Révolution du regard* (Gallimard, 1964), p. 234.

ANDRÉ MASSON

1. See the invitation, in Breton's hand, in the *Cahiers* of the Permanence du Bureau de recherche surréaliste, dated Monday, November 10, 1924, p. 17. Incidentally, acknowledging receipt of the first issue of *La Révolution surréaliste*, Paul Eluard noted on December 16 that the photo (on p. 27) of the second Masson drawing had been printed upside down.

2. José Pierre, *Le Surréalisme*, Les Maîtres de l'art Series (Fernand Hazan, 1978), no pagination.

3. "Mythologies" in Michel Leiris and Georges Limbour, *André Masson et son univers* (Geneva and Paris: Editions des Trois Collines, 1947), p. 124. In a lecture, "Peindre est une gageure," written in 1939, André Masson declared that the authentic artist must find for himself "the movement toward myth." Masson's text was published in *Les Cahiers du Sud* during March 1941 and was translated as "Painting is a Wager" in *Horizon* exactly two years later. In the meantime André Breton had stressed the importance of myth in surrealism, both in the catalog of the New York show *First Papers of Surrealism* (1942) and in his text "Vie légendaire d'un nouveau mythe" (1942), translated in *View* in April 1942 and reprinted in the 1945 edition of *Le Surréalisme et la peinture*, immediately after "Prestige d'André Masson."

4. "Scènes familières," in *André Masson et son univers*, p. 118.

5. Published in *Les Etudes philosophiques* 4 (October-December 1956): 634–36.

6. Published in *Méditation* 3 (Autumn 1961): 33–41.

7. José Pierre, *Position politique de la peinture surréaliste* (Le Musée de Poche, 1975), p. 20. The point made here about unintentional symbolic significance cannot be given too much emphasis. When, having left surrealism for good, Masson published a series of drawings he had done on the theme of desire, twenty of which he had completed in a single day of April 1947 (and the remaining two the day after), he specifically denied their automatic origin: "For there is not one of those drawings in which I cannot explain the symbolism. It would even be easy for me to discern an origin for most of them." See André Masson and Jean-Paul Sartre, *22 Dessins sur le thème du désir* (Mourlot, 1962).

RENÉ MAGRITTE

1. José Vovelle, *Le Surréalisme en Belgique* (Brussels: André De Rache, 1972), p. 69.

2. Remark to E. C. Goosens (January 28, 1966), as reported by Harry Torczyner, owner of the picture, in his *Magritte: Ideas and Images* (Harry N. Abrams, 1977), p. 48.

3. Apropos of creative action, René Magritte shared the opinion of Paul Nougé

rather than of André Breton. On Nougé, examined from this perspective, see J. H. Matthews, *Toward the Poetics of Surrealism* (Syracuse, N.Y.: Syracuse University Press, 1976), pp. 102–21.

4. Letter to James Thrall Soby, March 20, 1965, as quoted in Soby, *René Magritte* (New York Museum of Modern Art, 1965), p. 8. In August 1966 Magritte explained, while being interviewed by Christian Bussy, "Before, during, and after my stay in France, I underwent influences that were enlightening rather than determinant," cited in Torczyner, *Ideas and Images*, p. 30.

5. Quoted in Patrick Waldberg, *René Magritte* (Brussels: André De Rache, n.d. [1965]), pp. 251–52.

6. Letter to André Bosmans, July 20, 1960, cited in Torczyner, *Ideas and Images*, p. 75.

7. Cited in Torczyner, *Ideas and Images*, p. 23.

8. See the section called "La Vision déjouée" in Nougé's essay "Les Images défendues," in his *Histoire de ne pas rire* (Brussels: Editions de la revue Les Lévres Nues, 1956), p. 229.

9. Paul Nougé, "Toujours l'objet," in "Les Images défendues," *Histoire de ne pas rire*, p. 236.

10. Paul Nougé, "Peintures idiotes," in "Les Images défendues," *Histoire de ne pas rire*, p. 249.

11. Paul Nougé, "Dernière Recommandation," preface to a Magritte exhibition held in London in April 1938.

12. René Magritte, "La Pensée et les images," in the catalog of a show held in Brussels in May 1954.

13. Letter to Mr. and Mrs. Barnet Hodes, cited in Torczyner, *Ideas and Images*, p. 31.

14. Letter to Achille Chavée, September 30, 1960, cited in ibid.

15. Letter to Maurice Rapin, June 20, 1957, cited in ibid.

16. Letter to P. Roberts-Jones, April 26, 1964, cited in ibid.

17. René Magritte, prefatory remarks in the catalog of a show, *The Vision of René Magritte*, held at the Walker Art Center, Minneapolis in 1962.

18. Letter to Maurice Rapin, March 31, 1956, cited in Torczyner, *Ideas and Images*, p. 68.

19. René Magritte, "La Ligne de vie," *L'Invention collective* 2 (April 1940).

20. Cited in Jean Stevo, "Le Surréalisme et la peinture en Belgique," *L'Art belge* (January 1968): 61.

21. Letter reproduced in Paul Nougé, *Histoire de ne pas rire*, p. 218.

22. See Carlo Ludovico Ragghianti, "Accoucheurs de flamme," *Critica d'arte* 3 (May 1954): 267–73.

23. Letter of May 8, 1959, cited in Torczyner, *Ideas and Images*, p. 81.

24. René Magritte, in *La Carte d'après nature* 1 (October 1952).

25. Letter to Mirabelle Dors and Maurice Rapin, December 30, 1955, cited in Torczyner, *Ideas and Images*, p. 23.

YVES TANGUY

1. Cited in James Thrall Soby, *Yves Tanguy* (New York Museum of Modern Art, 1955), p. 17.

2. André Breton, "Avant-Dire," in his *Yves Tanguy* (Pierre Matisse Editions, 1946), p. 9, dated New York, May 1946.

SALVADOR DALÍ

1. The same effect was produced with exactly the same motif in *Echo morphologique* (1934–36) and again in "L'Echo nostalgique," Dalí's frontispiece for Paul Eluard's *Nuits partagées*, published in 1935.

2. José Pierre, responding to René Passeron's presentation "Le Surréalisme des peintres," in *Entretiens sur le surréalisme*, ed. Ferdinand Alquié (Paris and The Hague: Mouton, 1968), p. 262. In a somewhat muddled article showing no knowledge of Pierre's observations, "Dalí's Paranoiac-Criticism or The Exercise of Freedom," *Twentieth Century Literature* 21, no. 1 (February 1975): 59–71, Haim Finkelstein has attempted to analyze Dalí's theory as a strategic ploy.

3. Salvador Dalí, "L'Ane pourri," *Le Surréalisme au service de la Révolution* 1 (July 1930): 9. "L'Ane pourri" became the first chapter of Dalí's 1930 book *La Femme visible*.

4. Dalí developed his ideas on Millet's painting fully only long after his ties with surrealism were irremediably severed. See his 1963 book *Le Mythe tragique de l'Angélus de Millet*.

5. Jealous of his ranking among surrealists, in his "Au dela de la peinture" Max Ernst defined his technique of frottage as the real equivalent of automatic writing and presented it as the activity which later came to be called critical paranoia. In a footnote, without naming Dalí, Ernst spoke slightingly of the term "critical paranoia" on the grounds that the noun was not being used in its medical sense.

WILHELM FREDDIE

1. Karl Otto Götz, "Die drei Perioden Wilhelm Freddie's," in the collective volume *Wilhelm Freddie* (Copenhagen: Udgivet af Bjerregård-Jensen's Botrykkeri, 1962), p. 78.

2. Edouard Jaguer, *Wilhelm Freddie* (Copenhagen: Svend Handens forlag, 1969), p. 54.

3. José Pierre, "Surrealism, Jackson Pollock, and Lyric-Abstraction," in the catalog *Surrealist Intrusion in the Enchanters' Domain* (D'Arcy Galleries, 1960), p. 33.

ROBERTO SEBASTIAN ANTONIO MATTA ECHAURREN

1. Sarane Alexandrian, *Surrealist Art* (London: Thames and Hudson, 1970), p. 168.

2. Roberto Matta, "Hellucinations" (*sic*), reproduced in Max Ernst, *Beyond Painting*, p. 193.

3. "I begin my pictures under the effect of a shock I feel that makes me escape reality. The cause of this shock can be a small thread coming away from the canvas, a drop of water falling, this print my finger leaves on the shiny surface of this table." Joan Miró, "Je travaille comme un jardinier." *XX*ᵉ *Siècle* 5, no. 1 (February 15, 1959).

4. José Pierre, *Le Surréalisme* (Fernand Hazan, 1973), p. 115.

5. See Jean Schuster, *Développements sur l'infra-réalisme de Matta* (Eric Losfeld, 1970), p. 10.

6. Remark made to Alain Jouffroy, in "'La Question' de Matta" (May 1958), reproduced in Jouffroy's *Une Révolution du regard*, p. 86.

7. Paul Eluard, *Donner à voir* (Gallimard, 1939), p. 131.

8. See Jouffroy's account of "L'Exécution du testament de Sade" (originally 1959), reprinted in *Une Révolution du regard*, pp. 34–37. After the ceremony taking place in the apartment of surrealist poet Joyce Mansour, Matta imitated Jean Benoit in branding his chest with the letters S A D E.

CODA

1. Herbert Read, "A Further Note on Superrealism," in his *A Coat of Many Colours* (London: Routledge, 1947), p. 197. Read quotes the definition of surrealism, borrowed from Breton's *Manifeste du surréalisme*, in his own translation.

Index